From Méliès to New Media

From Méliès to New Media
Spectral Projections

Wendy Haslem

intellect Bristol, UK / Chicago, USA

First published in the UK in 2019 by
Intellect, The Mill, Parnall Road, Fishponds, Bristol, BS16 3JG, UK

First published in the USA in 2019 by
Intellect, The University of Chicago Press, 1427 E. 60th Street,
Chicago, IL 60637, USA

A catalogue record for this book is available from the
British Library.

Copy-editor: MPS Technologies
Cover designer: Aleksandra Szumlas
Cover image: Lobster Films 2011
Production manager: Mareike Wehner
Typesetting: Contentra Technologies

Print ISBN: 978-1-78320-989-7
ePDF ISBN: 978-1-78938-032-3
ePUB ISBN: 978-1-78938-031-6

Printed and bound by Hobbs, UK.

This is a peer-reviewed publication.

Contents

List of Illustrations

Acknowledgements

This book has benefited from the expertise and influence of some outstanding film scholars, who are also my colleagues and friends. As an undergraduate student in Cinema Studies, I took subjects taught by Professor Barbara Creed where I learned how to recognise the depth and detail that is beyond the surface and how to use cinematic language to explore complex ideas. Equally important was the influence of Professor Angela Ndalianis, a brilliant film scholar who was my colleague for fifteen years. Angela supported my research and encouraged me to develop subjects in the Screen Studies program at The University of Melbourne.

Just as important was the opportunity to teach early film and new media to Screen Studies students. It has been a pleasure to be able to explore cinema beyond traditional screening spaces like art galleries or in virtual spaces where we were able to reconsider the intersection of new media and film history. Teaching our own research is a privilege and I thank the students who may not realise that they also teach us. The production of this book was generously supported by a publication grant from the School of Culture and Communication.

The book was improved in response to some insightful feedback from three anonymous readers. I appreciate their close reading and constructive commentary on my manuscript. Leonie Cooper helped to edit drafts of two chapters and it was wonderful to work with her.

Finally, I am grateful to my family, Simon, Janine, Bessy, Linda, Rick and Jade. I dedicate this book with love to my parents – Alfred and Beverley Haslem.

Introduction

Beginnings and Ends: Historical Collusion

Chapter 1

Cigarette Burns and Bullet Holes: Celluloid Cues in Digital Cinema

Did you ever want to cut away a piece of your memory, or blot it out? You can't you know, no matter how hard you try. You can change the scenery, but sooner or later you'll get a whiff of perfume, or somebody will say a certain phrase or maybe hum something, then you're licked again!

(Al Roberts, *Detour*, 1945)

Thus, what I enjoy in a narrative is not directly its content or even its structure, but rather the abrasions I impose upon the fine surface; I read on, I skip, I look up, I dip in again. Which has nothing to do with the deep laceration the text of bliss inflicts upon language itself, and not upon the simple temporality of its reading.

(Roland Barthes 1973: 11–12)

Not so long ago whilst on the tram on my way home from work I began watching the 1945 celluloid print of Edgar G. Ulmer's B film noir *Detour* downloaded and configured for my mobile screen. As the tram ferried me home along Melbourne's wide boulevards, I became aware of traces of the history of *Detour*, particularly the visual and sonic signs that reveal an intricate confluence of older and newer technologies that produced this layered, fragmented view. I had always understood film history as a dynamic force, but looking at this film through a tiny screen, I could see, hear, touch and experience some of the ways that new technologies interact with film and how celluloid retains its presence as a subtle but intrinsic force within a pervasive digital media ecology. *Detour* was presented as a celluloid film displayed within a digital context, a constellation of older and newer media, technologies and materials. Within a culture fearful of cinema's obsolescence, I could experience the presence of film history in the impression of celluloid displayed digitally. In this case, the digital offers a sensory experience that enlivens the past within the present. This experience of watching *Detour* presents a complex arrangement of temporalities, one that displays the present image as both contingent on and haunted by the past, a co-existence of tense. Impressions of film history become evident as more than seventy years of the film's life is animated by the pixels and back lighting of this small screen. As Gilles Deleuze points out, 'It is characteristic of cinema to seize this past and the future which coexist with the present image' (2014: 38).

As I travelled on the tram watching the 'original' version of *Detour*, this small mobile screen presented a significantly different experience of the same version of the theatrical film. Thomas Elsaesser describes the experiential culture of contemporary cinema as one

in which everything has changed, but nothing has changed (2013: 26). Against the fear of imminent cinematic obsolescence, the digital display often preserves analogue traces. As Elsaesser points out, contemporary cinema is 'doing the same thing with different means' (2013: 26). These differing means re-situate the cinema into spaces beyond the traditional theatre. Theatrical cinematic screenings include familiar rituals such as scheduled exhibition times with audiences gathering, buying tickets and perhaps popcorn or an ice cream, moving into the theatre, selecting the best possible vantage point and watching (or ignoring) slides, advertisements, warnings about inappropriate behaviour in the cinema and previews for forthcoming films. On the tram the ritual differs. My digital screen provided an illusion of ubiquitous access to audio-visual content where there are few restrictions on the time and space of screening. I could avoid the advertisements and watch *Detour* in transit, uninterrupted, or even paused, rewound. I could change contrast to add to the brightness or darkness of the noir aesthetic and if I selected mute, I could watch it in silence. The options at my fingertips were not necessarily evidence of the domination of digital media (the film holds tight to its celluloid form), but it certainly illustrated how these different means created new experiences of cinema supported by technologies that reconfigure, reframe and provide new experiences of traditional media. I had the potential to manipulate this film, just as it created my experience. Watching *Detour* on the tram illustrates Elsaesser's ultimate point that the digital turn signals a soft revolution, a second Renaissance in visual culture (2013: 15). This soft revolution, however, seems also to reconfirm the significance of celluloid film history. The past remains evident as spectral, influential traces on the material foundation of film, even in more contemporary modes of digital display.

Originally, *Detour* was produced as a low budget film from the Producer's Releasing Corporation (PRC Pictures), a studio that occupied the poverty row edge of the Hollywood system. *Detour*'s director Edgar G. Ulmer was one of a group of influential European filmmakers working in Hollywood during the 1940s. These directors were responsible for creating a particular aesthetic that was high in contrast, an effect produced by heightening the key lighting and dimming (or excluding altogether) the fill lights. Noir filmmakers like Ulmer favoured night for night shooting producing the deepest blacks. Shooting at night helped to affect a pervasive ambience of dread, claustrophobia and a deep sense of hopelessness that was particularly characteristic of the B film noir universe. Whilst the original screen ratio of 1.37:1 was unfurled using an anamorphic lens in theatrical exhibition, I watched the chemical, celluloid material form of *Detour* on a tiny digital screen that was rotated so that it measured just over eleven centimetres in width and almost six centimetres in height. This mobile screen is closer to the size of the frames of the 35mm print than the dimensions of the theatrical screen. Whilst *Detour* was filmed using black-and-white film stock, the mobile screen seemed to add to this range using a digital palette capable of displaying colour, even in the exhibition of black-and-white film. This noir aesthetic that favours the extremes of its distinct black-and-white

spectrum could also be interactive as I was able to control both contrast and brightness, deactivating the 'automatic brightness' setting. The pulsing LED screen illuminated the film from behind, whilst in 1945 the stream of light of a projector penetrated the celluloid, projecting an image onto the front of the screen. Patterns of light are projected onto the screen and scattered back to my eye in projection. The backlit screen illuminates the tiny images and invites my eye to catch them as they unfold amid a panorama of possible views. The light of day streaming into the tram is transfigured by the addition of harsh interior fluorescent lights. I watched *Detour* in natural and artificial light, surrounded by passengers reading books, scanning newspapers on screens, engaged in text conversations, talking to one another and some who were just staring out the window. The viewing space is mobile, public and heterotopic. The sounds of *Detour*, originally recorded in mono, are now received via stereo headphones, which formed part of a broader soundscape that included traffic noise, the mechanical sounds of the tram, the voices of passengers and the broadcast announcements of stops. If I was distracted momentarily, I had the ability to pause, rewind the film and watch a sequence again. I watch this film in high definition, a level of resolution that was not available during the 1940s. Identifying this view as celluloid displayed digitally acknowledges the synthesis of the deep material foundation and the tactile surface of the screen.

Spectral projections are also evident in the abrasions that Roland Barthes imposes on the surface of the text. The fine abrasions and deep lacerations on the material surface of both celluloid and pixels of digital film reveal a slightly less visible, but dynamic intersection of the old and the new in contemporary screen culture. Aesthetically, the film becomes a composite of celluloid and digital, marked by the inscription of older technologies displayed on newer, digital screens. The limited, but captivating, lighting design of poverty row noir is visible even in the ambient light of day. Slight scratches in the print are evident and retained in the digital format. Most significantly, the intermittent cue marks in the top, right corner, the punched out holes or cigarette burns that act as signals for the projectionist that the end of the reel is imminent, remain visible more than seventy years after *Detour*'s release. These marks are the fleeting, almost secretive visual communication codes shared between filmmakers and the projectionists. Often cue marks appear in pairs, the first is a motor cue placed eight seconds prior to the end of the image sequence, the second is the changeover cue designating one second before the end of the reel. Traditionally punched or burned into the negative, sometimes even appearing as an 'x' scratched into the emulsion in the corner of the frame, cue marks appear in reversed colour scheme from the negative to the positive print. In some instances the mark was highlighted with black ink in order to register brightly white in the positive print. Characterized by its rough, white edged appearance, this signal creates the appearance of a bullet hole, a violent image and an appropriate visual motif for film noir, a genre that perpetuates the threat of violence within its *mise-en-scène*. This particular perforation also provides a visual indication of the fast pace of production for B films like *Detour*.

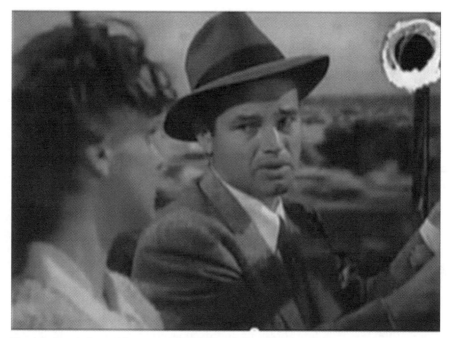

Figure 1: Detail of one of the cue marks from Edgar G. Ulmer's B film noir *Detour* (1945).

Cue marks appear in the corner of the frame of *Detour*, inviting the spectator to consider this film within the broad swathe of film and optical histories. Whilst they are extra-diegetic, they are inextricably connected to the flow of the narrative. Even though they penetrate the photochemical material, they are certainly part of its visual register and even though their impressions are fleeting, they can impact spectatorship. Such a material signifier might well be considered as a variation of the afterimage, an effect of the image that Jonathan Crary describes as 'events outside of the domain of optics, [...] relegated to the category of the "spectral" or mere appearance' (1992: 97). Crary notes the early nineteenth-century understanding of the afterimage as 'optical truth', citing Goethe's position that there is 'no such thing as optical illusion: whatever the healthy corporal eye experienced was in fact optical truth' (1992: 98). In its appearance and repetition, the cue marks sit in a space outside of the narrative, but within the domain of the visual. They trouble an easy distinction between the fictional diegesis and the tangibility of the film frame, the spectral illusion and its materiality, subjective perception and optical truth.

Cue marks function in a similar way to the abrasions of the text that Barthes imposes on the surface of the text and recognizes as sites of interaction and joy (1973: 11). These are reminders of the materiality of celluloid film and the connection of this print to technologies and to viewers across time. The cue mark is one of many traces of celluloid, deeply inscribed as spectral signs of the past that remain present in the digital image. Another effect that

becomes visible on my screen is an additional level of contrast in blacks and whites. As Al Roberts (Tom Neale) and Sue Harvey (Claudia Drake) walk home from the nightclub, a white fog surrounds them, threatening to obscure their image altogether. Shots of the couple walking are interspersed with street signs. The signs remain visible, whilst the couple appear to become obscured by their environment. Later, as Al and Haskell (Edmund MacDonald) drive into the night, the deep black background seems to pulsate behind them. The digital screen renders the contrasting colours of noir as extreme, animated environments and foreshadows the loss of each couple.

Further spectral indicators of *Detour*'s production history feature in the soundtrack. Dissociations between image and sound are evident in multiple forms in this version of *Detour*. This rendition shows a resistance to synchronicity, an imperfect intersection of sound and image in the celluloid print and its digital capture. The image and soundtrack show traces of missing frames and soundtrack in the decomposed film. Such de- and re-composition is a feature of the production itself. The slightly unnerving montage of Al playing piano at The Break of Dawn Club includes close-ups of the hands that seem to be producing the music for the soundtrack. The edit wants to suggest that they are Al's, but they actually belong to the film's composer Leo Erdody. Whilst cheat shots like these are common in the cinema, they also signal a degree of infidelity between image and sound. Moments of delay add to this. Time lags are evident in multiple forms of sonic dissociation in the transition to the digital screen. Occasionally the images appear in advance of the soundtrack, dissociating speaker from dialogue. Sometimes the sound disappears altogether. Al's phone call with Sue is only able to be comprehended from his own responses. The irony of this one-way conversation becomes clear with Al's utterance '[t]hat's what I wanted to hear you say' when we don't hear what Sue says. This scene is answered later in *Detour* when, desperate not to be heard, Al calls Sue and listens to her voice, but can't speak to her.

Occasionally frames are missing, resulting in the interruption of image flow, the deletion of words and ruptured sentences. When Vera calls the Hollywood police, Al panics and says, 'Wait a minute Vera, you shouldn't do that'. Her reply is obscured by missing frames and consequently, an obscured soundtrack. The image itself appears ruptured. Sometimes there are pauses where the image sat on my screen for seconds longer than had originally been planned. In this scene some of the frames land on the screen and appear to stall and bubble out before transitioning to the next shot. Tiny impressions of horizontal white scratches appear in patches across the image. Vera's (Ann Savage) incomplete response matches the rupture of the image flow. The soundtrack includes the incomplete dialogue that Vera spits at Al: 'wouldn't do that […] I'll show you if I would'. In voice-over narration Al describes their conversation as 'hectic'. The disruption of image and sound inherited by this digital copy extends the hectic nature of the dialogue to the image and narrative flow. The idiosyncrasy of this particular print is perceptible again just beyond the change of reel as an image of Vera and Al appears and seems to expand laterally, stalling the progress of their drive, and the narrative. Time distends, and the image blurs, as the sound of their dialogue falls away after Vera's death. A mobile camera surveys the scene, taking in Al's

reaction. Vera's face reflected in the mirror, finishing with a direct shot of her body lying on the bed with the phone cord wrapped around her neck. Shots of faces and details of the *mise-en-scéne* are pulled into sharp focus, whilst the mobile camera's transition between each is blurred. In metacommentary voice-over narration, Al talks of the quiet, wondering if he had suddenly gone deaf, and then addresses the spectator, noting the impact of fate putting its finger on you, or me.

Further inscriptions of the celluloid materiality of *Detour* include the optical effects of process shots, particularly the use of back projection and traveling mattes, as have been described by Vivian Sobchack (2014: 113–29). Sobchack notes that *Detour* begins with back-projected images that appear between the letters during the credit sequence, 'letting us know from the beginning that escape is impossible and that apparent movement forward will lead only to reversal, repetition, and eternal return' (2014: 114). The slightly blurred, startlingly bumpy image that introduces the film's location establishes a vibrating, unclear, uncertain horizon line, one that recedes jarringly into the distance. The ride is jarring, almost abandoning the seamlessness of continuity editing. Back projection destabilizes and complicates Al's forward momentum as well as the film's temporal and spatial chronology. Montages of driving surround the characters with shots that alternate back, front and side projections. Each image that incorporates projection ruptures the seamless illusion of continuity editing. The stock image, as Sobchack writes, 'would register on film as second generation in relation to that first generation action' (2014: 115). Identifying back projection and traveling matte shots as 'neglected phenomena', Sobchack understands these optical processes as earlier forms of compositing that emerged out of the 'contingent necessities' of wartime film production (2014: 116). Sobchack sees these 'technical flaws as indices of Ulmer's low budget' (2014: 121). To this we can add the sonic dissociation, the interrupted flow of frames, the unsettled images, the extreme high contrast of the noir aesthetic and the punched out, white cue marks.

Detour transcribes these historically specific processes as multiple illusions of celluloid materiality and extends them to my digital screen. The illusion of back-projected stock footage transcribed with the imprint of the opening titles produces a credit sequence as palimpsest. Decentring is evident further into the film where, 'Al's eyes reflected backward at us and himself in the rear view mirror' (Sobchack 2014: 121). Optical processes on digital screens split the film into three parts. The back projection of stock or second unit footage adds another time and space from the past; the screen that frames the action filmed within the studio provides images of the present production, and my mobile screen shrinks each so that I can hold the film in my hand and watch it again in the future. Each optical process affords a different view. Cue marks attract a surreptitious glance, whilst back projection directs my gaze into a space well beyond the diegesis and shakes it up. Whilst my eye sinks deep into a distance of the stock image, it is also drawn to the surface. The textures of the surface include the scratches, shadows, contrast and edits of the film. I add my own impressions to the surface of the screen. The tactile screen shows up my fingerprints and the trail of the swipe that brings the screen to life.

Optical and technical processes are spectral projections, indexical impressions of older technologies, processes and histories that not only survive, but are also sometimes nostalgically recreated in more contemporary cinema. These spectral signs signal the complex interrelationship between celluloid cinema and digital media where the marks of earlier film processes are retained in transfers from celluloid to digital. Processes of digitization faithfully attempt to display the aesthetic of cinematic materiality within a digital ecology. In the absence of a projectionist on the tram, that role is transferred to the mobile viewer whose eye might be drawn to these signs, perceiving them as either redundant, or, as I will suggest, deeply connected to the present history of cinema. The cue marks are reminiscent of the broad range of semiotic codes regulating the rhythm and flow of celluloid production and exhibition, highlighting its continuing influence in digital display. These are literal pointers to history, signs of time that are deeply relevant to the moment of projection. These cigarette burns in the digital display of celluloid act as micro-impressions reminding us that contingency is the crucial factor connecting the aesthetic ruptures inherent in screen media across the breadth of film history. Mary Ann Doane notes that the significance of early cinema, 'lies in its apparent capacity to perfectly *represent* the contingent, to provide the pure record of time' (2002: 22, original emphasis). This suggests that such a deep intersection between the material elements of cinema and its preservation and transformation in digital media forms requires a new approach to understanding film history in the digital age. The 70-year separation between the production of *Detour* and its reception on my small screen marks a period of significant change in film technologies, change that affects all stages of the creative process from pre-production to exhibition. Such change requires a new language of cinema and alternative approaches to historiography.

The End of Cinema?

Some of the reactions to the introduction of digital technologies in film production predict the end of celluloid film. In 2009 Anne Friedberg suggested that the specific celluloid materiality, the apparatus, distribution and exhibition were in danger of being displaced by a more interactive media form. Friedberg writes, '[j]ust as the chemically-based "analog" images of photography have been displaced by computer-enhanced digital images; the apparatus we came to know as "the cinema" is being displaced by systems of circulation and transmission which abolish the projection screen and begin to link the video screens of the computer and television with dialogic interactivity of the telephone' (2009: 440). This displacement model stretches to encompass the materials, as well as the spaces of cinema and the experience of its spectator. For Friedberg, the digital image and its concomitant shift from public exhibition to private, home screens (imagined as televisual or computer interfaces) requires a reconsideration of the broad sway of film culture from the creation of the image to its impact as a new media form. Friedberg writes, '[d]igital imaging, delivery, and display effectively erase the "messages" implicit in the source "medium". The digitized

11

Metropolis illustrates how almost all of our assumptions about the cinema have changed: its image is digital, not photographically-based, its screen format is small and not projection-based, its implied interactivity turns the spectator into a "user"' (2009: 439–40). Whilst the displacement model suggests the end of an era for celluloid film, simultaneously Friedberg identifies the production of a new experience of temporality for the spectator, one that includes a deferred or shifted time made available by electronic technologies. She notes that the new temporality produced by the VCR affects the concept of history and our access to the past (2009: 444). Rather than eradicating earlier film, new technologies disrupt the view of obsolescence by creating a sense of simultaneity of the old and new. The reification of abstract traces of history in new media provides a portal to the past in the present. Friedberg uses an analogy of narrative temporality to posit that the asynchrony of spectatorship, 'has always produced experiences that are not temporally fixed, has freed the spectator to engage in the fluid temporalities of cinematic construction (flashbacks, ellipses, achronologies) or to engage in other time frames (other than the spectator's moment in historical time)' (2009: 449). The transformation of celluloid material to virtual images extends the promise of cinema to transport viewers back in time by highlighting the experience of the past in the present moment. Film has always been subject to change – in its narrative, aesthetic, technological and material forms. Paolo Cherchi Usai understands both celluloid and digital as transforming media, subject to change with every screening, with every print struck. Usai suggests that moving images that are immune from decay would have no history (2001: 41). Transformation is a defining aspect of the history of film from pre-cinema to digital media. Following Usai, I understand cinema as a live material produced by transforming technologies within a culture defined by change. It is part of a dynamic, but not necessarily chronologically evolving history. Film texts often retain signs of cinematic specificity in their digital form. We notice this in films that use digital tools to revise an analogue aesthetic, in films that emphasize the materiality of their base, in films that are blown up to scales well in excess of conventional frame ratios and in films that are shrunk down to be able to be captured on small screens, activated with the slightest touch of the finger.

High-profile filmmakers Peter Greenaway and Quentin Tarantino offer passionate arguments against the use of digital technologies in film production and exhibition. Greenaway foretold the death of the cinema with the advent of the remote control in 1983, 'the zapper' as he called it (cited in Gaudreault and Marion 2015: 25). In *The End of Cinema?: A Medium in Crisis in the Digital Age*, André Gaudreault and Philippe Marion surround Greenaway's prediction with seven more reasons why cinema is in crisis. These include the introduction of the 'zapper', the impact of television (which they suggest 'stabbed cinema in the back'), the emergence of digital media and the original death prefigured by the father of the father of cinema, Antoine Lumière who, at the birth of this new technological form, claimed that cinema was an invention without a future (Gaudreault and Marion 2015: 26–28). However the question mark at the end of the book's title is crucial here. Rather than suggesting the end of cinema, Gaudreault and Marion agree with Usai, proposing a complex understanding of claims about the end of cinema as part of the life of cinema. They

write, '*cinema's entire history has been punctuated by moments when its media identity has been radically called into question*' (2015: 2–3, original emphasis). An examination of these intersecting moments of film history can reveal some illuminating resonances.

Against the wave of panic about ends, new ways to reimagine the cinema have emerged from a renewed internal focus on cinematic specificity and myriad intermedial connections. The deconstruction of cinema into its elements (light, celluloid, silver, framing, editing, colour, contrast and *mise-en-scène*) may well be cast into sharp relief due to the perception of changing technologies; however, this underlines the enduringly cyclic aspect of film history. The first exhibition spaces were variations on the traditional theatre. The earliest Lumière actualities and the special effect 'trick films' created by Georges Méliès were screened in cafés, in shops, at fairs and expos and even above the doors of the Theatre Houdin. Pre-cinematic phantasmagorias were projected in a range of public spaces like graveyards where screens could take on ephemeral forms consisting of smoke or fog. The innovation evident in early film culture pre-empts the 'new' directions that we ascribe to digital communications technologies. Moving images are exhibited in art galleries and museums, on big screens in city squares, on the small screens of mobile phones. Even though the dispersal of the image might seem like a new phenomenon, it is part of an earlier cycle. Innovative approaches to exhibition, screens, spaces and interactivity do not replace or succeed earlier forms of moving-image exhibition; rather, they return to the practice of the showmen of early cinema and remind us of the prescience of the inventors of pre-cinema. In a post-medium era, new media looks back at the similarly creative impulses that drove film culture and recreates the moving image with an entrepreneurial vision. New media revives, revises, reimagines and allows for a new, potentially interactive and certainly dynamic connection with visual culture histories. However, the traces of cinematic specificity provide compelling evidence of the pervasive impact of earlier film cultures on the digital era as well as the significance of the digital on the ability to access, re-make and receive early film. It is precisely at this juncture that the composite, contingent form of cinema, acknowledging celluloid material displayed on digital screens encourages a reconsideration of film history. New media reveals celluloid presence, just as it is thought to threaten to obliterate it entirely.

A Materiality that Materializes: Specificity and Indexicality

If the experience of watching *Detour* in transit provides a hint of the inextricable connection between celluloid and digital, early and late film history, how might that intersection be understood? How does it impact on traditional teleological historiographies of the cinema focused on the use of celluloid and digital as oppositional materialities? How might a reconsideration of film history influence the contemporary debate about the predominance of digital film culture and the decline of celluloid? Thomas Elsaesser asks whether the cinema is now part of a rush towards media convergence, or whether it is set on a divergent course (2013: 14). Focusing on media convergence and digital cinema as a conceptual pair, Elsaesser argues, '[n]o doubt, a look at the cinema from the vantage point of digital media can help

revitalize our historical understanding of previous media' (2013: 15). It is exactly this look, or more specifically a look back at film history that allows for its reconceptualization. This is a look back that identifies the significance of intersecting moments that are not necessarily connected chronologically. Amid the panic about the end of cinema, an evolutionary model of film history may inadvertently consign celluloid to the isolation and darkness of the archive. A more expansive view would understand film existing in both celluloid and digital forms. More than this, a new approach would recognize the high level of dependency involved. Elsaesser suggests that if we look at historical patterns, we notice that divergent media forms have not replaced one another (2013: 19). This is certainly the case when we consider the various ways that early film informs and influences digital film and how the digital illuminates and relies on celluloid. There is also historical precedence for similar change based on influence rather than replacement. Elsaesser points out that, '[c]inema did not "respond" to the magic lantern by solving problems that had arisen in the practice of magic lantern shows. It repurposed aspects of the basic technology and parasitically occupied part of its public sphere, along with the sites of live performance, such as vaudeville and the music hall' (2013: 19). An evolutionary model of film history is replaced here with one that revitalizes the perception of a past that is actively and dynamically present within contemporary film culture. It also sees contemporary media as dependent on its celluloid history.

The cue marks that are fleetingly visible in the corner of some of the frames of *Detour* prompt a comparative examination of the elements that comprise both celluloid and digital film. In its original celluloid form and as the only B film in the Library of Congress, *Detour* has a photographic base, a photochemical atomic structure. Its celluloid foundation and light sensitive coating is comprised of nitrogen, camphor, dye and ethyl alcohol, chemical elements that form a highly flammable concoction. The range of liquid chemicals that 'touch', or come into contact with the celluloid in processing include silver sulphide crystals and bromide chemical compounds that create clusters of atoms and release electrons in response to activating agents. The compound photochemical base as both solid and liquid renders it as a visible, tactile material. It is a series of images that can be seen, felt, cut, reorganized and taped or glued together. This light-sensitive, living base also means that films like *Detour* become susceptible to change. Over time colours can fade, contrast can intensify with exposure to light, the grain of the film can lose definition and most obviously, scratches can appear on surface of the print. The effects of duration can impress themselves upon the celluloid-producing spectral impressions of time on surfaces. The presence of light in exposure, processing and projection inscribes and then begins to obfuscate the image. The moment that is captured by light in the registration of the image becomes subjected to those same forces as the image devolves or evolves with exposure to subsequent light sources and chemical transformation over time.

As light-sensitive, photochemical material, celluloid film has been understood to have a direct relationship to the concept of indexicality. To understand the index and its relevance to *Detour*, we need to return to the literary origins of this concept. Writing on semiotics in 1931, Charles Sanders Peirce described the associative power of the index as, 'like a pronoun

demonstrative or relative, [it] forces the attention to a particular object intended without describing it' (1931: 195). As a compelling force within a tripartite semiotic framework that includes the icon and the symbol, Peirce isolates the index as expressive and indicative in literature, exemplified by words like 'this' or 'that', words that force attention towards an object without describing it. He offers a particularly evocative and relevant illustration of the index becoming visible as a bullet hole in a piece of mould that bears the mark and points toward the gunshot (1955: 109). Peirce elaborates the definition of the index with additional examples:

> A rap on the door is an index. Anything which focuses the attention is an index. Anything which startles us is an index, in so far as it marks the junction between two portions of experience. Thus a tremendous thunderbolt indicates that *something* considerable happened, though we may not know precisely what the event was […] A low barometer with moist air is an index of rain […] A weathercock is an index of the direction of the wind […] The pole star is an index, or pointing finger to show us which way is north. A spirit level or a plumb bob, is an index of the vertical direction.
>
> <div align="right">(1955: 109, original emphasis)</div>

Some of the characteristics of the index suggest that it has no resemblance to the object to which it points, that it refers to single units or collections of units, and most compellingly, '[t]hat they direct the attention to their objects by blind compulsion' (Peirce 1955: 108). These descriptions help to emphasize both the difference between the index and its object as well as the compulsive attraction to it, its forceful aspect. The difference from the object, the dynamic connection to the object and the impression on the reader is emphasized when Peirce expands the definition in this way: '[An index is] a sign, or representation, which refers to its object […] because it is in dynamical (including spatial) connection both with the individual object, on the one hand, and with the senses or memory of the person for whom it serves as a sign […]' (1955: 107). Here, Peirce is extending that forceful, compulsive deictic direction to note its subjective aspect as it impacts on both the senses and on memory. The index becomes part of a semiotic chain of contiguous associations that are sometimes registered on the surface of the skin, or through the senses and categorized with recourse to the depths of memory. Whilst the registration of semiotic indexicality in literature was established by Peirce, theorists like Barthes reframed the concept to examine whether it was also possible in the visual arts.

As Peirce's concept of the index is translated into visual culture, it is the realm of photography that becomes the site where the deictic language of the index carries traces of light to direct attention to its referent. Barthes writes,

> [s]how your photographs to someone – he will immediately show you his; "Look, this is my brother; this is me as a child," etc.; the photograph is never anything but an antiphon of "Look," "See," "Here it is"; it points a finger at certain *vis-á-vis*, and cannot escape this pure deictic language.
>
> <div align="right">(1981: 5)</div>

For Barthes, photography relies on a context-dependent language code that also impacts on the senses and relies on memory. Later, Barthes writes about recognition in family photographs that are 'speckled with these sensitive points' and defines this as the punctum, something that 'rises from the scene, shoots out of it like an arrow', as something that pierces him, felt as a sting, or a prick, something that bruises him (1981: 27). Such bodily recognition elaborates the characterization of the index as something registered as sensory and connected through memory. This conceptualization of photography set the pace for a reconsideration of traditional approaches to the ontology of the image and embodiment across the broader visual culture.

The cinema has a vibrant history of animating ghostly impressions that situate the past in the present. It could be seen as an index of spectrality. Andre Bazin describes the function of the death mask, terracotta statuettes, substitute mummies as, 'the preservation of life by a representation of life' (1960: 5). In this framework, reproductions become indexical traces of the original, reminders of both the referent and its resonance for the viewer. Bazin perceives the practice of embalming the dead as providing protection against the passage of time. He writes, '[t]hus providing a defense against the passage of time it satisfied a basic psychological need in man, for death is but the victory of time. To preserve, artificially, his bodily appearance is to snatch it from the flow of time, to stow it away neatly, so to speak, in the hold of life' (1960: 4–5). Bazin's thoughts hint at the refusal of cinema to stand still in time, '[t]he film is no longer content to preserve the object, enshrouded as it were in an instant as the bodies of insects are preserved intact, out of the distant past, in amber' (1960: 8). Celluloid films display impressions of time on their surfaces. Their deictic temporal language points to a referent in the past. Certainly, a film image attempts to capture a moment in time, but it also cannot escape the multiple references to time, past and present. Temporal traces are stamped upon the surface, included within the narrative and they circulate around the film. Celluloid offers indexical pointers in the form of punctuations like the cue marks that point to material specificity. Other indexical markers designating 'this' dynamic history include scratches, tears and damage that point to changes in the surface of the film. Others involve accidental silences as soundtracks are excised along with damaged frames. The index points to time and history, carrying its markers, emphasizing change, revealing its effects. Often these marks of time are preserved as older films are transferred to a digital format. In the transition, digital film carry traces of the history of celluloid upon its surface, compelling a consideration of its original material. This gesture of referring back to the source preserves the presence of celluloid film on digital screens.

The intersection of different historical moments and the illusion of oppositional temporalities is outlined by Laura Mulvey who writes, '[i]n this dialogue between old and new, past and present, the opposition between film and new technologies begins to break down and the new modes of spectatorship illuminate aspects of cinema that, like the still frame, have been hidden from view' (2006: 27). Mulvey sees the relationship between celluloid and digital as a dialogue, something that anticipates an exchange. This two-way flow of information reveals how new media is not only influenced by early experiments in film, but how more contemporary forms of media allow us to see, access and shape our vision of film history via new approaches to distribution and exhibition. Mulvey's research allows

for an elaboration of the position of the index across photography and the still frame of the cinema, but it stops short of attributing digital media with the potential to register an indexical inscription. Mulvey writes that,

> [o]n one side, that of pre-cinema, stands the photograph. The image is still, but like film, it is indexical. On the other side, that of post-cinema, stands the digital, unlike the cinema in its material composition but able to carry the mechanical, celluloid-based moving image into a multi-media future.
>
> (2006: 22)

Registration of the index is possible as an impression on the photochemical material of celluloid transferred to digital or viewed on new media screens, but it is thought to have rarely been able to be caught, inscribed and illuminated in the 'immaterial' form of digital film. Reimagining this semiotic framework for the digital image, I want to suggest that the sequential occurrence of the cue marks, impressions that I felt initially as a fleeting distraction, are in fact, repeated, 'forced' reminders of the continuing presence of film history. In a broader context, this indicates the potential for the indice to point towards its cinematic origins. This sign that was originally addressed to the projectionist is now a broader indication of the resonance of film history in the digital era, perhaps even a hint of a spectral, digital indice.

Within this framework, material and abstract information systems are interrelated in exhibition, adapting to the new, insisting on the old. This is evident in the conjunction of celluloid and digital whilst watching films illuminated by digital light sources. The ethics of creating composite film provokes important questions for the processes of preservation and restoration, as the example of *A Trip to the Moon* (Méliès 1902, Lobster Films, 2011) illustrates. Celluloid undergoes drastic change when film is restored using digital tools. It is nostalgically re-made using hybrid celluloid and analogue materials along with new techniques that mirror more traditional approaches to filmmaking. At the other end of the spectrum, cinema is reimagined on a gigantic scale by filmmakers like Tacita Dean who insist on the continuation of celluloid filmmaking in the new millennium. Intertextuality in forms of copying, revising, refashioning, re-making was very much a part of early film culture particularly prior to the application of copyright law (and even beyond). Mulvey describes the impact of the digital on celluloid cinema,

> [t]he new technology offers an opportunity to look back to the "before", to the "then" of the indexical image, in the changing light of the "after", the "now". The aesthetics of the past meet the aesthetics of the present, bringing, almost incidentally, new life to the cinema and its history.
>
> (2006: 21)

The impact of the digital is a reinvigoration and extension of film history, visible through an analysis of the intersection of new and old materials, transforming the indice within what has been thought to be an immaterial context.

Another way of reanimating the index is by producing spectral impressions of time. As a time-based medium, the cinema carries temporal signs on its surface, in its processes and in the depths of its histories. All of the films that I analyse here highlight and foreground various indexical references on their surfaces, in their aesthetics, in their structures. The index is taken beyond its traditional definition in the inscription of the real and understood as signs of temporality emerging from a more spectacular aesthetic. Early variations on the serpentine dance films depict time in the spiralling movement of the performance, in the momentum of the fabric as it glides through the air, in the transmission across a spectrum of colours, as scratches and impressions on the surface of the celluloid film, effects that are captured and frozen in the digital format. Digital versions of celluloid films provide all-encompassing references to histories past and present. These digital transfers defend against the passage of time; they preserve and are preserved. They endure in a hybridized form. As was noted previously, the index can also be that illusory sign that directs the spectator to look at 'this'. In early cinema the showmen often took on this role. Georges Méliès directs attention towards (and away from) his experiments in film editing. In some ways, it could be suggested that his role as a magician was also indexical. For early film the index could also be a sign pointing towards its own spectacular display as attractions cinema. Whilst we can see the indice preserved in celluloid and frozen in film as it is transferred to digital, is its registration possible in purely digital film?

Indexicality in a Post-Medium Culture

Claims of the death of cinema are supported by the perception of a loss of indexicality in digital forms and in the assumed immateriality of a post-medium culture. An alternative reading would suggest that a case can be made for understanding the increasing complexity of indexicality in a post-medium culture. Whilst cinematic indexicality is possible as celluloid is carried forward and displayed on digital screens, this is complicated by the shift towards total digital production. Discussing the ways in which the digital revolution retrospectively returns to questions surrounding the definitions of cinematic specificity, Elsaesser writes:

> the convergence theory as applied to the cinema is frustrated by the fact that a special kind of (cultural) value has become attached to the cinema's traditional material bases, the optico-chemical process, whereby celluloid, coated with a light-sensitive emulsion, directly bears the imprint of the objects or views that are before a camera. As digital conversion does away with this material basis, such a modification cannot but challenge definitions of what cinema is […].
>
> (2013: 22)

Elsaesser mentions the specific qualities of cinema: 'photographic iconicity', 'the special kind of indexicality' that guarantees its link to truth and to a 'special kind of historical "record"' (2013: 22). It is here that the distinction between celluloid materiality and digital immateriality

that has been used to support a change in the cultural value ascribed to film becomes apparent. The visible, tactile and liquid materials of film production, particularly the light-sensitive emulsions that coat cellulose or polymer film stock and the chemicals for activating particles of silver and bromide, circulated on strips and reels of film facilitate an inscription of an impression of the 'real'. In contrast, the seemingly immaterial form of digital film, the zeroes and ones, and the slightly more visible pixels (which certainly become visible under magnification) manifest as digital images that can be circulated wirelessly as movie files, flash drives or on hard discs. Those less visible materials, it is argued, do not have the capacity to capture and inscribe the real upon a surface that can appear immaterial. Elsaesser summarizes the opposition to digital indexicality suggesting that some cinephiles draw:

> a line in the silicone sand: in their eyes, the digital image is no longer cinema because of the loss of indexicality of the image touches the cinema's core: its reality status and photographic essence, defined by luminosity, transparency, and projection, none of which is a prerequisite of the digital image, however much it can emulate transparency, create luminosity as a special effect, and utilize projection.
>
> (2013: 31)

Taking this difference to the edge, Elsaesser suggests, '[a]t the limit, a digital image is not really an image; generated by a different process, it is in essence a set of instructions whose execution (visualization, materialization, manipulation) obeys a mathematical rather than an optical logic' (2013: 25–26). The digital numeric image comprised of pixels suggests difference at its most elemental level. However, a broader view indicates the persistence of 'difference' in the development of optical experiments that began with the use of glass slides and film using a paper base. The distinction between materials of production is an essential aspect of the transformation of those materials across the history of film. Reduced to the definition of the inscription of light on emulsion, an examination of digital indexicality reaches a premature conclusion. Whilst the light-sensitive coating on celluloid has been seen to be able to register the index, this position would suggest that digital media cannot do the same precisely due to the 'immateriality' of its form. Excluding the 'immaterial' from access to indexicality compounds the view of digital as irrelevant, a medium without a referent in the real world.

Comprised of mathematical algorithms consisting of zeros and ones, digital technologies are capable of producing high-definition imagery with pixels as its basic unit. This pixelated base in combination with computer-generated image effects renders the image extraordinarily malleable, able to produce illusory land/seascapes, composited, constructed images produced sometimes without reference to a referent. Elsaesser reframes the debate, suggesting that the term 'digital cinema' is an oxymoron. He writes,

> I insisted on the oxymoronic nature of "digital cinema," now highlighting the possible areas of *contradicto in adjecto* by setting in opposition not analogue and digital image,

but "the cinematic" and "the digital" in terms of their respective effects, properties, and logics.

(Elsaesser 2013: 32)

He is referring to the differing materials, the clash of terminology as well as the impact on the image as contemporary filmmakers move away from the organization of vision around a Renaissance perspective or real-world referent and towards 'horizonless' images where the view is comparatively more free floating rather than directed towards the centre (Elsaesser 2013: 39). Rather than an inscription of a referent in the real world, the digital can create the world anew. But, as Peirce argues, the index does not reflect its object, but points towards it. The virtual index also has the potential to create spectacular imaginary visions, images that do not replicate, but may well point to an analogous referent in the real world.

At the height of the debate about the introduction of digital filmmaking, arguments suggesting the end of celluloid filmmaking and a convergence of all media that would render any distinct media form obsolete identified a consistent theme of a loss of confidence in the veracity of the image. Some film historians questioned the status of the digital altogether. Mary Ann Doane asks,

[i]s the digital really a medium, or even a collection of media? Isn't its specificity, rather the annihilation of the concept of a medium? Its information or representations appear to exist nowhere and the cultural dream of the digital is a dream of immateriality, without degradation or loss.

(2007a: 143)

Doane identifies the intersectionality that characterizes a contemporary film culture that incorporates both material and immaterial media forms when she writes that the digital has frequently been located as the cause of the 'post-medium condition' precisely because it appropriates, deploys earlier media in convergence, whilst it translates and stores information as numbers, not as an inscription of light on a photochemical surface (2007b: 3). In this context 'post-medium' both includes cinematic specificity and refers to the cinema beyond its definition exclusively as photochemical. Indexicality is transformed in a post-medium culture. As Doane suggests, '[t]he index, more insistently than any other type of sign, is haunted by its object' (2007a: 134). Indices 'simply indicate that something is "there"', it is 'pure indication' (Doane 2007a: 135). The digital index indicates film's celluloid past, forcefully directing our eye towards the continuity of traces of history.

The Register of the Digital Index

It is in consultation with the research produced by Laura U. Marks that we can begin to perceive new approaches to reading the possibility of the digital image as indexical. Firstly, Marks points to some of the problems in associating the image with 'truth' or with the

capacity to faithfully represent the real. She identifies a severance of the existential connection between the analogue and the digital explaining that,

> [i]n photography, film, and analog video it is possible to trace a physical path from the object represented, to the light that reflects off it, to the photographic emulsion or cathode ray tube that the light hits, to the resulting image. In digital imaging this path is not retraceable, for an additional step is added: converting the image into data, and thereby breaking the link between image and physical referent.
>
> (2002: 162)

The traditional argument is that indexicality is excluded, or lost, because that traditional path is more difficult to trace in a digital ecology. This 'loss' has also been seen to compromise faith in the truth of the digital image. Marks writes,

> [p]ractically, as a result of the potential digital alteration of any electronic image, video and photography can no longer serve as indexical evidence, for example in the courtroom. Theoretically, the semiotic foundation of photographic images in the real world is thought to be destroyed in digital media.
>
> (2002: 162)

The vast potential for alteration is possible in the digital or electronic image. It is evident in production, in the transfer from celluloid, in restoration or preservation, in colour balancing or correction, in compositing objects, creating depth cues, backgrounds, foregrounds and even in writing over the image. The connection between the representation and its referent in the real world can be remote. But transformation or manipulation are not new for photography or film. As Marks explains, '[t]hese concerns are accurate, though it is exaggerating to see the advent of digital media as a watershed between truthful and constructed image making, as historians show that photographic media have been tinkered with since their inceptions' (2002: 163). Manipulation of the photographic image was a feature of pre-cinematic photographic experiments conducted by pioneers like Eadweard Muybridge. The assumption of the 'purity' of the celluloid indice is one of the flaws inherent in attributing indexicality to analogue media alone.

Turning her view to the debate that takes into consideration the materials of film and digital, Marks writes,

> [w]hat I question in the current rhetoric about the loss of indexicality in the digital image is that it assumes a concurrent loss of materiality of the image. As a result it is assumed that digital images are fundamentally immaterial, and that, for example, to enter cyberspace or to use VR is to enter a realm of pure ideas and leave the 'meat' of the material body behind. Digital and other electronic images are constituted by processes no less material than photography, film, and analog video are.
>
> (2002: 163)

21

The apparatus that creates digital imagery are certainly material and tangible. As Marks points out, the images produced with digital tools can also be seen as material in the wave or particle structures and in their contextual material base. Marks suggests that at fundamental level the digital is deeply material. She writes that, '[d]igital electronic media, though they seem to subsist entirely in a symbolic and immaterial realm, can remind us powerfully that they and we are mutually enfolded in material processes' (Marks 2002: xxi). The digital relies heavily upon an analogue base. Rather than creating a clear break, a reliance on the creative practice, language and codes offers filmmakers a range of options uncannily similar to governing processes of celluloid film production. One interesting difference between the capacity for celluloid and digital to register the index is in the realm of touch. Celluloid materiality privileges contact, touch, physical connection, or the ability to register an impression of the real. Touch is a fundamental element of celluloid filmmaking and the loss of direct, sensory tactility appears to be absent in digital production. Certainly, touch in its conventional form of contact with the celluloid, in cutting, in juxtaposing sequences, in editing is not applicable to digital filmmaking; however, an alternative form of tactility might exist. Touch in digital filmmaking is facilitated by the mouse, keyboard, screen or trackpad in digital post-production. Revealingly, the processes designed for the post-production of digital film clearly reflect the influence of celluloid film. Much of the language is similar in editing transitions (dissolves, wipes, fades) and in the production of title sequences or end credits. Direct contact with the solid and liquid materials of the film might not be available in digital filmmaking; instead, it relies on a slightly more remote, sometimes virtual mode of tactility.

The language of digital cinematography retains its heritage in early film. Composing the image retains descriptions for framing, lighting and shooting. Post-production editing will specify cuts, dissolves, fades, wipes and other familiar transitions. Digital also builds on the matte and optical printing experiments of earlier filmmaking. The creation of title and end credit sequences follows the formula established by mainstream filmmakers. More than merely borrowing the language of cinematography, contemporary filmmakers often select an aesthetic that is common to celluloid film. Lens flare, scratches on the surface of a digital image, flickering frames, sepia tones, bubbling decay, excised frames – all are consciously selected as options to mark the aesthetic of digital cinema as indebted to early film. Marks identifies this as another way in which the index is reincorporated into the image. She writes, '[a]mong digital videomakers, one of the manifestations of the desire for indexicality is what I call analog nostalgia, a retrospective "fondness" for the problems of decay and generational loss that the analog video posed' (2002: 152). As Doane writes, '[i]n a sense, the digital has not annihilated the logic of the photochemical, but incorporated it' (2007b: 5). She suggests that the digital moves beyond previous media by incorporating them all, 'and by proffering the vision (or nightmare) of a medium without materiality, of pure abstraction incarnated as a series of 0s and 1s, sheer presence and absence, the code' (2007a: 142). Ephemeral, electronic indices can create worlds without actual referents, force our eye towards the celluloid and broaden our apprehension of history. In tracing the nostalgic compulsion of contemporary cinema, I will show how digital filmmakers go to great lengths to reconstitute indexical traces of celluloid.

Many of the film examples that I will analyse here redeploy a particular historical aesthetic, an indexical pointer that compels the viewer to acknowledge the presence of film history.

An essential, elemental way of perceiving the cinematic index is as traces of light. Light is the original force that inscribes the indexical image in photography and on celluloid. Light inscribes images on photochemical surfaces. It is also the property that creates images in digital media. Whilst light is pivotal to the production of images, it is also the fundamental element of projection in exhibition. It is in the conjunction of this illuminating force (one that is immaterial, but certainly seen, felt and experienced) that the index relies on light. A reconsideration of the impact of light on creating the trace, illuminating the footprint or registering the image on photosensitive emulsion conjoins digital and celluloid indices. The technological focus of new materialism is examined by Sean Cubitt and Paul Thomas. Cubitt and Thomas reframe the traditional oppositional divide between celluloid and digital materialism, acknowledging the similarity of chemical and electrochemical reactions to light (2013: 7). This approach rapidly takes down any traditional hierarchy of materials and media forms that privilege access to the real. They not only see the problem of indexicality as a 'red herring for media art history', but also understand its lure 'into an interesting ocean' (Cubitt and Thomas 2013: 16). Having dived right into this interesting ocean and swum around, I want to pose a connection between analogue and digital, focusing on the intersections between materials, technologies and semiotics of celluloid and new media. The digital index illuminates the spectres of its celluloid past. The particular type of indexicality produced and perpetuated by the culture of digital media incorporates a complex pattern of directions, traces, times, histories and impressions. The index that emerges in the transfer of celluloid content to digital media points to celluloid film. Producing another version, another generation, digitization always refers back to its source. Digitization proliferates celluloid film history.

Indexical Spectrality

A comparison of the coherences that link earlier cinema and contemporary film blends and confuses temporal tense. Mulvey notes,

> the cinema's unique ability to confuse time. As people and history recede into the past, the traces they leave on the world mark their absence, the impossibility of regaining time, but also bear witness to their once-upon-a-time presence. With cinema the past is preserved in the full appearance of reality.
>
> (2006: 107)

Cinema is inherently the medium that not only captures, but continues to project spectral images. Jennifer Barker describes the film's body as a ghostly entity, the film self-consciously directing (our and the film's) attention towards one aspect of its mechanical body that

enables perception and expression – the celluloid (2009: 10). The mechanical body is intimately connected to the flesh in this instance. Barker identifies film behaving

> in ghostly ways, eluding our direct gaze, slipping through our fingers, skirting past us as we approach. Just as characters slip from the edges of frames, as the past slips into the present, and as memory slips into dream, the film's body slips from our grasp. In this way, a scene that seems to have no direct narrative relevance to the film turns out to foreshadow the precise embodied, tactile patterns by which the film will evoke and express its poignant theme of lost time, lost places, and lost love forever out of reach.
>
> (2009: 11)

The spectral impressions of celluloid present in digital media emerge from the layering of the new and the old. Contemporary spectral projections reveal the depth of history through the layers of lineage specific to the media form. As Mulvey points out, '[h]ere again the technology has rendered the presence of the index anachronistic, but its already ghostly presence can enhance reflection on the actual filmic image under consideration, its presence as an inscription of a moment of time' (2006: 26). Each instance of the older informing and directing the new, and the digital illuminating celluloid, calls for a renewed approach to the way in which we see and understand film history. In the single image and in its multiple histories, film is simultaneously both present and past. Lynda Nead argues that it is the movement of film itself that offers a kind of haunting that extends beyond the frame and into related media (2007). Nead writes that,

> [t]here are, however, other kinds of hauntings and spectral manifestations in early film. Still frames are haunted by the photographic likenesses of those who are no longer living, who seem vivid and real in representation but are gone. Like the enchanted portrait, each time the projector is set in motion these figures also step out of their frames and come to life.
>
> (2007: 1)

The spectral is inherent to film. This is true of early film as well as post-medium cinema, theatrical screens and interactive experiences of viewing films.

Evolving Coherences

Modernist historiographies proposed by Walter Benjamin, and later Michel Foucault, provide the foundation for my investigation of celluloid and digital at intersecting moments in their histories. Inspired by the examination of unconventional genealogies, subaltern discourse and forgotten histories pioneered by critical theorists like Michel Foucault (1969), a similar approach to film history here is dedicated to uncovering lost traces, illuminating previously neglected film processes, inventions and exploring new connections in the moving image across time. Although grounded in the literary, Foucault's examination of the archaeology of knowledge offers new pathways to historiography via associations. Foucault's work on

epistemology and the archive has inspired a new generation of historians mapping networks based on connections across time, space and various media forms, providing new ways to understand history. Drawing from Foucault, Friedrich Kittler examines the emerging history of new media and the materialities of communication that situate the digital amongst more traditional technologies (1999). Siegfried Zielinski's model is focused on discovering 'the new in the old' (2006: 3), an approach that involves an excavation of 'evolving coherences' (ix). This prioritizes associations between media objects across histories. Bolter and Grusin's media archaeology posits that all media was once new and its associated attractions, illusions, spatial reconfigurations and innovations can be used to describe all visual media at its emergence (2000). Bolter and Grusin's assertion that new media refashions older media, which responds by refashioning itself allows for an understanding of the degree of circular reciprocity at work in this relationship. An archaeology of new media allows for an investigation that develops both deep and lateral connections across time and it supports the development of a history that understands older and newer cinema as live and transforming forces.

Leading film historians Tom Gunning and Thomas Elsaesser propose dynamic approaches to film history using media archaeology. Writing specifically about digital and celluloid film, Elsaesser argues that digital media does not fit into traditional concepts of film history, but that this disconnection invites innovative approaches to the relationship between the digital and the celluloid (2004: 77). Elsaesser posits that digitization can be perceived as allowing a 'zero degree' from which we can reflect upon an understanding of film history and cinema theory (2004: 78). He writes,

> [a]s a zero degree, it is, necessarily, an imaginary or impossible place from which one speaks when examining either "the new" or "the now". Digitization, at this early point in time, may for historians of the cinema be no more than the name of this impossible place, serving as a heuristic device, which helps them displace themselves in relation to a number of habitual ways of thinking.
>
> (2004: 78)

Digitization of celluloid plays an integral role in the development of new networks, new audiences and in facilitating innovative modes of exhibition that transform traditional viewing practices. The digitization of celluloid also promotes the importance of the moving image in spaces beyond the traditional theatre.

Intersecting Moments Within a Materialist History

From Méliès to New Media: Spectral Projections contributes to this dynamic field of research in film history just as it is beginning to understand that forms of new media are not only indebted to, but firmly embedded within, the traditions and conventions of early film aesthetics and technologies. Across the chapters of this book, a materialist history is developed that brings together early and later moments in film history. It associates the materiality of

celluloid and digital. It perceives older cinematic histories as leaving spectral traces in new digital media forms and the existence of digital film as contingent on celluloid. This approach to history does not only attempt to intersect temporal moments, it also investigates the influence and transformations of the materials themselves. Such a radical transformation from celluloid to the seemingly immateriality of the digital usually signals a severance of historical lines. Such a refrain repeats the assumption that the cinema is dead; however, here I take up a position that identifies connections over ends, dynamic moments of influence over isolation, a perspective that sees the past haunting the present, perhaps even defining the future. Miriam Hansen paved the way for an imagination of history as a constellation of intersections between early and late cinema (1993). Hansen asks 'how can we compare post-classical and pre-classical modes of spectatorship, early-modern and postmodern forms of mass and consumer culture? Obviously, we are dealing with substantially different stages of historical development' (1993: 209). She proceeds to identify the affinities. These include: the variation from the classical norm of controlling reception through diegetic effect, resulting in greater potential for interactivity with texts (1993: 210). Hansen also identifies the media publics associated with early modern and postmodern media, characterizing them as inclusive of the periphery and she identifies the directions and possibilities not taken at both stages (1993: 210). Whilst Hansen's work is dedicated to an analysis of media publics and the reconfiguration of the historical frame, my timeline is focused on beginnings: the beginning of cinema, the beginning of digital film. Simultaneously, I have tried to emphasize these moments of new/old experiences of film as moments of the present that are deeply connected to their fore-histories. History is not defined by succession here, but by intersections.

André Gaudreault also understands film history as multifaceted. He argues that the Lumière brothers did not invent animated pictures, or cinema, rather that animated pictures had existed for some time. Gaudreault writes, '[w]hat they invented was a device, completed in 1894 and patented in 1895, that made it possible to project the images it recorded onto a screen or wall' (2011: 5). The Lumières enabled 'Edison's animated pictures to be set free from the box in which they were confined (the Kinetoscope) and take flight' (Gaudreault 2011: 5–6). Histories that posit singular, evolutionary narratives are ideologically limited and culturally exclusive. Gaudreault envisages speaking of the beginnings or 'source' of a sociocultural phenomenon as placing oneself 'in the service of a fundamentally evolutionist and quite possibly mechanical conception of history. It is to risk overlooking, consciously or not, the ruptures and continuities that make up history, or to risk not noticing them' (2011: 3). Gaudreault suggests that historians must adopt a panoptical vision, '[t]hey must take a panoramic perspective and assume a variety of successive observation posts that would be the envy of the most complex of Eadweard Muybridge's camera setups' (2011: 32–33). The approach adopted here shares Gaudreault's argument that understands history as both horizontal and diachronic. He writes, '[t]he movement we seek is not from the present to the past but rather from the past to the present-to bring into the present the fragrance of the past, a little like Marcel Proust's madeleines' (2011: 36). Whilst Gaudreault highlights

the importance of bringing into the present the fragrance of the past, here, I have tried to emphasize the importance of the intersection that acknowledges the past and present as inextricably reliant. The smell, taste and feel of history is interwoven. Instead of an end to cinema, Gaudreault and Phillippe Marion perceive cinema as 'born twice'. Here the material base is extended by digital technologies and, as they write: [a]ll of a sudden the 'medium' of moving pictures is able, synchronically, to designate an entire historical, transmedial, or transtechnological constellation (2005: 92).

Inspired by the layered complexity of Jeffrey Sconce's *Haunted Media: Electronic Presence from Telegraphy to Television*, this book traces the existence (and sometimes the aura) of celluloid as a 'living presence' in digital cinema (2000). Sconce's project brings together a range of media forms to examine the continued attraction to what he describes as the 'spiritual telepresence' of innovative media (2000: 22–30). The notion of haunted media provides an invitation for historians to look at the active and ongoing resonance of early technologies and the apparition of early experiments in newer media forms. Sconce juxtaposes fantastic accounts of electronic presence in various media forms, but argues against perceiving the relationship as evidence of an ahistorical deep structure connecting the accounts (2000: 10). Instead, he favours the 'distinct discontinuities presented by the specific articulations of these electronic fictions in relation to individual media' (2000: 10). Highlighting the differences in historical contexts produces an alternative to postmodern histories that elide cultural backgrounds. In contrast to Sconce, I want to suggest that acknowledging the importance of historical specificity, but recognizing connections, as well as disconnections, allows us to see history as a matrix of unexpected intersections. My book is dedicated to analysing the intersections of digital culture with early celluloid, seeing them as specific, but interconnected moments with an active presence in the present. My approach identifies historiographies that emerge from the indexical inscription of older media onto new surfaces. These histories are evident in shifts in aesthetic that are produced by technological and material consonance and dissonance. A look at various moving images produced as both analogue and digital cycles transform and allow histories to be read visually and written as dynamic comparison.

The Deleuzian approach that dissects history into two and acknowledges tenses that bleed into one another provides a solid framework for my comparative analysis of old and new cinema. Temporal flows of film history and time expressed in the image coalesce here. Drawing from the work of Henri Bergson, Deleuze identifies the proximity of present and past, suggesting that the past co-exists with the present that it has been. Referring to the crystal image, Deleuze writes that time

> has to split at the same time as it sets itself out or unrolls itself: it splits in two dissymmetrical jets, one of which makes all the present pass on, while the other preserves the past. Time consists of this split, and it is this, it is time that we *see in the crystal*.
>
> (2014: 84, original emphasis)

Ultimately it is Doane's work on time in the cinema in *The Emergence of Cinematic Time: Modernity, Contingency, the Archive*, where time is perceived as synchronic and contingent, that provides the context for this understanding of film history based on a matrix of connections. Doane refuses chronology, emphasizing instead 'contingency' as pivotal to the challenge that the digital presents to celluloid. She argues that divergent temporal registers are linked by chance and contingency, a relationship that is characteristic of cinema (Doane 2002: 23). The proximity between past, present and perhaps even future and the view of history as built from the dynamic intersection of images across time are accentuated in both the imagery and the experience of watching films in the digital era. This blurring of tense, or the potential to see the facets of time depicted within film, finds a perfect model in the approach to history inspired by evolving coherences, contingencies and crystalline, intersecting temporalities.

Many of the films that I explore in this book favour spectacle over realism, some prioritize non-linear, experimental narration over linear, classical narrative form. Many of the older (and some of the newer) films exhibit surfaces etched with markers of time, and as such, they provide a rich surface aesthetic to encounter and explore. My approach to writing on film has always been to try to explore the surface of the film itself. That means prioritizing the aesthetic, looking for moments where details of the spectacle reveal history. My tendency is to zoom into surface details, focusing on the traces of celluloid that remain present within a digital ecology. Material detail, surface, aesthetic and *mise-en-scène* drive my film analysis. This is also an approach that prioritizes the senses. It is Vivian Sobchack's foundational research on embodiment and the sensual, corporeal address of the cinema that provides both methodology and precedent for the type of film analysis that inspires this work. She identifies how 'sensual reference in descriptions of cinema has been generally regarded as rhetorical or poetic excess-sensuality located, then, always less on the side of the body than on the side of language' (Sobchack 2004: 58). Movies, for Sobchack, 'provoke in us the "carnal thoughts" that ground and inform more conscious analysis' (2004: 60). The phenomenology of film experience is also pioneered by Laura U. Marks who describes her own engagement with film and media as being one of 'haptic criticism'. She writes about pressing up against the object, brushing, almost touching the object, taking an impression of its shape and translating the experience of the work into words, revealing that 'the task is to make the dry words contain a trace of the wetness of the encounter' (2002: x). Haptic criticism focuses on the surface impression rather than the symbolic, a vital approach that understands touch as encompassing senses including and beyond the visual. In this instance, touch refers to both the tactile surface and to the differing planes of the materials of the film and screens for exhibition.

From Méliès to New Media: Spectral Projections is organized into three sections. The first section investigates early film experiments and their influence on (and impact of) digital technologies and ecologies. Section two shifts the focus to the middle history of cinema, exploring how classical narrative entwines older and newer film. The final part of this book explores the ways in which early cinema is recreated in non-theatrical cinematic spaces and on mobile screens. Each chapter presents an approach to history that focuses on the

endurance of the cinematic image as a living illusion. Each chapter prioritizes a discussion of materiality and technology in both analogue and digital media, analysing the impact of the older on the newer and vice versa. This introductory chapter has focused on some of the issues in examining film history at the intersection of new media, with a particular focus on the controversy around the possibility of indexicality in digital imagery. It has presented a comparison of differences and similarities between the material forms of celluloid and digital film, refusing to discount an inscription of the indice across the digital. The argument that attributes indexicality to cinematic specificity is complicated by the example of watching the hybrid celluloid-digital film, Ulmer's 1945 film *Detour*, and specifically those spectral traces of film history embodied by the redundant, but deeply resonant cue marks.

The second chapter, 'Applied Colour: Chromatic Frankenstein's Monsters?' examines the processes of digital restoration, considering pivotal questions about originality in preservation and the ethics of digital transfer. This chapter investigates the discovery of additional footage, colour correction and the potential obliteration of celluloid in the production of a digital recreation of the recently restored version of *Le Voyage dans la Lune* (*A Trip to the Moon*) (Méliès [1902] 2011). It looks at the debates around originality and the aura in early cinema. It also highlights the proliferation of the re-make and indicates its endurance in contemporary media. This chapter ends by looking at the recasting of *A Trip to the Moon* into a 3D, high-definition special effect. The third chapter, 'The Serpentine Dance Films: "Dream Visions that Change Ten Thousand Times a Minute"' expands this investigation of originality in early cinema, but the focus falls here towards the production of coloured light beginning with the early experiments with radium created by Loïe Fuller. This chapter examines coloured light as pre-cinematic projection. It then looks at some of the early films that use the serpentine dance to register both movement and colour. Traces of its production history are evident in the use of colour and in scratches, bubbling and damage that is evident in these early films. Intellectual property and patents are shown to be of little value in the proliferation of the dance. Finally, the discussion draws in a very contemporary serpentine dance, dissolved and abstracted into digital pixels in Lana Del Rey's music video *Shades of Cool* (Nava 2014).

Chapter 4, 'Memory and Noir: Neon Contrasts' extends the interrelationship between films of differing eras, focusing on the digital reimagining of 1940s noir cinema. I begin this chapter with a consideration of the ways that *Blade Runner 2049* (Villeneuve 2017) remembers and revises postmodern and classical noir. Film noir relies on a specific aesthetic influenced by German Expressionism where contrast, shadows, lighting design and night for night shooting express mood and darkness. This chapter investigates the ways in which aesthetics, narrative and characterization of post-noir rely on memory. Memory is common to how noir films are defined and mapped across time. Light is also key in this chapter, but it is explored in relation to its transformation from the harsh, key illumination to the glowing pink artificial neon of neo(n) noir. The following chapter shifts focus to explore some of the approaches to editing using film and digital video. Entitled 'Cutting: Shock and Endurance', this chapter investigates the challenge that editing presents to the spectator. It also shows how Eisenstein's concept of vertical montage informs editing

patterns across time. This exploration begins with reference to the first major shock in film, *Un Chien Andalou* (Buñuel and Dali 1929), and moves to look at the protracted view that is produced by the refusal to edit and the consequent challenge that George Franju offers the audience in presenting detailed facial surgery sequences in his film *Eyes Without a Face* (1959). The consideration of parallels between editing and an assault on the body is extended with the incorporation of contemporary installations created with the use of the supercut in montages edited by Christian Marclay. In Marclay's installations the edit unsettles an easy embodiment as the experience becomes one of attack. The senses are assaulted as the skin is stabbed, shot, cut.

Chapter 6, 'Screens, Scale Ratio: Vertical Celluloid in the Digital Age' takes a broad and detailed view of films scaled up for screens that exceed the limitations of vision. I examine aspects of framing and ratio, in films that are inspired by the impetus to recreate film on a grand scale, a hyperextension of film right at the 'end' of cinema. Two films from 2011 feature in this chapter. Tacita Dean's *Film* (2011) and Christian Boltanski's *Chance* (2011) are explored in the ways in which celluloid is augmented and escalated. With the image substantially scaled up to dimensions that exceed the capacity of the eye to apprehend the image, spectators are invited to see the continuation of early film processes at its earliest moments. 'Hallucinatory Framing and Kaleidoscopic Vision' presents an analysis of film screened within alternative spaces, particularly within the gallery where spectatorship becomes mobile and the visions of film, fleeting. This chapter offers a comparison of the most famous Lumière brothers experiment in the exhibition of the moving image focusing on *L'arrivée d'un Train en Gare de la Ciotat* (1895a) and *Phantom Ride* (Crooks 2016). This comparison is designed to illustrate how film history drives the exhibition and reception of moving images in the gallery. Here, I explore the new rules for viewing as a mobile spectator. I ask how spectatorship changes and what characterizes this new mode of engagement? The transferral of the moving image into the gallery also has consequences for the film itself, with the reduction of feature length films to key sequences, or artefacts. Sometimes films are slowed down entirely, sometimes they are compressed into single images of entire films as seen in the artworks created from Alfred Hitchcock's cinema by the visual artist Jim Campbell.

The final chapter, 'Ephemeral Screens: The *Muybridgizer*', explores how pre and early cinema are imagined on interactive and mobile screens. This chapter shows how the earliest experiments in silent film are inextricably and immediately connected to forms of new media. This connection between newer and older screens extends to an analysis of iPhone applications that replicate pre-cinematic experiments like The Tate Gallery's 'Muybridgizer'. This is an app that allows users to create their own content based on Eadweard Muybridge's experiments with capturing time and movement on film. Early cinema and new media share a desire to explore their own limits and exploit the possibilities of vision and illusion. I refute a history of film that perceives only ends and propose a new understanding of cinema in the digital age that is defined by interlaced moments, two beginnings that are separated by more than one hundred years.

A Present Haunted by a Past and a Future

As we return to a consideration of the celluloid-digital hybrid, we notice that the trace of the indice in *Detour* is not limited to the photochemical medium. The cigarette burn cue mark begins as a punched perforation through the negative film, which is reversed and transferred onto positive prints of the film. This is the beginning of a series of evolving coherences. Once viewed on the small screen, the cue mark draws attention to the spectral presence of the past illustrated by these filmic processes, marks of celluloid materiality making clear the contingency of their dual existence. Noticing the traces of the old in the new enables a broader reflection on not only the extended scope of film history from optical experimentation to new media, but it also provokes a consideration of how connections between film movements allow for an understanding of history through a matrix of intersections. In this instance, the digital display of *Detour* advances an approach to film history based on its own history of continuities that indicates resonant connections between the production of the film in 1945 and its digital display now. Historiography reflects a desire to communicate with the past. Looking at the confluence of the past and the present helps to reconceive film history in terms of its productive conjunctions. Whilst the past influences the present, the present would be shallow without reference to the past. Cinematic signs are preserved, revised, re-made and continue to exert the presence of the past in current and future images. Focusing on the intersections between early film and post-cinema helps us understand the history of cinema as a constellation of associations where the experiments of the era of pre-cinema inform contemporary and possibly even future filmmaking.

Section I

Early Cinema: Colour and Spectrality

Chapter 2

Applied Colour: Chromatic Frankenstein's Monsters?

Even the most perfect reproduction of a work of art is lacking in one element: presence in time and space, its unique existence at the place where it happens to be. This unique existence of the work of art determined the history to which it was subject throughout the time of its existence. This includes the changes which it may have suffered in physical condition over the years as well as the various changes in its ownership. The traces of the first can be revealed only by chemical or physical analyses which it is impossible to perform on a reproduction; changes of ownership are subject to a tradition which must be traced from the situation to the original.

(Walter Benjamin 1999: 214)

A restored, reconstructed, recoloured version of *Le Voyage dans la Lune (A Trip to the Moon)* was screened on a hot night in the Piazza Maggiore, officially opening Il Cinema Ritrovato (2011) in Bologna, Italy.[1] The audience recognized the significance of this second public screening of this version of the film. With all seats filled and very little standing room left in the Piazza, I stood at the back of the square, watching a film that I had seen in black and white many times, but this time it hit the screen in the beautiful watery, translucent colours characteristic of the effects of hand painting in early film and photography. Audience members watched from all points within the Piazza, some even from behind the screen. There was such a thrill in the crowd that although I was standing, I felt like I was jumping. I certainly wasn't standing still. This resonance was in part a response to seeing *A Trip to the Moon* projected in colour. The colours offered another level of enchantment for this film, furthering the dynamic collision of science and art in both form and content. Surrounded by people standing, sitting on steps and folding chairs, with their dogs, bikes and dripping gelato, I was reminded of Anne Friedberg's description of the dual screens that projected images of coloured slides and moving images created by the Lumière Brothers at the Paris Exposition in 1900 (2006: 196). Particularly resonant was Friedberg's point about early experiences of film screenings where the size and format of screens and the fixed seating arrangement and consequent viewing positions were 'not yet the dominant form' (2006: 197). In this instance, watching *A Trip to the Moon* provided a hint of the barely composed excitement and mobile viewing positions characteristic of a film experience prior to the imposition of the dominant form. It provided an invitation to consider the complex relationship between the original and reproduction in current film culture. It compelled a reconsideration of the place of early cinema in contemporary film culture. This particular film has become a provocation for scholars to reexamine contested definitions of restoration,

to reconsider film history beyond the prevailing evolutionary approach and to explore the sensory impact of celluloid films presented in digital form.

The documentation that accompanies the 2011 version of *A Trip to the Moon* narrates a particular history. It identifies that this film was discovered in 1993 amongst a collection of 200 silent films donated by an anonymous collector to the Filmoteca de Catalunya in Barcelona (Groupama 2011: 12). This edition of 'the original colour version' of *Le Voyage dans la Lune (A Trip to the Moon)* (Méliès 1902, Lobster Films, 2011) had its premiere at the Cannes Film Festival. The one hundred and nine years separating the first screening of this famous science-fiction film and its recent revision bridge the beginning and, for some film historians, the end of celluloid film culture (see Rodowick 2007; Usai 2010; Hanson 2004). However, Méliès's filmmaking career also endured a series of threats. In 1917 Méliès was forced to destroy much of his collection; 400 of his films were melted down to make heels for the boots of soldiers during WWI (Ezra 2000: 19). Many of his films were bought outright and some were edited and renamed. A single film could appear in different versions, with a different colour palette across different territories. Retaining ownership through the patent system and copyright claims was an ongoing struggle for Méliès.

The reconstruction of this film poses questions about the status and evolution of cinema at the intersection of celluloid and digital. How do newer technologies, particularly those used in digital restoration, impact the original source? Is colour restored or revived by digital techniques? Is the digital restoration of *A Trip to the Moon* a conservation project, or does it result in the creation of yet another new version of the film? An investigation of the 2011 restoration blurs traditional notions of originality and complicates the relationship between reproduction and conservation. This restoration highlights the evolving complexities that arise between film history and digital cinema. Evidence of the old and new can be detected across the surface and secreted in the details of the latest version of *A Trip to the Moon*. By maintaining traces of the old within the new medium, the 2011 colour version maintains and acknowledges these divergent historical moments, but, as I will argue, ultimately reveals the inextricable, but sometimes uneasy, connection between early cinema and digital media.

Materiality, Colour and Illusions of Temporality

A close examination of the history of the 2011 version of *A Trip to the Moon* reveals that it was built from two distinct sources. One was a black-and-white nitrate film and the other was the recently discovered coloured film. But both are coloured really. Black-and-white nitrate film registers light as subtle gradations in the spectrum from the deepest black to the lightest white. In his film production, Méliès 'artificially arranged' the *mise-en-scène* to register tonal variations and contrast. He notes that in creating the set: 'painting is done only in shades of grey, using all the intermediary grey colours between pure black and pure white [...] Scenery in colour comes out very badly. Blue becomes white, reds and yellows become black, like greens; all the effect is destroyed' (quoted in Groupama 2011: 168). Nitrate orthochromatic film stock is receptive to all colours from blue to red, which it reflects as

white to black. The registration of colour on black-and-white film is evident in the red lips of the man in the moon rendered black on film. This specific celluloid material also provided the base for the application of a dynamic range of aniline colours. These colours had to be applied to provide the perfect balance of tinting the celluloid, whilst allowing light to pass through the film. The aniline dyes were transparent and luminous, allowing for the creation of spectacle and an illusion of depth. The pastel palette created artificial impressions to support the fantasy of the attractions cinema. Méliès notes that,

> as important films are often coloured by hand before being shown, it would be impossible to colour real photographed objects, which, if they were bronze, mahogany, red, yellow or green cloth, would become an intense black, and thus without transparency, and it would be impossible to give them the translucid tone necessary for projection.
>
> (quoted in Groupama 2011: 168)

The artificial pastel colours of costumes and sets, landscapes and seascapes were both functional and spectacular.

The colours of the 2011 version of *A Trip to the Moon* expose traces of history in the animation of the colours themselves. Early colour seems to be alive. It breathes and transforms. The colours flicker, quiver, transform and frequently escape the outlines of objects that they had originally intended to colour. Its instability reveals contemporary interventions, the effects of time and the original historical moment when celluloid films were hand painted. The catalogue that accompanies the restoration of *A Trip to the Moon* notes that '[a]ll his known colour films present image instability typical of hand-colouring and brushstrokes are clearly visible' (Groupama 2011: 169). The coat worn by one of the scientists in the observatory tableaux wavers from blue to green and then returns to blue. The colour bleeds into the scientist's wig. Inside the factory, the rocket itself transforms from anodized pink to terracotta orange. In one sequence, the watery blue of the outfits worn by the team of young female marines preparing the rocket for launch is rendered in a single horizontal brushstroke. The smudge of translucent blue-green paint connects the women across frames, highlighting their uniformity and choreographed movement. It also reveals traces of the artist and her process of painting miniature frames. Just as the sequence ends and the women wave their hats to signal the imminent departure of the rocket, a barely perceptible pause reveals the effect of quite extensive damage to the print. Noticeable in this blurred image are incomplete patches of colour and damage that are revealed in the blue-green, pink and yellow paint that has shrunk from and exceeded their outlines. Apparent also is the dissolution of definition as the colours appear to sit on top of the celluloid, clearly revealing the intervention of time on the colour and on the film. We might also notice the fleeting presence of a character wearing pants. Moments prior, this character was an invisible, uncoloured figure who stood behind the women. As the frames progress, he steps forward and is coloured by the artists. This is also a moment that reveals Méliès's use of superimposition in editing. The subsequent image of the rocket launch is just perceptible below this image, waiting to rise to the surface as the image of the celebration gradually

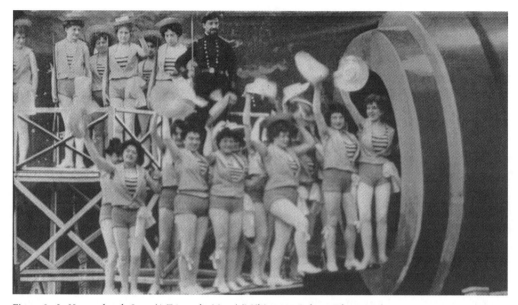

Figure 2: *Le Voyage dans la Lune (A Trip to the Moon)* (Méliès 1902, Lobster Films, 2011).

dissolves and disappears. Without any clear traces of restoration, this image ruptures the narrative flow and offers a momentary indication of the extent of the film's damage. It is a moment that carries indexical traces of the history of the film, retaining some of the 'flaws' that were not erased using processes of digital restoration. In retaining these damaged frames from Méliès's original film, the processes of its production, invisible presences and marks of over a century of radical change in film history dominate the digital version.

Additional spectral traces of early approaches to filmmaking, its materiality and technologies remain in the 2011 version of *A Trip to the Moon*. In early film, the speeds of filming and projection differed and the movement of characters could appear frenetic. As the scientists led by Professor Barbenfouillis (Georges Méliès) gather to discuss the voyage at the observatory, and later when they explore the subterranean moonscape, their gestures and movements appear accelerated. The green Selenites on the moon also seem to jump and twirl in fast motion. However, the kinetic conditions of early cinema are not limited to the gestures and movements of characters. Instead, colour itself adds a further level of kinetic temporality. Although the scene where the scientists gather in the observatory is shot with a fixed camera, the walls pulse slightly, backgrounds quiver almost imperceptibly. Barely discernible vertical patterns – further evidence of damage to the film – waver at the edges of the screen. The colours of the arched windows oscillate between opaque blue and transparent grey. Movement is not purely generated from the conditions of filming and exhibition, but also by the effects of colouring the film in post-production. The image reveals both the beautiful softer focus of the coloured celluloid print and the higher definition and perceptual clarity of the digital print.

Often the outlines of the windows become blurred producing softer lines, but occasionally the image snaps back into focus, revealing a level of definition more common to the digital medium. The film also retains evidence of damage in the vertical patterns that waver at the edges of the frames. The 2011 incarnation of *A Trip to the Moon* is built on celluloid foundations that are embellished using digital tools. The surprising kinetic illusions, unexpected temporalities and wild colouring produces new visions and experiences arising from the synthesis of early and late cinema. These materials and technologies combine to create a further layer of astonishing spectacular aesthetics, characteristic of late forms of early cinema.

Colour was key to the attraction of this screening of *A Trip to the Moon*, with colour design used for visual and emotional impact. Joshua Yumibe reveals that as early as 1929 Kodak identified the potential for colour to affect the emotions. Whilst Kodak developed Sonochrome tints like Rose Doree to 'quicken the respiration' and Peachblow for 'brief, joyous moments' (Yumibe 2012: 23), twenty years before, Méliès employed young women to apply translucent aniline dyes to create spectacle, to provoke sensation and to create a direct, emotional appeal to the audience. In *A Trip to the Moon* colour is used to create emotional impact, to direct attention and to inspire a sense of wonder. Gunning notes that 'colour seems to function as an attraction, a very direct visual stimulus. It's something to look at, something to surprise you, to amaze you […] a purely kind of sensuous play' (1996: 41). Explosions on earth are painted red to designate the heat that is at its core. Anti-naturalistic colours suggest the unfamiliarity of the lunarscape. Explosions on the surface of the moon are sometimes blue, but at other times a hybrid of pink and green. Colour also creates wonder through contrast. The buttery yellow of the asteroid is foregrounded against the deep green background of the lunar sky. In the subterranean lunarscape, tree trunks are rendered in a deep pink whilst mushrooms appear with a burnt orange hue. The illusion of cascading water is painted in a startling blue. The sky turns bright pink when the scientists attempt to escape. The Selenites are painted green, in line with the fantasy colours of an alien.

The blue brushstroke that links the marines also reveals the imprint of one of Elisabeth Thuillier's team of young female painters. It highlights the symbolic value of the effect of colour in augmenting the emotional impact of the cinema of attractions and hints at the marginalization of creative labour. By expanding the history of *A Trip to the Moon* from 2011 to 1902, we can identify how the imperfections that are retained in the recent version can point towards aspects of its hidden history, in this case the film's uncredited female painters. Painter and colourist, Mme Thuillier and her workers hand painted all of the prints that Méliès required in colour. Thuillier notes that,

[t]he coloring was done entirely by hand. I had 200 people employed in my workshop. I passed my nights selecting and sampling colors. In the daytime, the workers applied the colors according to my instructions. Each specialized worker took responsibility for one particular color. There were often over twenty (specialized workers).

(Groupama 2011: 168)

The process of hand painting was intricate and arduous. Each of the young women working for Mme Thuillier was in charge of painting a single colour across the 13,375 frames that comprised *A Trip to the Moon*. Research on hand painting in early cinema repeatedly points to the presence of these young, female painters, but rarely identifies their impact in any detail. Steve Neale (quoting D. B. Thomas writing on Color Motion Pictures in 1969) writes: 'The colouring was done by girls, each of whom applied one colour only' (1985: 115). Yumibe mentions that the labour involved in hand colouring was classified as 'detailed handicraft' and that the creative processes were structured according to an assembly line where labour was divided by hue to increase productivity (2012: 48). Yumibe writes that, '[t]his work was most often carried out by young women and girls working with magnifying glasses and brushes at times as small as a single horse-hair' (2012: 3–4). He points out that young women were exploited as cheap labour and were rationalized to have been suited to this task because, 'women have historically been seen to be more attuned to color and more susceptible to its sensual influences [...] color was explicitly coded as feminine, being grouped as an ornament and compared to a feminine cosmetic' (Yumibe 2012: 45–46). Colour reveals the impact of a relatively hidden feminine workforce. The materiality and affect of this film is inextricably linked to the conditions of its production. It is here that we see the influence of hidden female colourists and their impact on the value of the film. The sale price of a black-and-white print of *A Trip to the Moon* is listed in a catalogue for Star Films as US$130, but even though a definitive price is not quoted, versions of Méliès's films that had been hand painted by Mme Thuillier's hidden workforce were considerably more expensive than the black-and-white prints.

The blue brushstroke is also one element of the palette that includes translucent blue, pink, green, orange, red and yellow, a spectrum designed for a specific audience. The colour palette was designed with regional distribution in mind. Applied colour techniques involved the creation of particular colour ranges for specific territories. The 1902 print was coloured for an imagined Spanish audience. Whilst the red and yellow flag raised at the launch of the rocket specifically mirrors the national colours, the broader palette can be seen to reflect the symbolic colours of Spain. Film historian Niccola Mazzanti reveals that it was common practice to create a specific palette and design for geographical territories, '[a]ltering colour schemes was only one of the many elements shaping an overall strategy of adaptation to foreign markets', adding that when more than one print of a film distributed in different countries is discovered, the variation in colour schemes can differ dramatically (2009: 70). Colour, in this version, is selected to resonate with a specific audience. The selection, composition, and de-composition of colour also become a site where materials, technologies, and hidden labour become evident. It is a site where imperfection is retained beyond the final restoration, offering valuable insight into the obscured histories of celluloid film.

Exchange and Restoration

An investigation into the research on the exchange and details of restoration offers insight into the contested site of digital restoration. Multiple voices present differing historical

narratives. The catalogue that accompanies the 2011 version tells us that in 1999 *A Trip to the Moon* became part of an exchange deal organized by Anton Giménez, director of the Filmoteca de Catalunya and Serge Bromberg of Lobster Films. *A Trip to the Moon* was exchanged for *The Gold Spider* (de Chomón 1909). De Chomón and Méliès had collaborated previously and his short film *An Excursion to the Moon* (1908) is one of the many that replicates *A Trip to the Moon*. In early film culture it was common to re-make films that had proven to be popular. The restoration of *A Trip to the Moon* was a long and complex process. Bromberg narrates the transfer: 'The deal was done, and some time later, we received a case containing the precious relic. Inside there was a 35mm film on which we could distinguish some of the first film images framed by the small perforations characteristic of early films' (Groupama 2011: 183). But this coloured version of *A Trip to the Moon* was extensively damaged. Cellulose nitrate film is chemically unstable and particularly prone to brittleness known as 'vinegar syndrome'. Exposure to air deteriorates the filmic material, often resulting in shrinkage and 'channelling', a buckling that occurs when the acetic acid is released from the celluloid. Bromberg notes that '[u]nfortunately our round reel looked more like a ring of wood, such was the extent to which decomposition had transformed the originally supple film into a rigid, compact mess' (Groupama 2011: 183). The film required extensive restorative work. Conservation of this print was at stake in the processes of restoration. Single frames were excised, restored, and reassembled one by one. The damage was so extensive that the traditional restoration methods of wet gate optical printing and copying onto celluloid were not possible. Consequently some of the restoration techniques required a reimagining of conventional approaches. The fused images on the reel were prised apart using a flexible card and, as Bromberg defines it, 'infinite patience'. In *American Cinematographer*, Robert S. Birchard details that, 'for the most part, the film was fused only along the perforated edges of the film, and with infinite patience and a small, flexible card, it was possible to peel the film apart from itself' (2011: 68). Bromberg describes the broader risk assessment in this way:

We had two options. Either we tried to give the film back its original flexibility so that it could be duplicated, or we photographed each image using an animation stand, but at the risk of breaking the film. The first solution required chemical treatment which would render the film pliable for a short period, but which would unfortunately accelerate its decomposition subsequently. The second solution would lead to numerous tears and would be delicate and long.

(Groupama 2011: 183)

Ultimately the restoration process included the photography of individual frames, chemical treatments and the flexible card, amongst a range of other approaches. Bromberg says: 'The copy was sent to Haghefilm laboratory, where it was place[d] for several weeks under a glass bell, subjected to vapours of a chemical mix developed by the *Archives Français du Film*' (Groupama 2011: 183). Beneath the glass bell and enshrouded by chemicals, time and duration impacts on the film once more. In this instance the life of the film is both activated as images

clarify and then reduced as the material of the film succumbs to the vapours. As Bromberg recalls: 'every time a few images were recovered, we'd photograph them before they turned to dust, which is a consequence of using the chemicals. Basically there were only a few days to photograph the stills, which can be considered the "scan" of the original source' (quoted in Birchard 2011: 70). Almost a third of the film was saved onto an inter-negative film. Bromberg says that some frames were 'given back to us in formless fragments that the prolonged stay in chemical vapours had made even more brittle' (Groupama 2011: 183). The images that survived the chemical treatment were photographed using a three million pixel digital camera.

Celluloid was used as scaffolding and support for the development of the digital copy. The digitization process took place from 2002 to 2005. Bromberg and Eric Lange replaced frames that were damaged beyond repair with images from the black and white fine grain master positive. The master was also used as a guide for the timeline of the original film. 'To replace most of the material missing in the color footage, the team turned to a black and white nitrate print owned by Madeleine Malthete-Méliès, granddaughter of the pioneering filmmaker' (Burton quoted in Birchard 2011: 70). The original version of A Trip to the Moon was hand cranked at approximately fourteen frames per second, whilst the restored digital version needed to be standardized to 24 frames per second. This use of multiple speeds, versions and materials presented many issues for conservators like Tom Burton from the Technicolor Foundation for Cinema Heritage. Frames from A Trip to the Moon were photographed and scanned in forms including TIFF, TGA and JPG files (Groupama 2011: 184). Burton reveals that,

[w]hat we received from Lobster Films were digital files in various formats and in several resolutions. Some frames were captured on a digital camera, frame by frame, and some were captured on a digital scanner from short sections of the 1902 original that could be copied on Haghefilm's step printer in Holland.

(Burton quoted in Birchard 2011: 71)

Burton worked to restore damaged frames and to ensure consistency in the image. The challenge was to integrate the disparate celluloid frames, shots and sequences into the digital version of this film. Colour 'pre-grade' processes were used to resolve variation, ensuring that colours and density matched. He notes that, '[m]uch of the image data represented broken frames and shattered pieces of frames, and there were even several versions of some shots, with the files differing greatly in color, density, size, sharpness and position' (Burton quoted in Birchard 2011: 70). Burton says that '"de-flicker" processing was applied to help balance the massive frame-to-frame and intra-frame density variations resulting from the physical deterioration of this old photochemical element' (Groupama 2011: 184).

The common format selected for the digitized version of A Trip to the Moon was the Digital Picture Exchange file. This was selected to represent the density of each colour channel of a scanned negative film in an uncompressed 'logarithmic' image. This new file format introduces a range of potential differences from the original. Significantly, the range of colours available is more extensive than what was used in the original. The difficulty

of restoring the colours of this 1902 print is corroborated by Burton who describes their approach in this way, 'we eye-matched individual color frames and short frame sequences. In this editorial conform we were able to see for the first time exactly what original color material existed, what condition it was in and which material was missing entirely' (Burton quoted in Birchard 2011: 72). DaVinci Resolve colour correction software was then used to cohere the range of 'wildly diverse colors and densities of the various capture sources into reasonable proximity with one another' (Burton quoted in Birchard 2011: 72). Burton reveals, '[o]ur restoration team rebuilt shattered frames into new full-frame re-creations of their original state. The black and white material was then digitally painted to replicate the original color frames where the original colors had not survived' (Burton quoted in Birchard 2011: 71). Restoration and cleaning techniques enhance the depth and clarity of detail in the frames and achieve a definition that was well beyond the scope of the original.

It is not only the processes, but also the techniques that were designed to replicate the original state of *A Trip to the Moon*. The digital painters at Technicolor used small frames, modelling the original conditions for Mme Thuillier's team of painters. Electronic brushes, frame ratios and the colour palette were designed to mirror the conditions of applying colour in 1902. 'This helped them establish, for the final painting process, the look of the hand-painted colors sometimes overflowing and sometimes not quite filling the image' (Burton quoted in Birchard 2011: 72). What might have been mistakenly dismissed as the effects of damage is reconceptualized as the imperfection of hand painting that was deliberately replicated in the 2011 version. The combination of digital and practical approaches to restoration resulted in the production of a new version of *A Trip to the Moon*, one that was redesigned to enhance continuity and to augment spectacle. Colours are more vibrant, definition is clearer, timing shows consistency and precision. However, beneath the spectacular surface, traces of the earlier version remain. Retaining damaged images in the digital version points to the hidden histories of the production design. These traces of early cinema are indexical signs of celluloid materiality, time and history that have not been erased by digital restoration processes.

Reactions against the 2011 film reflect some of the ethical issues surrounding the concepts and practices of film restoration. Film historians Roland Cosandey and Jacques Malthête provoke fundamental questions about the definition of 'restoration' in direct response to the digital film (2012: 7–10). In their view, the exaggerated colour saturation, the regularity of colouring, the distinction of the outlines, the reframing and erasure of the yellowish hue actually erase aspects of the materiality of the 1902 version (Cosandey and Malthête 2012: 10). Further, the presence of Méliès's own retouching work, the magician's sleight of hand that produced the special effects, has been concealed in the process of transformation from celluloid to digital (Cosandey and Malthête 2012: 10). A special issue of the *1895 Journal* dedicated to exploring the issues of restoration identified the 'parenthèse argentique', the silver parentheses that distinguishes celluloid film from the numerical digital form (Albera et al. 2013: n.pag.). It also complicates the history that is woven around the 2011 version in identifying alternative origins for the 'Catalunyan' copy of the film. With the film showing the type of perforation common to films distributed in the United States, and by the Edison Company, Cosandey

and Malthête raise the possibility that it may not be a first-generation print as was claimed more recently (2013: n.pag.). The process of 'restoration' was firmly rejected and instead, described as a 'radical intervention'. Concern was raised about 'variants' being misrecognized and circulated as originals, with the processes of their transformation obscured. Cosandey and Malthête argue that no archive could describe the 2011 film as a restoration (2012: 10). These complex ethical questions surrounding restoration are indicative of the continued difficulty in ascertaining distinction, originality and ownership amid a culture of circulation and reproduction. This is seen most spectacularly in the treatment of colour.

The Difficulty of Colour

Film restoration is a complex task, and creating a faithful reproduction can be elusive. Colours evolve, change and deteriorate with every projection of light and when films are stored for long periods. Celluloid is a live material. As such, the original intensity of painted colours cannot be known definitively. Pathé developed 'colour codes', details printed onto the leader of each film. The details anticipate the need for future restoration, but these codes were not applied to hand painted or stencilled films produced prior to 1910. As Paolo Cherchi Usai explains:

> Our knowledge of color in silent films is largely derived from a treasured misconception that we are accustomed to accept without question: tinting, toning, coloring by hand or stencil, first and second Technicolor are loosely translated in the duplicates struck by preservation laboratories into systems radically different from the original techniques.
>
> (2000: 39)

Further, '[f]rom a cultural standpoint, color film preservation (as much as film preservation in itself) is a necessary, interesting mistake' (Usai 2000: 40). This is corroborated by Mazzanti who identifies the limited documentation of the history and processes of coloured films. Mazzanti writes, 'we have nearly no testimony about how specific colours came into the world, and by whose decision' (2009: 70). In the shift from celluloid to digital, Mazzanti notes that,

> [t]echnologies designed for (mechanical, chemical, or digital) reproduction of colour might feature a stronger or weaker component of indexicality; they might display a more or less effective "synchronicity" of colours in space (the rose is red, and its stem is green) and even more importantly in time (the ever changing hues of a sunset).
>
> (2009: 74)

Mazzanti argues that the processes that are used routinely to duplicate original coloured prints struggle to reproduce the original colours faithfully (2009: 77). He writes that,

> some colours are reproduced more faithfully than others, with the result that the overall chromatic balance (within the frame when hand or stencil colouring is used, or between

shots when different colours and processes are applied) is distorted to an extent that has led some authors […] to define these processes as "simulations" rather than "duplications".

(Mazzanti 2009: 77)

Giovanna Fossati suggests that film restoration leads to the creation of multiple originals, creating a geneaology of films with slightly differing features (2012: 550). Fossati writes that the digital copy introduces another kind of estrangement from the original film format than the other one introduced in analogue duplication, going from nitrate to polyester film stock (2012: 551). In this context, the digital copy becomes part of a chain of change, with slight variations in aesthetic, but transformation in materials that include nitrate, polyester and digital. Characteristic of this change and exchange is estrangement that is evident amongst the originals. In this framework, 'each copy of the film acquires authenticity as it is a subsequent sign of a film's life-line' (2012: 553). The heredity analogy identifies connections that are not linear, but are passed down in incomplete forms. Each copy of a film as an artifact carries marks of its authenticity, reflecting back its heritage or familial associations. Identifying the potential for films to create multiple originals diffuses its singularity and reframes ethical questions relating to intervention. Fossati writes that this provokes questions for film restoration ethics, such as, 'is a film restorer allowed to *improve* the original aspect of a film and, if so, where does the boundary between improvement and distortion lie?' (2012: 561, original emphasis). These are particularly significant issues for the restoration of film colours. Fossati reveals that,

[f]or techniques such as hand painting, tinting, toning, and stencilling, used to color black-and-white films from 1895 until about 1930, digital technology offers a system of simulation which can give results that are much closer to the look of the original colors than photochemical duplication methods.

(2012: 563)

Digital restoration tools can offer an impression of the earliest form of the colour and they can be used to exceed that colour, but the effect is colours that are fixed, or petrified, rendering them endlessly new. This produces an uncannily spectral simulation that does not evolve or change as celluloid does, instead, those restored digital colours produce an unnerving intensity in hue, a stillness and estrangement as the simulation exceeds the original. Perceiving digital versions of films like *A Trip to the Moon* as simulations acknowledges the importance of the source in the development of its digital variant. It also accounts for those perceptible traces of celluloid in the hybrid aesthetic of the 2011 version. Describing the digital version of *A Trip to the Moon* as a simulation also acknowledges its position within a culture of online circulation where films can be downloaded and transformed, again. Usai argues that any attempt at preservation means that the original viewing event 'drifts' towards 'fictive artefacts' (2000: 101). It is exactly this drift, this inability to remain fixed in any form, celluloid or digital, that highlights the importance of those spectral impressions in early cinema that make their presence felt within their digital simulations.

Across the history of cinema, simulations have been created by producers, distributors, directors, censors or restorers from a 'family' of film elements (prints, negatives, copies) 'a version implies a deliberate choice and concerns a number of elements' (Mazzanti 2009: 77). However, a variant applies to a single film element – in this case the recently discovered coloured print, and can be the result of an accident, or a deliberate act. Mazzanti writes that,

> variants can derive from accidents. For example, parts of a print can decompose, some or all of the colours can fade or decay, inconsistencies or errors can occur in the production process. Secondly, variants can derive from the deliberate act of a collector or an archivist.
>
> (Mazzanti 2009: 77)

The simulated version of *A Trip to the Moon* arises from both the rediscovery of this important film, and the processes of intervention using hybrid analogue and digital materials and technologies. Imagination, mistakes and science coalesce in this project. With intervention taking the form of renewal rather than conservation, the simulation was re-made with digital hues that did not exist in 1902. The range of colours available and the technologies used in the process result in the 2011 simulation 'exceeding' that of the source. The excess in colour, definition, pattern, aesthetics and movement introduces new visions, or degrees of simulated effects. As Mazzanti warns, prints derived from films that use differing colour schemes have the potential to create 'chromatic Frankenstein's monsters' (2009: 77). The simulation of *A Trip to the Moon* is the product of celluloid and digital, black and white and colour, eye matching and chemical vapours. It is also part of film's complex history of revision, reproduction and intermediality.

Always, Already an Intermedial Text

A Trip to the Moon imagines a voyage to the moon 67 years prior to the first landing. This may have been the first film to imagine the moon from the earth. The mythology that surrounds Méliès positions him as central to a range of 'firsts'. Méliès was the first director to design and equip a film studio (his 'image capture theatre'), to create storyboards for his film productions and to develop editing techniques (particularly appearance/ disappearance, substituting, multiplying effects) to facilitate special effects and trick photography with moving images (Groupama 2011: 77). Firsts, however, construct limited historiographies. Lists of firsts elide more complex details. The value of Méliès's pioneering aesthetic and special effects were not immediately recognized. Whilst *A Trip to the Moon* has become the most recognized of all of Méliès's films, Elizabeth Ezra reveals that,

> [a]t first, however, he had difficulty persuading fairground exhibitors to buy it because of the high price resulting from the film's lavish production costs; so he lent the film

to exhibitors free of charge for a single showing, confident that its popularity with audiences would convince exhibitors that they would recoup his asking price.

(Groupama 2011: 120)

At this stage in the emerging film industry, individual films were sold to exhibitors directly so lending the film for a single premiere screening was designed to enhance the value of the film to exhibitors. The various elements of Méliès's innovation in production and distribution become key considerations in the processes of restoration. How can films retain the spectacle of its display and reveal the specificities of its historical trajectory?

Ultimately, Méliès is credited as inventing the cinema of display and entertainment. *A Trip to the Moon* is spectacular, intertextual and self-reflexive, a cinema of active display. In the performance of the 'trick' effect, Méliès both reveals the spectacular illusion whilst at the same time, concealing the filmic devices that create the illusion. This form of early cinema emphasizes the 'thrill of display' and the spectacular presentation of illusion developed by the magician Méliès (Ezra 2000: 3). Tom Gunning positions early films as emblematic of the 'cinema of attractions', spectacular visions that create an aesthetic of astonishment (1990: 56–62). This astonishing spectacle is built from the combination of editing and framing. Often performing the tricks himself, Méliès directs on and off screen. When he is on screen Méliès guides the look. Off screen, he carefully frames and edits to create the illusion. André Gaudreault notes the degree of self-reflexivity in Méliès's early cinema, suggesting that the aim was to encourage spectators to 'appreciate the illusion' by recognizing the camera's presence and the potential audience (2001: 34). Gaudreault writes that 'he interpellates both the camera and the spectator into the text as he acknowledges their existence through direct address' (2001: 34). Méliès's trick films extend the wonder and curiosity produced by the magician and transpose it onto film.

Whilst the perception of Méliès's cinema as part of the attractions tradition is clear, it is also important to acknowledge the depth, range and intermediality of his *oeuvre*. *A Trip to the Moon* is also built from a range of literary, media and experiential events. An element of its spectacular effect relies on its intermedial status as one film within a constellation of circulating texts. The circulation of differing versions of *A Trip to the Moon* is augmented when we consider the divergent influences that inform the development of the film itself. Matthew Solomon describes *A Trip to the Moon* as an intermedial film, a film that emerged from a matrix of historical influences and one that continues to inspire new forms of the moving image (2011: 18). The original version was inspired by Jules Verne's novel *De la Terre à la Lune (From the Earth to the Moon)* (1865). Méliès reveals that:

The idea of *A Trip to the Moon* came to me when I was reading a book by Jules Verne called *From the Earth to the Moon and Around the Moon*. In the book, the humans could not land on the moon so I imagined, in such a way that I could put together some arresting and amusing fairytale images, show the outside and inside of the moon, and

some monsters who might live on the moon, add one or two artistic effects (women representing the stars, the comets, snow effects, the bottom of the sea).

(quoted in Groupama 2011: 166)

Other influences include the HG Wells novel *The First Men in the Moon* that was published in France just before *A Trip to the Moon* was filmed. According to Laurent Mannioni, it is quite possible that news of the exhibit at the Pan American Exhibition in Buffalo called *A Trip to the Moon* (1901) would have influenced Méliès (quoted in Groupama 2011: 167). The turn of the century inspired a range of multimedia visions and imaginings of voyages to distant places.

Perpetual Unoriginality

Early film culture was typically unoriginal. Solomon argues that whilst an 'obsession for completeness' might motivate contemporary film collection and restoration, historically film culture relied on the circulation of prints of varying conditions and lengths (2011: 9). Solomon writes that 'the very notion of a definitive version of any early film is rather anachronistic given that films were sold as "semi-finished products" over which their producers had largely relinquished subsequent control' (2011: 8). Furthermore, early film exhibitors often made changes to the film itself, cutting, editing and revising it for their own projection purposes. It was common practice to buy and then edit, intervening in the material of the film itself. Solomon adds that early films were 'projected at different speeds, combined with various types of performance, and sometimes even colored and reedited by exhibitors' (2011: 8). These exhibition practices meant that different versions of *A Trip to the Moon* in circulation were claimed and exhibited by filmmakers other than Méliès. Questions of ownership, intellectual property and copyright undermined Méliès's career. *The Complete Catalogue* for 'Star' Films notes that a New York paper advertised *A Trip to the Moon* by four or five different filmmakers, 'each pretending to be its creator' (Méliès n.d.). The *Catalogue* begins with the pronouncement: 'In opening a factory and office in New York we are prepared and determined energetically to pursue all counterfeiters and pirates. We will not speak twice, we will act' (Méliès n.d.). In an attempt to control early pirating, Méliès inserted his brand within the images directly. The visible logo of Star Films that appears at the beginning of Méliès's films is also embedded within the *mise-en-scène* and in the documentation and credits of his films. In *A Trip to the Moon* it appears on the rocket itself at the celebration of its return to earth. We also see the attempt at controlling 'counterfeiting' in the establishment of offices in London, Barcelona and New York. However, against a broader culture of ownership and transferrable creative and intellectual property, control akin to copyright remained elusive to Méliès for the duration of his career.

The most popular iteration of *A Trip to the Moon* closes with the rocket descending to earth, landing underwater and then being towed into shore by a boat. These 'final shots' appear to provide resolution for the narrative by returning the astronomers to earth safely.

The ending of the more complete variant of the film shows the rocket, now branded with the 'Star-Films' logo paraded through the streets, accompanied by the astronomers returning to a celebration, receiving oversized 'moon' medals and unveiling a sculpture dedicated to Professor Barbenfouillis. The sequence displays the Selenite who was last seen clinging to the rocket ship as it left the moon. The Selenite is captured, chained and hit with a stick as it is paraded in front of the crowd on a leash. This ending is one that highlights and cements the colonist theme. Segundo de Chomón's variant, *Excursion dans la lune (Excursion to the Moon)* (1908) offers an alternative resolution. Solomon cites this ending as one that concludes not with an ironic celebration of lunar conquest, but with the formation of a couple. He writes,

> [o]ne of the astronomers runs off with a dancing moon-maiden and brings her back to earth in the damaged capsule. Instead of being displayed and beaten like the captured moon-dweller in *A Trip to the Moon*, she is welcomed to earth with open arms and quickly betrothed to the astronaut with whom she returns.
>
> (Solomon 2011: 13)

The wild, battered alien of *A Trip to the Moon* is replaced as an exotic love interest in de Chomón's 1908 film. These numerous variants (coloured, black and white, edited, lost, found, re-made, duplicated, transformed and inspired) provoke a reconsideration of the insistence on the chronological evolution of films across history in favour of traces of early cinema as present in contemporary simulations, offering an alternative imagination of the end of cinema. The most well-known and circulated black-and-white version of *A Trip to the Moon* is not the definitive or complete form of this film. Solomon notes that the Museum of Modern Art Film Library's version has been struck from an incomplete print of the original film (2011: 8). The 2011 digital restoration included an extra three seconds discovered in a 1929 nitrate negative, but in the Museum of Modern Art's version the celebratory scenes from the end of the film were missing. *A Trip to the Moon* was inspired by earlier literature and exhibits. It was, and continues to be, one variation amongst many.

The marks of history that are retained in the digital version of *A Trip to the Moon* – the flickering of time that returns us to the earliest recordings of movement, the etched surface of the celluloid that is maintained by the manual and digitized processes of restoration, the stroke of blue that reveals the hand of the young painter – add layered complexities to the history that the new version releases. For *A Trip to the Moon*, this reproduction highlights cinema's multiple histories. This film has multiple versions, contexts, prints and its uniqueness is predicated upon multiplicity. The Lobster Films version adds another edition to the complex history of this film. However, it is in the dialogue between materials that the celluloid remains insistently present in the digital version. The 2011 simulation connects the historical and contemporary, creating an intersection between celluloid and digital. Ultimately, all versions of this film challenge the assumption that film history is teleological.

Restoration of the Aura

The intersecting histories of the various versions of *A Trip to the Moon* complicate clear definitions of authenticity, originality and the traditional understanding of the inability of films to contain and express an aura. The more traditional conception of the aura of an artwork excludes both mechanical, and presumably, also simulated reproductions of films. In 1936 Walter Benjamin identified the 'aura' as the material and magical qualities of an original artwork that are only present to a viewer through immediate contact (1999: 20). Benjamin describes the aura in binary terms. He understands it as dependent on distance rather than closeness, uniqueness not duplication, permanence instead of ephemerality and that the artwork needs to be historically embedded in the 'fabric of tradition' (1999: 217). The artwork becomes a singular object of veneration, idolatry, often in the service of magic or a religious ritual. Benjamin argued that original artworks contain and express an aura at the exclusion of reproductions. He famously identified the dissolution, or decay of the aura in mechanically reproduced works of art like film. Here, the work exists outside of its history and culture, as Benjamin writes, mechanical reproduction not only destroys the presence of the work, but more so, 'the technique of reproduction detaches the reproduced object from the domain of tradition' (1999: 215). Benjamin singles out film as one of the newer technologies that have the potential to fundamentally destabilize relations between signifying systems that prioritized history, authenticity, originality and truth, with the potential for reproduction producing a revolutionary art that becomes both democratic and political (1999: 234–35). With multiple versions and branching histories intersecting past and present, older and newer media, films like *A Trip to the Moon* complicate clear distinctions that separate authenticity and originality.

The aura is redefined in a contemporary media ecology. Jeff Malpas extends Benjamin's work on the decay of the aura to question how new 'technologies release cultural objects from their unique presence in a place and make them uniformly available irrespective of spatial location' (2008: 13). His research examines how place, space, time, subjectivity and identity are altered in the age of new media and what this implies for the experience and interpretation of cultural heritage (2008: 14). Malpas suggests that new media reproductions dissolve the presence of the thing in its place (2008: 19), emphasizing that such obliteration gives rise to a loss of spatial and temporal distance, or 'relative locatedness' and a 'proper sense of heritage' (2008: 13). The impact of reproduction is that the object is removed from its original context; it therefore becomes generic, rather than unique, and it ceases to be historical (2008: 22). He coins the term 'virtualism' to describe entirely new works that exceed the original (Malpas 2008: 17). Malpas suggests that in duplicating the original, reproduction

> also duplicates the marks of its history, but it does so without that history belonging to the reproduction as such – the more perfect the reproduction, the more completely will the history of the reproduced work be obscured by its replication of the traces given in the original.
>
> (2008: 22)

Writing specifically on the restoration of film, Usai argues that 'the lack of an "aura" of uniqueness in the traditional photographic film gives no incentive to treat the copy in question as an artefact' (2000: 51). Usai hints at the creative dissonance at work in cinema between uniqueness and reproduction. He writes, '[t]he transition from analog photographic motion images has both exacerbated and contradicted the perception of a lack of uniqueness in cinema – an art and culture of reproduction' (Usai 2000: 51). Furthermore, some theorists of digital culture perceive an opposition between the power and history of the material, in contrast to the ephemerality and insignificance of the digital. Andrea Whitcomb writes,

> [t]he material word carries weight – aura, evidence, the passage of time, the signs of power through accumulation, authority, knowledge, and privilege. Multimedia, on the other hand, is perceived as "the other" of all of these – immediate, surface, temporary, modern, popular, and democratic.
>
> (2007: 35)

In this binary, the digital has no capacity to generate an aura. The simulation of *A Trip to the Moon* proves otherwise. A hybridized simulation of an original print contains evidence of the original in the traces of the passage of time as well as the colours that were matched by eye and painted using digital tools.

It is also possible to perceive the aura expanding beyond its traditional boundaries. If we can locate it in the celluloid medium, it may also appear within the digital simulation. Bruno Latour and Adam Lowe understand the potential of the aura as a force that is able to migrate from the material to the immaterial, adding new layers of originality to the original (2011: 277). Peter Walsh suggests that the aura has been misunderstood. Walsh writes,

> [i]n fact, Benjamin has the aura of art exactly the wrong way around. It is the mechanical reproduction – the photograph – that created the aura of the original, much as it was the machine that created the "handmade," the negative that created the "positive," and the digital that gave retroactive birth to its latent opposite, the "analog".
>
> (2007: 29)

Photographic reproductions, for Walsh, add to the significance of the aura, '[t]he more reproduced an artwork is – and the more mechanical and impersonal the reproductions – the more important the original becomes' (2007: 29). In this scenario, the simulation can reactivate the aura of its source. The presence of history, perhaps even the cinematic aura, is seen and felt in the insistent blue brush strokes of the young women painters, in the presence of its imperfection and decay. It can be noticed in the flicker of inconsistent temporalities, the hesitancy of its continuity, in the momentary stillness that calls attention to the earlier, celluloid source. The simulation duplicates and transforms marks of its history. It also retains frames that seem unchanged. It is an imperfect reproduction, an incomplete historical reference and a simulated text, removed from its source.

The aura describes the apprehension (or apperception) of the magical qualities of the original work of art, its history and locatedness in time and space. The index is the specific ability to point to referents in the world. Both are assumed to exclude the cinema as an art of reproduction and simulation. However, an examination of *A Trip to the Moon*, its original conditions of production and an examination of its restoration may well allow its rhizomatic history to be seen, preserved, restored or transformed. The index in *A Trip to the Moon* is the digital pointing towards the celluloid, the celluloid making its presence felt, reintroducing, representing histories from earlier and later cinema. It may well provide the foundation for the recognition of an aura in simulated media forms. The digital version of *A Trip to the Moon* extends the presence of this coloured, celluloid version in space and time. Simulated images have the potential to question a clear, imminent connection between the signifier and its referent. New generations, versions or simulations have the potential to create new experiences for the spectator, new historical networks and new histories. In some instances, new media technologies and screens have the capacity to allow spectators to see more and with greater definition than has been viewed previously. The intense colours and layers of complex historical references contained within the simulated original might actually provide the conditions for an intensification of the aura.

Reincorporating History

Laura Mulvey's investigation of film and history proposes an understanding of new and old cinema based on an interweaving and intermingling of past and present (2011: 71–81). She posits that new technologies open up new forms of temporality. Mulvey argues that the transfer of celluloid into a digital format allows for complex temporalities receiving greater visibility (2011: 76, 77). In the cinema, time asserts an indexical presence; the single moment sits alongside the insistence of temporal duration. The damage highlighted by the blue brushstroke in the paused frame reveals the endurance of celluloid in *A Trip to the Moon*. Mulvey writes, 'the "then-ness" that appears within the old celluloid image brings the history that belongs to it palpably into the present, translated onto an easily accessible form' (2011: 76). The dynamic interrelationship between past and present is rarely depicted more clearly in film that has been restored and transferred to the digital format. The momentary pause that exposes the traces of orthochromatic film and the colours that escape their outlines display how, in Mulvey's words, 'different kinds of temporality and relations between times become more clearly apparent as the indexicality of celluloid is translated onto and manipulated through new media' (2011: 77). In response to the anxiety about the end of cinema, a more accurate and nuanced understanding of film history becomes possible as

> [t]he perception of change shifts away from an imaginary pattern derived primarily from the register of time, a foreclosing of the past, a hastening towards the end of an era, into an imaginary pattern derived from space, of threshold, of holding past and future suspended in an uncertain present.

> (Mulvey 2011: 79)

The indebted, inextricably linked relationship between film history and digital media is evident in the visibility of processes of restoration as well as in the traces of celluloid deliberately retained in variants.

The 2011 restoration of *A Trip to the Moon* is not the definitive version; rather, it is one of numerous lunar fantasies that have appeared before 1902 and will continue to circulate into the future. This film is part of a constellation of old and new, celluloid and digital, unique originality and simulated variant. Importantly though, the technologies used in the restoration process result in images that exceed the celluloid print, certainly in comparison to the state of the film when it was discovered. On digital restoration, Usai writes that,

> the tools available to film preservation professionals in the digital domain have enabled them to achieve what would have seemed impossible with traditional photographic chemical methods: color, contrast and image stability can be greatly improved (more faithfully to the original, or, problematically, even beyond) with techniques previously unimaginable in the "analog" laboratory.
>
> (2010: 152)

However, whilst the digital simulation of *A Trip to the Moon* exceeds its celluloid counterpart, it's 'faithfulness' to the original is complicated by the multiple sources that it draws upon, is restored according to and is influenced by.

The digital version exists in the state that is 'more' or 'beyond faithful' to the original, but this is not only evident in the simulated variant. Concurrent with the restoration was the re-popularization of Méliès through Martin Scorsese's *Hugo* (2011). In this context sequences from the short film are excised, digitized and projected in three dimensions. Cut up and with the addition of depth and definition, *A Trip to the Moon* is reduced and twice removed, becoming a special effect that provokes wonder for the characters within the diegesis and in the theatre. In this variation, the film is spectacular and astonishing. The aesthetics of astonishment extend to incorporate three dimensions and high-definition imagery. Mulvey's work addresses this celluloid/digital connection, one that we can see in the quotation of *A Trip to the Moon* in *Hugo*. Mulvey writes,

> [a]s the flow of cinema is displaced by the process of delay, spectatorship is affected, re-configured and transformed so that old films can be seen with new eyes and digital technology, rather than killing the cinema, brings it new life and new dimensions.
>
> (2011: 80)

Hugo brings *A Trip to the Moon* to new eyes, but it reduces and reconfigures it as special effect sequences and situates it as moments within a biographical narrative. Here, the early film is reframed as a dialectical contradiction. Presenting the early film sequences of *A Trip to the Moon* excises and obscures it, just as it clarifies and illuminates it as a high-definition, 3D film.

Instead of an end to cinema, Gaudreault and Marion perceives cinema as 'born twice'. Here the material base is extended by digital technologies and, as they write: '[a]ll of a sudden the "medium" of moving pictures is able, synchronically, to designate an entire historical, transmedial, or transtechnological constellation' (2005: 92). Celluloid forms the foundation of the digital version of *A Trip to the Moon*. The celluloid is unfurled, prized apart, copied, separated and spliced back together with images from another black-and-white version using processes that replicate the conditions of hand painting in Mme Thuillier's Parisian factory. It relies on the logic of the photochemical, but annihilates its celluloid base by reducing it to dust in processes that ultimately are neither conservative nor restorative of the material, but instead capture, reproduce and simulate the image. The blue brushstroke that was painted by the young woman in Paris in 1902 is transformed and re-animated with processes and a colour palette that were beyond the possibilities of the original painter. Such a hybridization of old and new results in a simulation that retains a glimpse of the vision of the original painter, her continuing impact on the film illustrating the presence of film history in newer media.

Note

1 An earlier version of this chapter appeared in *Senses of Cinema* (issue 65, 2012).

Chapter 3

The Serpentine Dance Films: 'Dream Visions That Change Ten Thousand Times a Minute'

The thrill of *Annabelle Serpentine Dance* and other films like it lay partly in the sheer frenzy of movement as Annabelle spins across the tiny screen, the sort of muscularity characteristic of early cinema. However, another pleasure in watching Annabelle was the spectacle of sex, which had everything to do with temporality. As viewers cranked the handle that set these images into motion, there existed (at least in viewers' minds) the teasing possibility of glimpsing the unseen: patrons could slow the rotation of the images to a stopping point just at the moment when those billowing skirts reached their most titillating height, at which point they might, theoretically at least, reveal flesh. Annabelle's sexuality was expressed as movement, muscularity, and vitality, yet her patron's desire may have been to *stop* her movement at the crucial moment.

(Jennifer Barker 2009: 135)

The Serpentine Dance: 'An International Rage'

In 1895 the Edison Manufacturing company produced *Annabelle's Dance*, a single shot view of an unidentified dancer performing the serpentine dance, a performance that Paolo Cherchi Usai describes as 'an international rage' (2000: 21). Loïe Fuller is understood to have created the serpentine dance as a pre-cinematic, multimedia spectacle, one that was designed to project a spectrum of transforming lights and colours onto the fabric of the dress, imagining it as a screen. Fuller was a performer, a choreographer, a stage designer and an inventor. She was credited with developing and patenting a range of costumes, glass floor theatrical designs for lighting, chemical mixes for gels and slides. She is also known for her experiments with radium salts designed to create luminescent lighting effects on stage. However, Fuller was unable to claim ownership of the serpentine dance. Whilst there are multiple versions made and circulated, there are very few celluloid films showing Fuller actually performing the serpentine dance. One 16mm film attributed to Pathé Frères is held in the collection of the Museum of Modern Art. Currently, there are multiple serpentine dance films on the Internet that have been misattributed to Fuller. Whilst she may not be acknowledged as the creator, her presence remains as the inspiration for performances of the serpentine dance. Fuller's stage presence and lighting effects are apparent within a variety of serpentine dance films as early filmmakers attempted to capture a similar impression of sensuality in their experiments with temporality and motion on film. *Annabelle's Dance* is one of multiple serpentine dances depicted across the spectrum of visual media, each of

which can be mapped as individual moments within a historical matrix that connects pre-cinema to digital film.

Much of the historiography that is written around Fuller identifies her work in terms of innovations and origins. Some writers note the difficulties involved in claiming ownership. Whilst the serpentine dance itself became a phenomenon in the early twentieth century, Fuller was unhappy about the numerous attempts to replicate her performance in the theatre as well as on celluloid. Many performers were presenting her 'radium dance', for reasons that diverged significantly from Fuller's aim to use the dance to display the results of her scientific research. Fuller believed that the feeling of the dance was unable to be communicated effectively, experienced and 'felt' beyond the live performance. She wrote, '[s]o unliving a thing is it that it exists only in itself and can no more be copied than wind and storm are copied in the camera [...] gives us no idea of what the storm or wind would make us feel' (Fuller 1907–11). Whilst Fuller describes how she invented the serpentine dance in the 1890s, she was unsuccessful in her effort to sue dancers like Minnie Renwood Bemis for performing and benefiting from the dance. The court resolved that the ephemerality of the performance was not appropriate material for copyright. It is precisely these complex definitions of ownership and originality amid a culture that embraced duplication, which positions the serpentine dance and its revisions as pivotal examples through which to consider how the contested originality of performance can reveal interconnected moments in pre-cinema and post-medium digital film.

Carolyn Sinsky provides an early hint of a contemporary media archaeology analogy by acknowledging the multiple influences visible in Fuller's own historical background, revealing that,

> [h]er early experience in burlesque, vaudeville, and circus was transformed into stunning visual effects and artistic innovations, resulting in what her French contemporary Arsène Alexandre called "the marvellous dream-creature you see dancing madly in a vision swirling among her dappled veils which change ten thousand times a minute".
>
> (Alexandre [1900] quoted in Sinsky 2010)

Here, both writers encapsulate the framework for my approach to Fuller and the serpentine films by emphatically connecting and implicitly referencing the changing colours, shifting patterns of light and the flow of movement that inspires this performance across histories and in various new media forms. This dual perspective is reinforced by Tom Gunning's acknowledgement of the need to keep past and present in focus, in dialogue, to avoid holding a mirror up to the past without engaging it (1996: 79). Here, Gunning's model of dialogue and engagement will be extended to the older and newer forms of the serpentine dance films to focus on colour as a metaphor for a dynamic historiography.

As an inventor of colour and lighting processes in the theatre, Fuller was an influential figure in the development of colour effects. In many ways the live performance of the serpentine dance resonated with advances in optical technologies, developments that led towards the invention of the cinema. The serpentine dance films are key aspects of an intermedial, historical continuum. However, they are also susceptible to alteration. Films in the silent era (and the digital era)

transform significantly over time and as prints were bought and sold, edited or damaged. The serpentine dance specifically includes early as well as contemporary artefacts (found films, perhaps), derived from accessible versions of earlier films. An investigation of the ways that these films are made and re-made, circulated and accessed allows for connections to be posited across the historical matrix. This is further substantiated by an exploration of experiments with light and colours, particularly how they evolve and devolve and are transferred from live performance to the painted film frame and then to the precise timing of digital colours.

Hand painted and even stencilled colours that trace movement in early film often appear 'undisciplined', adding another layer of kinetic spectacle that is unable to be constrained by the diegesis. Such colours have been described as 'fugitive', unable to be restrained or fixed (Hertogs and de Klerk 1996). Colour attracts, directs and diverts attention, refusing to regulate perception into a singular, coherent structure, instead providing myriad viewing possibilities. Colours applied to film frames create additional levels of time and movement. Gunning considers sensational colour in early cinema beyond the indexical link that limits its heritage to photographic experiments. Gunning writes,

> [b]ut if Bazin, writing in the 1950's, witnessed the triumph of this indexical color, the silent era seems more notable for the other tradition of color, color which is not due to indexical photographic processes but was manufactured by various processes of more or less arbitrarily applied color, including hand painting, stencil coloring, and various varieties and combinations of tinting and toning.
>
> (1996: n.pag.)

It is in this realm of more or less arbitrarily applied colour, or sensationalist colour, that my focus on the serpentine dance and its connection to, and elision of, linear taxonomies, or non-indexical histories can be seen clearly. Gunning provides the framework for this approach to history. He writes that in an effort to understand the functions and 'connotations of this form of color applied primarily for its sensuous, spectacular and metaphorical effects rather than its indexical and realist associations I believe we need to broaden our scope a bit, while maintaining a very definite historical specificity' (Gunning 1996: n.pag.). This broader scope allows for the development of connections across time, media and materials. Even though Fuller was not the first serpentine dancer and she began as a live performer unconvinced that the sensation of the dance could be captured and reproduced by film, her experiments in science, technology and aesthetics allow us to see the influence of time expressed in complex patterns within the films, patterns that illuminate complex histories that are hidden behind the imagery.

Experiments with Coloured Light

In 1896, Fuller observed a series of lighting experiments with phosphorescent salts, radioactive oils and with X-rays at Edison's laboratory in Merlo Park (Gomez 2014: 14). When she established her own laboratory in Paris, Fuller was able to record and name approximately

13,000 colours that 'changed under polarised light in constant motion, demonstrating the potential of the artificial compared with the natural' (Gomez 2014: 14). Her investigations were driven by the desire to see, categorize and name colours; she had a particular focus on transitions between colours and the effects of light. In her notebook Fuller wrote that,

> in addition to working with all kinds of structural machines for providing rays of light, I was occupied in turning out fantastic colours, harmonious shades, shifting forms and shapes through augmenting the decomposition of colour matter from combinations of chemicals on glass slides through which to throw the light.
>
> (1907–11)

As much as she was interested in composing colour, Fuller was equally driven by the dissolution of hues and the transition of one colour into another along a spectrum. Fuller described her visions of colour in this way, 'I *see* the colors just as you *see* them in a kaleidoscope', extending this perception to the haptic, saying that she could, 'feel rays of light in disintegration or in transition' (Fuller quoted in Sommer 1975: 63, original emphasis). Fuller's approach tested the materiality of colour, its temporal dimension and its evocative effect. These experiments with the transformation of colours were designed to conjure illusions of spectacular movement and to provoke an emotional and sensual response.

Fuller understood her experiments as contributions to the natural sciences, exploiting rationality in the natural world. In handwritten notes for a lecture on radium, she reveals her concern with things that, 'are looked upon as unreal – supernatural – are – one by one, proving to be the results of natural causes – all part and parcel of this world and its products, the most advanced "unreal" fact being the telegraph without wires' (Fuller 1907–11). This premonition of advances in technologies shows Fuller's ability to articulate an imagination of wireless communication. Her detailed classification of colours and reflections on experiments with chemicals, light and fabric uses science to identify, activate and exceed the colours of the natural world. Fuller writes that,

> [a]lthough the wonderful green of sulphur of zinc was astonishingly beautiful, the sulphur of calcium dresses – so like the light of the moon was exquisite and much very very much [an] […] expression than the zinc. Then we made a dress and a veil out of black gauze and spotted it with the calcium. When the veil was thrown up into the air it disappeared into the darkness and only the falling luminous drops were seen elongated in their descent taking on the form of great […] blue leaves.
>
> (1907–11)

Initially Fuller experimented by applying radium and zinc salts directly onto the dress that was to be used in the serpentine dance. In another experiment a fabric ribbon was coated with sulphur of calcium, set alight and, as Fuller details: 'it was an intense moment of excitement. And suddenly a flash, a boom and we knew no more' (1907–11). Destruction is

characteristic of Fuller's work. The direct implementation of colours onto a dress was also unsuccessful as it stiffened the fabric, making the flow of movement screening the ephemeral transition of colours impossible. Gradually her focus shifted to the development of 'underlighting' using filters to colour the beams of light projected onto the dress. Inspired by views of Parisian fountains that were lit from below to illuminate the female statue, Fuller developed and patented the underlighting technique for stage performances in 1893 (Sommer 1975: 58). Here the lighting technicians used gelatin filters and coloured glasses to tint the beams of light that were projected from below the stage through glass plates. The movement of the coloured beams was achieved by rotating the filters and with the refraction of various lights as they met on the surface of the fabric. Red filters allowed Fuller to create the illusion of her costume catching fire at the hem and then becoming engulfed in intense red flames for her performance of 'Le Danse Feu'.

A comparison between electric light and radium light illustrates Fuller's aims. She notes that whilst electricity results in a hard light produced by rays, radium offers a soft, glowing illumination without rays. Fuller writes that whilst electric light appears in a form that is vibrating and unsteady, radium is both uniform and steady. Electricity is punctuating, whilst radium is permeating. Electricity is produced by building up something, but radium is created by 'unbuilding everything' (1907–11). This soft, glowing, steady, permeating light that is produced by 'unbuilding' highlights the potential for the fabric to capture light, and for it to screen the de-composition and transition of colours. Fuller described the type of phosphorescent light that radium produced as marvellous (1907–11). It provided a prototype for the soft glow that would eventually illuminate the dance on stage.

Fuller also explored the potential for movement to express the transformation of sounds, shapes and colours. Movement encompassed the body, the fabric of the dress as well as the light projected onto the fabric. The stage lighting that she developed was designed to use the constant brilliance of radium light to illuminate the kinetic, spinning surfaces and the flows of the silk fabric. A consistent form of illumination supported the transformation of colours and the flowing movement of the fabric. Sally R. Sommer highlights the importance of movement in the stage performance, describing it in this way:

> The movements of her costume, made from hundreds of yards of fine, diaphanous silk, ranged from delicate ripples to large configurations shaped by the dancer as she tossed and whipped the silk about her. Crucial to the effect was the projection of light upon the moving surface. As light hit the material it was fractured and diffused by the movement; the effect was one of color washing, bleeding, running across a shimmering and iridescent surface.
>
> (1975: 54)

The effect of light projected onto fabric is pivotal in generating the illusion of transforming colours in all forms of the serpentine dance. Whilst Fuller used the dress as a screen to capture the moving colours that were projected through the glass floor of the stage and to scatter these illusions back towards the spectator, in transposing the effect onto celluloid,

early filmmakers saw the light, mobile shapes created by the filmed dance as providing a series of still frames containing outlines available for the application of colour. In the filmed versions light is projected through the celluloid, penetrating the watery aniline tint, reaching the screen and creating an illusion of colour and movement.

The song 'Loin du Bal' initially accompanied the live performance of the serpentine dance. Her manager introduced this music to Fuller in 1892 (Fuller 1913: 38). All performances of the serpentine dance combined sound with colour, light, movement and rhythm to animate time. Sommer notes that Loïe Fuller claimed that she could 'see' music and ultimately was motivated by the desire to visualize music in the movements, flows and colours of the serpentine dance (1981: 390). She describes the spectacle of the performance: 'Wearing costumes made from hundreds of yards of China silk, she danced beneath a dazzling array of multi-hued electric lights, which set the material aflame with color' (Sommer 1981: 392). This multifaceted performance included dance, lighting, transforming colours, material, screens and sound – all presented in cycles of building and 'unbuilding' intensity.

Over the course of her experiments with radium in the production of light and colour, Fuller understood the importance of experiencing, seeing and feeling colour. Sommer notes Fuller's remark that she could feel rays of light in transition and in disintegration (1975: 63). Fuller expands on this in her notebooks, writing, '[t]hus, a living, moving mass of colour or colours must be seen and felt to be known and understood' (1907–11). But colour is perceived, felt, known and understood in many ways. Carol Mavor reminds us that colour particles are visible as light that is 'scattered back' from the object to the eye (2013: 11). Colour is light, or varied wavelengths that are registered by the eye. Colour wavelengths are blocked, reduced, reflected and scattered back to our eyes. Cones within the eyes will determine the degree of saturation received, if any at all. Visions of colour require the eye to block out wavelengths other than that pigment absorbed by white light. A white object reflects all wavelengths, but black absorbs them all. Light is deconstructed cinema. Fuller used similar experiments in both the production and reception of light; with the scattering of chemicals on the material of the dress, the fabric itself is used as a screen that is receptive to light, and that would capture colour and scatter it back towards the eye of the spectator. Fuller's experimentation and performance connects the arts with biology, chemistry and metaphysics.

Fabric, Bodies, Emotion

The illumination, transformation and dissolution of colour are matched by the appearance and disappearance of the body in the serpentine dance. At moments the fabric enshrouds the body, making it disappear completely. Other moments, however, emphasize the expanse of translucent silk fabric that touches the surfaces of the body, revealing some of its curves and shapes. Colour, light and the dancer's body are bound in a relationship of concealment and revelation, presence and absence according to Gomez who recognizes the impact of lighting in the 'dematerialization' of the body as part of a 'quest for abstraction' (2014: 14–15). Giovanni Lista elaborates:

Figure 3: *Loie Fuller Dancing* (Samuel Joshua Beckett 1900).

When the beam of light touched Fuller, her raw silk veil did not present an impenetrable surface, like that of the cinema screen. Instead, it seemed to let itself be penetrated by the light, to the point of becoming intangible and a source of luminescence in itself.

(1994: 39)

For Lista, the illuminated fabric results in a body becoming light. Lista posits that Fuller was a, 'dancer whose body was denied, perpetually concealed by her veils, whose movements were designed to construct a completely different picture of femininity' (1994: 29). Lista's point is that Fuller radicalized and inverted the traditional eroticization and idealization of the feminine body by prioritizing the veil. In Lista's conception, the body disappears, becoming instead an expression of line, movement and repetition with the metamorphosis of form manifesting a 'new female body, one that was physically absent' (1994: 29). However, rather than dismissing the feminine form and rendering it abstract, Fuller used processes of dematerialization and revelation as elements that heightened the depiction of the body. In

its illumination of the body shapes, in the folds and gatherings of the material, in the colouring of moments in the performance, in the revelation of glimpses of skin, the dance itself was provocatively sensual. The serpentine dance provided visions of the body transfigured in time and motion.

The dance itself can be compared with the burlesque skirt dance performed by dancers like Kate Vaughn in London at the turn of the nineteenth century and the famous Parisian can-can, both performing to the external gaze. However, to perceive these performances as purely designed for the voyeuristic view is to limit their potential to impact the development of technologies of vision and risks reducing the status of the dance to derisive scandal, rather than an art form. The potential for the dance to provoke emotion is evident in various responses to Fuller's performances. The Symbolist literary figure Stéphane Mallarmé saw Fuller perform at the Folies-Bergéres in 1893, comparing the dance to the dream, or to an inner subjective vision, identifying, 'the emotion caused by her dress' (quoted in Albright 2007: 43). Comparing the performance to poetry, Mallarmé identified the potential for the dance to simultaneously write and to express poetically. The emotion caused by Fuller's dress was the product of the flow of fabric, the movement of the body and its illumination with coloured lighting. Lista describes the spectrum of emotions incited by the colours of Fuller's live serpentine dance performances as offering the,

> most ancient human sensations, the most primitive visual experiences, were thus bought onto the stage: the glowing light of dawn, the fiery glow of sunset, the brightness of day, the moonlight at night, the sparkle of a diamond, the vividness of a flower and the brilliance of a star, but also the pallor of terror, the red of anger, the dull hues of melancholy or the increase or decrease in depth of colour which marks the different states of matter and indeed accompanies the passage from life to death throughout the universe.
>
> (1994: 30)

Looking into the Serpentine Dance Films

Joshua Yumibe suggests that the first public projection of coloured film might have been a hand coloured print of an Annabelle film screened through the Phantoscope created by C. Francis Jenkins, an event which took place at the Cotton States Exposition in Atlanta, Georgia in September of 1895 (2009: 167). The hand-painted images of the serpentine dance films re-animate the experimentation with colour and light characteristic of Fuller's live performance. Each cinematic recording of the dance captures the ephemerality of movement and colour, but these early film versions rely on kineticism (of the fabric, its colour, the movement of the body in the dance as well as the moving aesthetic) to explore the essence of film as a time-based medium. A compilation of early serpentine dance films titled *Loïe Fuller – Danse Serpentine* (Lumiére and Lumiére 1897) has been digitized and uploaded onto YouTube. This compilation mistakenly attributes Fuller as the performer, the Lumière Brothers as the

filmmakers. However, an aesthetic analysis reveals how the colour, movement and transformation, combined with depth cues, proscenium arch framing and the single-shot long take of the serpentine performances introduce a complex matrix of connections. This celluloid/digital hybrid version relies on a range of tones, repeating the pink washes that range in intensity from a deeper magenta pink to softer rose pinks, sequences of purples leading into greys, oranges that become yellows and some frames hybridize greens with pinks. Transforming colours highlight the cyclic rhythms of the dance and it is in the movement of the fabric that we see a very clear expression of time, one that is spinning (or gliding) through a spectrum. Coloured sequences are repeated in this montage, emphasizing the repetition of gestures and colours all presented within a slowed, stilted momentum similar to stop motion animation. Colour offers visual prominence to the movement of the fabric, transforming as sequences literally unfurl in centrifugal forces that create a spinning timeline of colours illuminated by the propulsion of the silk dress. The coloured sequences shudder obliquely which is evidence of the imprecision of hand painting where there is variation across frames. Ruptured continuity makes temporality visible. This movement of colour in cycles of appearance and transformation is reminiscent of Fuller's experimentation with radium light as steadily glowing and permeating, effectively constructing and then 'unbuilding' the image to reveal the processes of early cinema and its expression of time.

This compilation offers multiple ways to imagine time registered as flickering colour. The translucence of the aniline wash provides the ability to see through the colour, offering a dual perspective that reminds us of the original black-and-white celluloid beneath the colour wash. The shadows, barely discernible in the muted colours that appear at the periphery of the dress, offer a spectral impression of the dance in a moment of delay. Here, colour escapes its outline and becomes visible as another depth cue within the *mise-en-scéne*. Shadows of movement occasionally push the dance beyond the limitations of the fabric as it spirals in multiple concentric circular patterns. The stability of perspective (and the omniscience of the viewer, originally peeping through the eyepiece of a kinetoscope, and now on the expanse of the screen) is undermined by a clash between the static framing and the kinetic performance as the dancer occasionally disappears beyond the limitations of the frame. Coloured sequences are repeated in this montage, emphasizing the repetition of gestures, of colours, all presented within a slowed, stilted momentum, an effect of the attempt of the digital timeline, to capture and manipulate the variations in the hand-cranked kinetoscope. Ute Holl suggests that, [i]nscriptions of light on film surfaces can create pleasant effects of shades and tones, but when applied excessively they ruin the surface and destroy the image' (2014: 160). These moments of excess are expressed in the colours that bleed beyond the outlines, in the fade of some tones, in the diminishing contrast, in the transition to successive colours and in the lines and scratches etched into the surface of the film. The image becomes infused with history as time reveals itself across the surface and within the depths of the celluloid. The colours both match and are not able to be constrained by the performance. Here multiple references to time within the film function as an internal reflection of the complex histories that surround this film and early cinema. Rather than

destroying the image, it connects it to others within the compilation and across a broad spectrum of media history.

These serpentine dance films reveal the importance of the black background both for its ability to cast the dancer into the foreground and for its point of contrast with the transitory, coloured light. The black colour resists the penetration of light across its surface, creating a strong contrast with the luminous illusions projected by the silk. Here, the dark backdrop translates to the celluloid version of the dance, with the representation effectively providing an optical illusion of the movement and flow of time in the surfaces and folds of the fabrics of both the serpentine dance and its staging in light. Sommer's description of the live performance of the serpentine dance reveals this darkness as instrumental for the expression of colour. Sommer writes,

> [t]he figure of the dancer was now concealed, now revealed. She darkened the auditorium, stripped the stage of décor, and hung it with black chenille curtains so that she seemed suspended in space, caught in a colorful web of the most impalpable materials – silk, light and air.
>
> (1981: 392)

Whilst this compilation does not include Fuller, her presence is marked in the staging of the performances, in the transforming colours and in her misattribution in the title.

The black also provides a backdrop (literally a draped cloth) against which the damage to the surface of the film becomes visible. The black offers a deep background connecting to and making visible the surface of the film, and most importantly, the etched surface, the time and progression of the film. The history of the film is expressed as damage to its surface. A subliminal register of time is also evident in these imperfections, with the borders of the frames barely visible in the infinitesimal variation between frames circulating somewhere between fourteen and sixteen frames per second. Materiality is foregrounded in the scratches across the surface of the film. These traces are maintained by digital exhibition. The digital form has frozen some of the changes in the celluloid, and doing so, introduces its own particular indexical markers of time. These are evident in the pixelation of the image, in buffering, in the delay, the still freeze frame and circling wheel icon on the computer screen, or even by the disappearance, or forced quitting that characterizes the disaster of download. The film itself is both alive and dying as digital captures the decay, or as I prefer to describe it, traces of the film's history. The moving image is a living material.

Mediating the Serpentine Dance

William K. Dickson's serpentine dance films were made for the Edison Studio and coloured by the unnamed wife of a named Edison employee, Edmund Kuhn (Yumibe 2012: 49). *Annabelle Dances and Dances* (Edison 1894–97) features Annabelle Whitford Moore, Crissie

Sheridan and other unnamed performers, reflecting the larger agenda of history to gloss over the impact of individual women. Moore was one of many serpentine dancers, but here she is distinguished by her vibrant orange hair, colour that remains relatively consistent within a montage that features a range of experiments with additive colour processes. Whilst this collection of serpentine dances begins in black and white, it gradually begins to reveal an extended range of colour experimentation, including the use of multiple, watery colours across the outline of the fabric, many of which don't always quite match the image. Sometimes the colours are missing; sometimes they exceed outlines and form. Jacques Aumont calls this type of colour 'free-floating', floating in front of objects, blurring their shapes (1996: 53). The colours are certainly floating, unable to be constrained by the performance. In many of these images, the outline is barely a reference point as colouring does not cover the whole of the dress. Some frames show a coloured top/cape whilst the bottom layer remains white. It is here also that we note the imprecise colours, evidence of hand painting where aesthetic continuity, or what we might now call colour grading or colour timing, is not the primary objective of the application of colour in these sequences. In some shots the colours that don't

Figure 4: *Annabelle Dances and Dances* (Edison 1894–97).

quite fit the outline remind us of the time and distance between the camera recording the live performance and the hand painting during post-production. Expressed via aniline dyes/paints, colour is also indicative of a particular palette and chemical combination used in the experiments of early film, a time frame itself.

Two intensely coloured sequences are significant. The first is when a deep purple tint transforms into a discernibly hand-painted red swirling fabric. The purple tint remains, revealing the insistent state of the tint against the hand-painted colouring. These divergent additive processes appear in contrast with one another. The stillness of the purple background contrasts with the momentum of the flowing, red robes. The second important sequence shows a tri-coloured image that splits the frame into magenta and lemon thirds. This fleeting image is evidence of colour that doesn't reference the dress or the performer; this is a pure and spectacular experiment in colour illusion. Abstraction dominates as the colours take priority over the outline. The intensity of the colours in this fleeting image produces a sensual form of communication. The imprint of the colourist tinting the celluloid is clear here. The time frame referenced in both of these images is the moment of post-production. Gunning understands the filmed versions of the serpentine dance performance as pure form and motion, with 'colour as pure attraction, something whose very essence is just to be constantly changing' (1996: 41). The Edison montage pushes the movement of the dancers towards abstraction. Some shots within the montage are exhibited at differing speeds so that the dancer appears to be dancing at a regular pace, then slightly slower and more flowing. One performance is not lit, or barely lit to register on the film stock so it is difficult to discern the outlines of patterns, shapes and colours. At other moments the movement of the air becomes visible in the way that it animates the dress, making it billow out. The joy of the dancer is registered as she seems to lift from her feet and almost jump into the air before she turns to glide laterally through the space. One black-and-white performance features so many swirls of fabric that it almost erases the woman dancing.

But there are other traces of time expressed on the surface of the celluloid. This is most evident in the impression of rib-like horizontal lines appearing as a palimpsest, stamped on, or written over the black background. Another sequence is etched with vertical white lines that seem to be raining down on the dancer. These traces of time expressed in what is conventionally seen as damage, but are, in fact, markers of the film's endurance imprinted onto their surface. The surface patina reveals the history of the film as it has passed through various technologies for projection: the kinematograph; the mechanical and digital projectors. This montage is also remarkable for the impressions cast into the celluloid. Well before the term was used in cinema, the inscription of 'subliminal' words can be glimpsed marking single frames. An abbreviation of Patent along with August 1897 is written over the image of the dance in one frame; stamped letters signalling that the image is copyrighted to Edison is only visible via the freeze frame in another. The sequence ends with the typed, official notice that identifies the film as patented in March 1893. This is signed in ink by Thomas A. Edison. This is yet another marker of time, but this time it is black and white, text based, static timestamp, an image that contrasts with the flows of materials, movement and colours. Gunning writes that,

the arbitrary and unnatural uses of color, more intense than reality, allowed color to be experienced as a power in itself, rather than simply a secondary quality of objects. Even the slightly uneven fit between color and object in hand painting and stencil coloring, so that the colors seem to lift themselves off the surface of reality and quiver in a scintillating dance, has the effect of underscoring the independent power of color, even if unintentionally.

(1996: n.pag.)

It is in this slightly uneven fit between colour and object where the colours seem to lift themselves off the surface and quiver in a scintillating dance that we can see colour animating time and contributing another aspect of time to the many temporalities present in the film. The colours of the serpentine dance films are transitory and evanescent, they seem to dance themselves. The colours painted by hand with aniline paints evolve and transform as the film ages, in response to projected light, with every transition to an alternative material (from nitrate to acetate to digital), with every circulation and screening. Gunning describes colour in films as 'tenuous', a perfect way to imagine the process of painting multiple frames and the transition of colours as they develop, are illuminated by flickering light, as they age and are transformed by time. Here, colour is ephemeral, a slowed version of the movements of the silk, the fabric that doubles as both celluloid and canvas, or screen. Gunning remarks that, '[t]he very way that colour seems to shimmer on top of things with stencilling and hand colouring has this kind of weird insubstantial quality, is part of its joy in the silent era' (1996: 39). Gunning argues that colour is less eternal than form,

[t]he debate […] has gone back and forth, ranging from philosophy to art, but the general feeling, going back to Plato, has been that somehow the outline, the form of something is more essentially related to the concept and idea of the thing than colour, which seems to be temporary, secondary, seems to have more to do with instants of time and situations than with the eternally knowable. In fact, part of the joy of colour lies in inverting this model, accepting transience.

(1996: 39)

In the serpentine dance films colour is projected light, but it is also a registration of the movement of time. The particular type of time registered, however, is circular and irregular.

At the 1995 workshop on colour in early cinema, Heide Schlüpmann raised the possibility of colouring time rather than space,

maybe we should talk about colouring time rather than space […] To talk about colouring time is to talk about colouring strips of film or colouring the time of the film, which isn't just some mechanical process, because from one frame to the next it's fundamentally *time* that we experience, and time, therefore that we're colouring.

(1996: 65)

The ensuing debate posited that colour had no temporal dimension, existing, instead, as 'pure presence' (Lewinsky 1996: 43). Mariann Lewinsky notes that, '[w]hether a film was made three weeks ago, or a hundred years ago, we experience the colour now' (1996: 43). Both positions hold an element of truth. We experience colour in the present, in the series of instants that Gunning sees as elemental to the cinema of attractions (1990). But colour is also inextricably linked to its past, in the design of its colour palette, in the moment of painting of the still frame (the basic unit of film, the still that gives rise to the illusion of movement) and in the materials of its era. Those colours transform over time and by coming into contact with new technologies and media forms. The colours of the past are not static. Deleuze writes about not only how the cinematographic image is 'necessarily in the present', but also how this present image is both haunted by the past and simultaneously prescient of the future (2014: 37–38). The debate hints at the complexity of time, particularly as it appears within these films, expressed in accelerated, slowed, stilted, ruptured and intermittent forms, in the artefacts (or simulations) of the serpentine dance. It is the spectrum of colours that identify the twists and turns, the temporality of the dance, where the colours of time are highlighted. The transformation of the hues projected onto the flowing robes makes the viewer aware of the complex flows of time in the serpentine dance and in its restaging in film.

Colour and the Senses

In the serpentine dance films colour is chemical, industrial, cultural, physical, material, technological, aesthetic, emotional and historical. Ute Holl writes that '[c]olour is a barely perceivable yet affective thread in the texture of cinematic historiography' (2014: 160) and the serpentine dance films provide evidence of the connection between colour, the senses and emotions. Gunning argues that painting on black-and-white film contributed less to realism and more to the development of a sensual intensity. He writes,

[e]ven the surviving tinting from the earliest period of exhibition, Edison's films of Annabelle's skirt dance, use color in a spectacular rather than realistic manner, with the changing tints on Annabelle's billowing dress undoubtedly intended to convey the effect of colored lights common in dances of the Loïe Fuller genre.

(Gunning 1994: n.pag.)

We can extend this to consider the impact of colour and movement on haptics, beginning on the surface with the impact of transforming colours and dynamic movement and extending that focus internally towards the rhythms of the viewer's body.

Jennifer M. Barker writes on early cinema's fascination with the body in motion, noting that this is initiated by a series of investments that the spectator has with early film (2009: 132). She suggests that as she/he drops the coin into the slot,

'[t]his single act marks not only a monetary exchange between patron and industry, but also, more important, the contribution of the spectator's bodily movement and action to the event, which precipitates the motion of the film itself. Without the motion of the viewer depositing the coin, there would be no "motion pictures".

(Barker 2009: 134)

And this gesture initiates greater impact on the body and the senses as, 'these machines insisted on the immediate presence and proximity of the spectator's body to the apparatus and the film itself at every level' (Barker 2009: 133). Serpentine films seen through the viewfinder of the kinetoscope invite viewing/feeling/experiencing on an intimate scale. It is Barker's suggestion that film impacts the body and the senses well beyond the surface. She writes that, '[t]he affinity between our visceral rhythms may be subtle and barely perceptible, but it is also palpable. Cinema gives us a feel for our own deep rhythms, reminding us what we are made of' (Barker 2009: 129). She writes about the ability of film to penetrate surfaces of the body, where the moving image is felt in the 'murky recesses of the body, where heart, lungs, pulsing fluids, and firing synapses receive, respond to and reenact the rhythms of the Cinema' (Barker 2009: 3). Barker's identification of reciprocal tactility with the body feeling film on the surface of the skin and into the organs, responding to the movement(s) of cinema, has specific relevance to the experience, or re-enactment of the rhythms of early cinema. These rhythms vary with the film moving at around 14–16 frames per second through the projector or being hand cranked through the kinetoscope, and with the whirling, cyclic, continuous flow of silk and colour within the serpentine dance films themselves. The kineticism of the technology, the force of the machine propelling the moving image, producing the wonder of animation of the illusion, both allows for and sits uneasily against the desire to pause or to delay the movement of the image. Slight interruptions to the flow are reminiscent of the 'imperfection' of early films. The intensity of patches of colour, their transformation and de-composition, the scratches and stamps across the surface of the film, are all elements of the range of temporalities that we see in the early serpentine dance films re-animated by digital cinema.

The Digital Serpentine Dance

Fuller's serpentine dance is reimagined in the music video *Shades of Cool* produced by the American singer-songwriter, Lana Del Ray and the filmmaker, Jake Nava. This music video begins with a false reflection. A close-up of eyes become saturated with an indigo tint etched with white lines, the colours and markings imposing a false reflection of the view. Lana Del Ray is introduced from behind and begins to turn towards the viewer ever so slowly. The digital colours and outlines of the dress become blurred and her figure becomes abstracted from the background, creating a spinning spectral presence. The outlines take the appearance of an oil slick, one that separates and returns the colour back into its wavelengths. The colours that are projected on her dress circulate and then scatter back

Figure 5: *Shades of Cool* (Nava 2014). (Source: Interscope.)

towards the camera. Whilst the fabric remains remarkably still, the light, colour and painted images animate the dress. The colours here vibrate and move similar to the kineticism of the painted films. As Lana Del Ray begins to spin, colours transform, taking on shapes including fireworks, flowers and even birds. These shapes escape the fabric and take flight. The spin propels the abstract colours, transforming them into chemical and natural forms. The colours projected by Fuller and later painted onto the celluloid of early films take flight, escaping the fabric screen, spinning towards the periphery of the frame. The digital colours in the music video shift from abstract to figurative, from illusion to forms of flight that escape the dress. Lana Del Ray's serpentine image is a digital revision of the transitory, unstable, frangible, fugitive colours of early cinema. The digital version also shows the direct influence of Fuller's performance and aesthetic/scientific investigations. The saturated colours of the music video are composed and then decomposed, a digital iteration of the colour cycle process that was so central to Fuller's performances.

Shades of Cool extends Fuller's experiments with colour and light and the effects associated with the serpentine dances into the digital realm. Here, they are animated by the centrifugal force of the dress as it spins. The illusions of imperfection in silent film are incorporated and reimagined in this digital dance. The vertical lines of early film damage are transformed into the horizontal white lines that appear as tails of comets across the image. Subliminal traces of refracted light disrupt the longer takes, cutting across the image. The sequence in the park replicates the instability and damage of early film where the image becomes destabilized and transitions to the next shot before it dissolves completely. Interruption is a key element of

temporality and, as Barker suggests, a danger to the continuation of viewing. In *Shades of Cool* stillness is introduced as a kind of counter-argument, to identify it existing at the edge of the video, but to reaffirm the power of continuity by dismissing it. The stilted temporal flow of movement provides a counterpoint to the expectation of rhythm and continuity in the music video. Stillness is also implied in the ways that the music video cuts away to other spaces, interrupting the dance. The combination of movement and its disruption is characteristic of the serpentine dance. A flickering light offers another reference to early cinema and to the instability that Fuller found in testing electric light. By incorporating clear references to early film, not least being the precariousness of earlier technologies combined with the desire for the aesthetic of damage, this music video takes up and displays the impact of celluloid time on its digital surface. It acknowledges its proximity to early film and maintains its connection to it in its experimentation with colour and light. This is not merely pastiche or nostalgic recollection, but the presence of early film evident in digital form.

Shades of Cool is illustrative of how the serpentine dance can be identified as an enduring contribution to the range of experiments with colour and light that began on the stage, appeared in early cinema and continues in the form of the music video. The connection between media forms has been noted by a range of contemporary film historians interested in examining the intersections of early and late cinema. Mary Ann Doane writes that 'technologies of mechanical and electronic reproduction, from photography through digital media, appear to move asymptotically toward immateriality, generating images through light and electricity' (2007a: 131). Whilst the material of the digital is thought to be invisible, perhaps its very form is that of light and electricity, the immaterial. Light and electricity returns us to the heritage of early film and theatrical experiments. These are key elements for the pre-cinematic theatrical experiments developed by Fuller in creating spectacular, multimedia performances and then in the early films that revise the serpentine dance. The intersecting histories of all of the serpentine dances indicate the degree of reliance between media forms, much more than a nostalgic quotation or an intertextual allusion. The surface aesthetics of the hand-painted films frozen and transformed by online digital distribution networks, and the digital created as early cinema in *Shades of Cool*, provide new ways to trace the intersecting histories of the dance. *Shades of Cool* reprises Fuller's experiments with ribbons of calcium in the creation of optical illusions of intensifying and decomposing colours.

The Future of Colour

The serpentine dance films are a particular kind of multimedia performance that provide a means of thinking through the history of cinema beyond origins and ends. In exploring cinema as continuum of connected moments, it is possible to see film history beyond finality, unhinged from chronologies as celluloid intersects with digital. Here, I have pointed to some of the ways that the life of the film (and particularly the life of colour) can offer pathways towards intermedial historical networks. I have pointed to the curious and

contingent nature of the practices that comprise the serpentine dance, a genre of performance that began as experiments with the materialities of colour illustrated by the work of Loïe Fuller. When filmed at the turn of the twentieth century, the temporal and material nature of colour was amplified further. An exploration of the serpentine dance films not only reveals the significance of colour within early cinema, but also draws attention to the consequences of historical analysis. Colour has been marginalized as a historical subject. Gunning suggests that this is so because colour is less eternal than form. If colour is transient, then the 'joy' that it offers is in permanent flux. The serpentine dance is a figure of this historiography, movement and effects that are historically contingent but have no limits. The continuity of the dance could be compared to the image that Deleuze describes as, 'inseparable from a before and an after which belong to it, which are not to be confused with the preceding and subsequent images; but in addition it itself tips over into a past and a future of which the present is now only an extreme limit, which is never given' (2014: 38). The Lana Del Ray music video represents a recent example of an 'extreme limit', but it is one that will be succeeded by another impression of the dance. It takes colour and light experimentation towards a form of digital light that splits the light into a visible spectrum as it creates coloured forms that lift off from the dress. The music video also complicates chronological approaches to history that insist on the separation of past, present and future. The image of Lana Del Ray spinning and gliding can be imagined as part of a past history to which the serpentine dance and films belong. It is a present image that holds traces of the past and indications of the future of colour The glowing digital light creates the illusion of colour now. The bird's lines of flight are reminiscent of the glowing, transforming colours that were developed in Fuller's lab, and those fugitive aniline hues that were painted onto early film.

Section II

Luminescence, Montage and Frame Ratios

Chapter 4

Memory and Noir: Neon Contrasts

But instead of a constituted memory, as a function of the past which reports a story, we witness the birth of memory, as function of the future which retains what happens in order to make it the object to come of the other memory […] it is in the present that we make a memory, in order to make use of it in the future when the present will be past.

(Gilles Deleuze 2014: 53)

The 'neon noir' film *Blade Runner: 2049* (Villeneuve 2017) recasts the memory of film noir in the future. Memory in the film, and of its predecessor *Blade Runner* (Scott 1982), is often obscured and occasionally, deliberately presented inaccurately. In Villeneuve's film, memory is an avowed artificial construction. Memory is constructed artificially by Dr Ana Stelline (Carla Juri) 'the memory maker' who reveals that in this post-apocalyptic neon noir universe, 'it is illegal to use real memories'. She is kept behind glass in a fluorescent lit, quarantined white space, at a distance from the neon chaos of K's world. Viewing K's (Ryan Gosling) memory via an updated kinetoscope, Ana tells him that 'they all think it's about more detail, but that's not how memory works. We recall with our feelings. Anything real should be a mess'. Ana's experience of memory, and of this world, is characterized by dissociation. However, later in the film memory of detail of colour signals the demise of Rachel (Sean Young). Rachel's digital double approaches Rick Deckard (Harrison Ford) with dialogue echoing, '[d]id you miss me? Don't you love me?'. She touches him, to make a physical connection, or to make sure that he is real. Deckard inspects her closely, and as the lighting on his face dims he utters the fateful line, '[h]er eyes were green'. This is the signal for her demise, and she is immediately shot in the head. Rachel's status as human or replicant was a question that sustained the narrative of the 1982 version; however, in the more recent revision, her presence is fleeting. The image of Rachel was borrowed from Sean Young's earlier appearance in *Blade Runner* and superimposed into the 2017 film. Here, she exists as a digital hologram of a femme fatale who comes to realize that she is a replicant with implanted memories. Rachel's persona also comprises the characteristics of a classical femme fatale. Hyper-stylized with a hairstyle that resists gravity, dressed in a suit that is cut to emphasize line and angle, Rachel carries with her the traits of the classic femme fatale. As a digital double femme fatale, Rachel's image is a key signifier of digital cinema's reliance on the celluloid film history.

The history of noir from classical to digital post-noir is a relationship that is itself based on remembering, a type of remembering that is both facilitated and complicated by its technologies. Technologies maintain the continuity of the noir aesthetic and build it anew.

Memory is evident in the visual style of noir, in the appearance of high contrast aesthetics, chiaroscuro, expressive shadows and low key lighting. However, memory is both subjective and fallible and as such, post-noir both replicates and forgets particular elements of the classical aesthetic. Whilst colour was used occasionally in noir of the 1940s, it now escalates in prominence and takes on an expressive role. Neon and fluorescent lighting render surfaces hard and artificial. These colours defamiliarize noir worlds producing preternatural memory-scapes. The use of colour with black-and-white, gaseous neon with electric lighting contributes to the revision of noir and reveals the further dispersal of noir across media forms in a post-medium culture.

Memory has particular significance for noir narrative form, its characters and spaces. It is a critical part of the process of detection itself in the details that are used in processes of detection. It persists in the convoluted temporal folds of the noir narrative as the present relies on details of the past. It appears in the gaps created by the bare bones of the plot and its insistence on 'just the facts'. Long- and short-term memories are often in conflict in noir narrative form. Memory weaves a complex shape around identities as characters seem to perform noir in their gestures, in the rapid pace of their dialogue, in costume, in their look and in what they look for. Characters often have obfuscated histories, shady pasts. They can't rely on their home to house memories because noir homes are more like hotel rooms, impermanent alien zones. Dana Polan notes the experimental films of the 1940s that offer images of home as sites of the fragmentation and loss of self, and a similar dissociation is evident in noir (1986: 10). Characters display their difficulty with short-term memory by remembering their predecessors, but sometimes conventionally forgetting the details of their own back stories. Noir narration relies on a type of memory expressed as flashbacks directed by voice-over narration. Mirroring the fluidity of memory, noir narratives refuse linearity, delaying the revelation of cause, whilst emphasizing the sensation of effect, until the resolution.

When memory appears within the world of noir, it shatters an insistence on chronological time. In place of linear continuity, it provides a constellation of recollections, snappy dialogue, reflective moments and gestures. This destabilization of temporality within the films provides a model for perceiving noir history as a series of diachronic nostalgic connections. An indication of this complexity is evident in the fragmented periodizing of noir into movements identified by prefixes like pre, classical, neo, postmodern, digital and post-noir. Each instance of post-noir becomes a recollection of earlier iterations and a proposition of the next. As with most uses of the prefix 'post', post-noir contains the spirit of its origins simultaneous with its hyperconscious revision. In its characteristic collision of past with present, post-noir is as malleable as memory. This chapter is dedicated to an exploration of the ways that both celluloid and digital noir remember noir in variations of its narrative, in the perpetuation of character archetypes, in a recreation of its aesthetic across divergent materialities. Throughout this chapter I investigate the intersection of memory and history, aiming to uncover the complex relationship of synaptic, diachronic pathways that connect pre-noir with post-noir. The focus on memory will be used to look

at a collection of revisionist noir films inclusive of: *Blade Runner, In The Mood For Love* (Kar-wai 2000), *Memento* (Nolan 2000), *Drive* (Refn 2011) and Yang Fudong's *The Fifth Night* (2010). First, however, I examine the ways in which memory is fundamental to the historical classification of film noir.

Film noir is a site of historical flows, interruptions and transgressions. Its lineage can be mapped as moments of present and past memories, direct recall and lapses. Across its fragmented history, noir emerges from within divergent national cinemas and it arises at distinct times. Contemporary noir relies on the memory of its past to revitalize the aesthetic, themes and sensations of noir in the post-noir movement. The origins of contemporary noir are often attributed to a range of diverse cultural and historical movements such as German Expressionist cinema, silent British film and French poetic realism. In historical lineage and within the film text itself, noir films reveal a significant reliance on memory. As a precursor to noir cinema, Fritz Lang's film *M* (1931) relies on the evocation of memory in stillness and silence to highlight the loss of the child. The table setting in the Beckmann house, the empty stairwell, the negative spaces emptied of the spirited sound, song and movement of children's play all signify loss. Tom Gunning labels these empty spaces 'still lives', spaces that are still in contrast to the rhythms of daily routine (2000: 170) Memory takes an important role in the detection of the murderer in *M*. A whistle heard by a blind beggar identifies the murderer when he recalls the sound. The indexical chalk mark surreptitiously placed on the back of Hans Beckert's jacket offers a visual sign of the murderer. The M signifies a link to past violence as well as potential future threat. Film noir borrows the dark aesthetic, negative spaces, high contrast, chiaroscuro and pervasive undercurrent of violence evident in German Expressionist cinema to highlight the instability of its own universe. Memory of previous film styles impacts the form, content and historical context of noir cinema. Even in developing future visions, noir is characteristically retrospective. This chapter looks at how memory connects noir films across the spectrum from pre- to post-noir films. It also isolates the vicissitudes of subjective memory for noir characters and investigates how memory complicates linear narrative form. With each iteration, the film analysis isolates lighting design and technologies of light to identify the materiality of light as a consistently transforming element of the noir aesthetic. Lighting is the key characteristic that identifies noir films across the history of film. With each iteration, noir films create a display of light that acts as a memory of noir. Taken more broadly as an approach to historical mapping, memory allows for a consideration of the influences and various iterations of noir, its presence and absence across time in a Deleuzian rhizomatic network rather than as an evolutionary teleology. Memory influences the very definition and classification of film noir.

The history of film noir is dynamic and complex. Noir has been classified as a genre, visual style, historical movement, phase, collection, family tree, mood, tone and/or inflection. Its transformations have been cleaved and classified according to descriptive prefixes such as classical noir, Gothic noir, neo-noir, postmodern, post-noir and now digital noir. Film noir was classified retrospectively from a collection of Hollywood films that flooded French screens when the post-Second World War embargo was lifted in the 1950s. At the height of

its production, noir films were not named as such, instead they were called 'male melodrama', 'crime films', 'police procedurals' or 'detective films'. French film theorists Raymond Borde and Étienne Chaumeton identified film noir retrospectively. Borde and Chaumeton recognize the continual aesthetic darkness and expression of anxiety in the American films that were produced during and post-Second World War. According to Borde and Chaumeton, these black films 'shared a strange and violent tone, [were] tinged with a unique kind of eroticism' (1996: 17). Noir filmmakers prefer nocturnal settings and night for night shooting to ensure that the blacks are jet black, uncompromised by daylight. In these nocturnal worlds drinking and gambling are commonplace, foregrounded is the obsession with crime and criminals. The noir universe is one of extremes. Frank Krutnik writes, '[i]t is precisely through the triggering of sensations that film noir speaks most elegantly' (1994: 98). It might be dark and wet on those back streets, but it is also hot and steamy. Paul Schrader writes that noir films show a passion for the past and present, and a fear of the future (1972: 11). These hazy, impressionistic memory sites provide the foundation for the expression of the strange and violent tone and unique kind of eroticism that Borde and Chaumeton highlight at the core of the noir universe. Film noir names a constellation of films emerging from multiple decades, from dramatically different cultures and industries, a memory of cinema built from distinctive lighting design and narrative form.

Old and New Perspectives on the Historicization of Noir

Whilst the dominant approach to historicizing the cinema generally relies on the production of an evolutionary taxonomic timeline highlighting its development, transformation, demise and revitalization, film noir exposes the limitations of such rigid linear mapping. The history of film noir comprises multiple points of origin and influences. These can be imagined as parallel 'lines of force' that connect and intersect at various moments across time and space. Understanding noir through a history of diachronic intersections provides a way of understanding its cyclic appearance, decline and resurgence in various intermedial forms. Beginning with the retrospective naming of noir, this diverse collection of films has been identified according to histories imagined in various ways. This history of noir is described in terms of phases, movements, family trees, ephemeral moods or tones and transgeneric inflections. Raymond Durgnat highlights the aesthetic darkness of noir, suggesting that in these films 'black is as ubiquitous as shadow' (1996: 37). In a medium that relies on light to transmit images, such distinctive darkness seems to run counter to the elements of cinematic illusion. That blackness that Durgnat describes is shaped by light. Additionally, Durgnat classifies noir films by mood and tone, the interbreeding of dominant cycles and motifs (1996: 39). Whilst Durgnat identifies noir predecessors in Italian, French and English film, his approach is to develop schematizations of some 'main lines of force' (1996: 39). These lines of force include 'Crime as Social Criticism' that he describes as 'prohibition-type gangsterism, devoid of social criticism' and identifies themes of corrupt

penology, miscarriages of justice, prison exposes, along with juvenile delinquency and boxing narratives (Durgnat 1996: 41). Other lines include: gangsters, characters on the run, private eyes and adventurers, middle class murder, portraits and doubles, sexual pathology, psychopaths, hostages to fortune, blacks and reds along with Guignol horror and fantasy (Durgnat 1996: 41–51). Durgnat maps these lines of force within a 'family tree' format. Here, the notion of influence, rather than evolution is suggested, a genealogy of noir through thematic lines and their intersections. Durgnat's mapping provides the foundation for approaches that do not limit noir to a fixed generic classification.

Paul Schrader also identifies darkness as characteristic of noir. He sees noir films coalescing by tone, style and colour (Schrader 1972: 9). He writes that, '[r]ather than haggle definitions, I would rather attempt to reduce *film noir* to its primary colors (all shades of black), those cultural and stylistic elements to which any definition must return' (Schrader 1972: 9, original emphasis). Later, Schrader argues for noir to be understood in three broad phases beginning with *The Maltese Falcon* (1942) and ending with *Touch of Evil* (1958) (1972: 11). This periodizing historiography is flexible enough to include both transformation within movements and elastic, overlapping time frames. Schrader's phases of noir includes Wartime Noir (1941–46) where the emphasis falls on the private eye as the alienated hero, where films are driven by dialogue rather than action, producing highly stylized films shot on studio sets (Schrader 1972: 11). Overlapping and succeeding this is the phase of Post-War Realistic Noir (1945–49) where crime is situated on the city streets, political corruption is highlighted and where heroes become less romantic and more vicious (Schrader 1972: 12). Psychotic action and suicidal impulse (1949–53) is a phase where the protagonist becomes the psychotic killer with the diegesis characterized by despair and disintegration (Schrader 1972: 12). Schrader's historiography prioritizes the aesthetic before cleaving the films into historical phases. His work highlights the fluidity of noir time frames, periods defined by the eruption of specific tones, moods, language, spaces, crime, justice, violence and corruption.

In 1994, R. Barton Palmer acknowledged that the origin of the 'dark film' produced by Hollywood studios is evident 'in critical, rather than industrial practice' (6). As he suggests, 'if anything, it was a grouping of disparate films made according to intellectual taste and preferences, originally French' (1994: 6). Featuring cities tainted by amoral, alienated criminality, these films depicted the bleak underside of the American dream (6). Palmer posited the notion of noir not as an exclusive, individual genre, but as a 'transgeneric phenomenon', existing across a range of associated and divergent genres (1994: 32–52). This broader encapsulation of noir notes its tendency to elude strict generic classification and it includes the potential for noir characteristics to spill over into diverse forms of media. Elisabeth Cowie expands this definition of generic slipperiness to suggest that noir is better understood as an 'inflection' (1994: 129). Cowie's definition understands noir as intermedial, trans-historical, perhaps also transcultural. It is trans-historical in a way that it creates lateral connections across media, and includes the resurgence of neo-noir in the 1970s and 1980s. It creates a genealogy that refuses to align itself exclusively with the identifiable stereotypes or language, or black-and-white cinematography of its earlier

history. Certainly noir is best seen as an inflection, one that relies on the sensations that are felt across genres, including generic hybrids, narrative and intermedial forms. As an inflection, noir can be seen to manifest most strikingly as patterns of light and dark, high contrast and expressive lighting, an aesthetic inflection that appears across history and in various forms of media. Understanding noir as both transgeneric and as an intermedial inflection defined by lighting, mood, tone or overlapping moments introduces a system of classification that has the subjective fluidity of memory, rather than the objective and taxonomic view of historical evolution. However, the formality ascribed to history and the fluidity that characterizes memory may well suggest that these terms clash.

Sites of Memory

The French historian Pierre Nora suggests that history and memory exist in violent opposition (1998: 8). Nora's position is that history is static, an incomplete attempt to reconstruct a past that no longer exists, whilst memory is fluid, in a constant process of rediscovery and is something that 'remains in permanent evolution' (1998: 8). Nora argues that history works to undermine memory, that it is perpetually suspicious of memory, its true mission is to suppress and destroy memory (1998: 9). Crucial to Nora's argument is the notion that 'real' or 'traditional' memory is threatened by processes of historicization. For Nora, 'lieux de memoire' become sites that protect histories, which block the possibility of forgetting and act to 'remember for us' (1998: 19). Lieux de memoire are sites where (as Nora suggests), 'memory crystallizes and secretes itself' (1998: 7). These sites are constructed in an effort to 'protect' memory from dispersal in forgetting. These sites can be actual, tangible forms like archives, exhibitions, personal shrines, collections of photographs, objects, tickets, diary entries, notes, remnants, or they can be less tangible memories of events. Film noir can be imagined as a site of memory for the cinema. Film noir produces impressions of the past in the present (and future) image. Revised, re-made for large and small screens, reimagined in pixels rather than relying on photochemical registration, contemporary digital noir exists as a spectral affect of classical noir. Contemporary noir creates sites of memory by revising and reusing remnants of classical noir. These ephemeral sites of memory exploit chiaroscuro lighting styles, high contrast compositions and the aesthetic effects of noir. Its various iterations are evident in revisions, changing technologies, and in its expansion across media forms. Film noir is a continually transforming site of cinematic memory.

Fredric Jameson argues that history is transformed visually into mirages, stereotypes or text (1984: 46). His exploration of the postmodern aesthetic suggests that the cultural dominant is distinguished by the random cannibalization of styles of the past, a play of stylistic allusion. He argues that intertextuality is a deliberate, built-in feature of the aesthetic effect in which the history of aesthetic styles displaces 'real' history with a new connotation of 'pastness' (Jameson 1984: 20). Jameson's approach, 'endows present reality and the openness

of present history with the spell and distance of a glossy mirage' (Jameson 1984: 21). This new aesthetic mode emerged from the waning of historicity and demonstrates the inability to fashion representations of current experience. History fills the present. The dual focus of postmodern culture attempts to 'lay siege to our own present and immediate past, or to a more distant history that escapes individual existential memory' (Jameson 1984: 19). In this context, the nostalgia film frames and provides ways of understanding history. Jameson's reference point is neo-noir and he offers astute observations about how films like *Chinatown* (Polanski 1974) draw from the past by revising the aesthetic, characteristics and themes of noir. Jameson cites neo-noir as a reworking of classical noir conventions, linking 'distant histories', even if they are remembered visual or narrative histories. These distant histories extend the matrix of rhizomatic pathways across celluloid and digital materials, where the 'glossy mirage' is an affect of the past. Noir histories have always been connected by cycles of repetition and variation. This tendency to remember the past and to reimagine it as a future vision of the present is evident in some hybrid forms of noir narrative, particularly in the design of the post-noir diegesis. Such a clash of tenses is evident in the sci-fi noir hybrid, one that is situated in the past as well as the future.

Remembering the Future

An adaptation of Philip K. Dick's novel *Do Androids Dream of Electric Sheep* (1968), *Blade Runner* is a science-fiction/noir hybrid that remembers and revises the aesthetic, characteristics, themes and 'distant histories' of classical noir but introduces it to the settings, locations and visions of the future. *Blade Runner* is a film that uses fluorescent and neon lighting to add colour to classical noir's interest in contrast. It is a film that reimagines the potential of photographic technologies to find details that would otherwise remain barely visible, and that questions the connections between memory and history, photography and the index. In *Blade Runner* film noir is reimagined as a range of highly stylized intertextual signifiers. The detective is distanced and disenfranchised, something that is emphasized by Harrison Ford's monotonous internal monologue that begins and ends the director's cut. The extreme noir lighting design, exemplified by darkness punctuated by harsh shafts of light and strikingly artificial neon hues, takes the noir aesthetic to the extreme in these artificial spaces. Amalgamating noir with sci-fi produces a collision of perspectives and diverse temporalities that coalesce a future vision within a nostalgic revisionism. *Blade Runner* produces a futuristic dystopia by modifying recollections of a past cityscape. One of the most distinctive features of this neo-noir is its imagined, futuristic, dystopian cityscape that looks backwards and forwards simultaneously.

 Blade Runner was one of the watershed transgeneric sci-fi-noir films that re-made noir for the future, literally. Within the film itself the 'Off World' presents a future characterized by an aesthetic of harsh edges and lurid neon colours set against a seemingly perpetual darkness of radiating neon yellow lights that are particularly noticeable as they illuminate

Harrison Ford's face while he eats outside. The darkness characteristic of classical noir exterior illumination is replaced by the artificial yellow lighting of this post-apocalyptic world. *Blade Runner* makes noir lighting artificial and animated. Mobile illumination animates both exterior and interior spaces. The neon that slips between the slits in the venetian blinds, creating an unnerving, restless presence inside Deckard's apartment, heightening the presence of surveillance characteristic of noir. This is a noir universe of vertical cities where perpetual advertising denotes a culture dominated by commodity trade. However, this imagined city is also marked by fluid boundaries particularly evident as intersections of global cultures. The sounds of the 'Off World' feature a convergence of multiple languages and cultures, a fantasy of a globalized blur. *Blade Runner*'s spaces appear in opposition to Edward Dimendberg's conception of classical noir's map of centrifugal or centripetal space, producing instead a contrast between the horizontal maze and vertically inclined space with skyscrapers, towering buildings and advertising billboards in the sky (2004). The sky is a site of fluid mobility, contrasting with the difficulty of movement and the cacophony of sounds at ground level. In *Blade Runner* the 'Off World' attracts our peripheral vision, extending vision beyond the Renaissance principles that foreground centrality and depth. It also attracts attention to this world built of illusions and simulations.

Blade Runner's simulated world presents a postmodern globalized culture marked by the increasing difficulty of discerning truth and reality, the physical world from the virtual world. A vision of Jean Baudrillard's hyperreality, *Blade Runner*'s diegesis is composed of media, screens, cyberspace, spectacle and simulation (1994). Disembodied voices, floating billboard screens and neon lights mediate, filter and shape the world of the film. This apprehension of the hyperreal world pivots on the belief that the real no longer exists, that it has been replaced by mass communications, mass media images and the proliferation of signs, a world containing only simulacra. The rapid flow of information through various communication technologies provides experiences more intense and involving than actual, lived experiences. Within such a society of simulation, identities are constructed by the appropriation of images, shaping subjectivity and perhaps limiting the scope of intersubjectivity. Baudrillard's revision of Ferdinand Saussure's theory of signification where the signifier, the image, symbol, icon precedes the signified dominates the experience of hyperreality in the Off World. *Blade Runner* creates a simulacra cityscape with consistent references to reflective surfaces, particularly its use of television and film screens. The emergence of imagery or signs precedes and often replaces actual objects. This is exploited further in *Blade Runner 2049* as impressions of femininity are reduced to holograms that can be turned off and on using a remote control. Joi is introduced to the film as an illusion of a stereotypical 1950s housewife, one who worries about the length of time the meat has been marinating. Joi is also an unstable, glitchy presence. She is joined by giant holograms of naked women with pink hair advertising sex and a desert of remnants of hypersexualized statues, symbols of a 'unique type of eroticism' coded on one hand as omnipresent and on the other as defunct. Even Rachel is an imperfect simulation. She strides into the new film, just as she did in the original, but as Deckard points out, her eye colour is inaccurate, denoting

the imprecision of the copy. In each instance, the re-make constructs noir femininity as a conjured illusion.

In the original film, *Blade Runner* presents a paranoid, panoptic view of the city via the electric eye of his own version of 'new' media that Deckard relies on for detailed information and surveillance. Deckard combines the spoken with the ocular in his investigation of the image. He inserts a hard copy photograph into his Esper machine and asks it to 'enhance', which it does accompanied by the clicking sound of an analogue shutter or the slide carousel. Inside the Esper machine, the image is overlaid with a vertical and horizontal grid, similar to the picture of landscape produced by a theodolite. Deckard sits on his sofa, blending into the darkness of the upholstery and of his apartment generally. It is difficult to discern his presence amid the darkness and thick air. He is lit from behind by a combination of roaming searchlights and the red, backwards neon text outside, offering an uneasy sense of surveillance. A similar investigation takes place inside as Deckard looks into the image. The exterior searchlights are mirrored by the artificial light projections emanating from Deckard's screen. Still, it is not quite bright enough to light the apartment, just enough illumination to emphasize the darkness of the world. At Deckard's command the machine shifts across the image and zooms in on details. Highlighted is the flesh of an arm, a hand, the glass surface of an inkwell, an etched glass and then, finally, a mirror. The Esper machine appears to be an imagined hybrid of prescient image development, one that combines the rounded edges of a cathode ray television screen with the labyrinthine pathways and projected light of a film projector. All of these visual technologies combine with a video or DVD box that prints out a polaroid image. This mesh of futuristic technologies transforms two dimensions into three, hardcopy paper into light projections. It also allows Deckard to see around a corner, to zoom in and find an image of Zhora reflected in a mirror, a spectral image that is beyond the capacity of the eye and the representational possibilities of the photographic image. This clue would have been glossed over, forgotten without the optical enhancement provided by the Esper machine.

The Esper machine has the potential for exploration beyond the limitations of the image captured, expanding the possibilities of the photograph. It helps in the process of detection and also reveals a clue, something that is discovered as a reflection, barely noticeable in the original image. Here, the truth is found behind the image. Roland Barthes refers to the photographic equivalent of a similar affective photographic detail when he introduces the 'punctum' and the 'studium' (1981: 27–60). Whilst the studium refers generally to codes within a culture, providing a context for the image, the impact of the punctum lies in the captivating detail, one that overwhelms its context. Although the detail within the composition might be minor and not its central focus, the effect is subjective and expansive. It refers beyond itself to something more resonant and evocative of lived memories. Barthes describes the affect of the punctum as akin to a sting, an impact that he feels with a visceral physical intensity (1981: 27). He recognizes this in the photographic detail of his mother's watch, a symbol of connection to his maternal lineage and simultaneously a powerful impression of a history that existed during and beyond his lived experience. For Barthes,

memory reinforces the connection to his matrilineal history. Whilst Barthes' punctum was a powerful expression of the collision of absence and recognition, Deckard's technological excavation of the photograph is revealing of an image that evades his view. In *Blade Runner* the punctum only becomes accessible with the use of new optical technologies. The detail that is revealed is one that retrospectively calls into question his own status as human or replicant, lived or prosthetic memories.

If identities are defined by memory, this neon noir film focuses on a lack of memory and replaces this with an injection of synthetic memories to blur distinctions between the replicant and the human. Although they appear in human form, replicants have no memories, only those implanted memories from another human. There is little or no physical evidence to distinguish the human from the replicant; self and other are barely perceptible. The complexities involved in identifying humans from replicants are highlighted in the interrogation of Rachel's memory. Hoping to provide proof that she is human, Rachel offers Deckard a photo and says '[l]ook, it's me with my mother'. In this filmed photograph, it is the image that attempts to provide evidence of history through genealogy. Positioning the photograph as visible, material, indexical proof of heritage is supported by a linguistic pattern that clarifies and then occludes the investigation. Deckard tests her memory by beginning a story about watching a spider egg hatch and Rachel completes the narrative when she says, 'and a hundred baby spiders came out. And they ate her'. However, whilst it is offered as indexical proof of existence, it is Deckard's interrogation that reveals that Rachel's reminiscences as implants, memories belonging to Tyrell's niece. In this instance, memories, usually the qualifier of subjective identity, are fluid enough to be able to be transferred between characters. The photograph that usually acts as indexical proof of existence now points to the potential for the false image index. Rachel's photograph indexically points towards a past that was not her own. In *Blade Runner* characters are not just doubled, but schizophrenically connected as fake backstories are transferred by implanted memories. This film interrogates synthetic, prosthetic memories ultimately identifying them as signifiers of false histories.

In *Blade Runner*, memories don't need to be experienced directly to be felt acutely. In a broader media culture, memories don't need to derive from lived experience and they don't even need to be 'ours' in order to be felt. As ephemeral phenomena, memories blur actual and virtual experience. Memories are framed by the present. The phrase 'prosthetic memory' was coined by Alison Landsberg to define the link to those histories that do not originate from a subject's direct and lived experiences. Instead, prosthetic memories are derived from media engagement that includes televisual and cinematic imagery (2004). Prosthetic memories are direct and indirect. They are direct in their audio-visual presentation as images, and indirect in that they always refer to another spatio-temporal realm. Landsberg defines prosthetic memories as: 'memories that circulate publicly, that are not organically based, but that are nonetheless experienced with one's own body – by means of a wide range of cultural technologies' (2004: 25–26). Prosthetic memories are both collective because they are available to, and may have resonance for, more than a single person. They are also

90

individual, in that they become part of a specific range of experiences, virtual and real, 'part of one's personal archive of experience' (Landsberg 2004: 26). Prosthetic memory manifests in those memories articulated by Rachel, memories that distinguish replicant from human. We can expand this out to consider a similar framework of retrospective connections between forms of noir cinema. Producing an identification based on recognition and embodiment, prosthetic memory provides a mode for imagining connections between neon and classical noir. Both *Blade Runner*s carry stylistic indices that point back to the foundations of classical noir. We see this on their surfaces and in the depth and complexities of their storylines.

Meta Memory: *Memento*

Almost fifty years after classical noir was identified, writer/director Christopher Nolan's *Memento* was released. This is a key neo-noir film that represents a displaced, fragmented, memory of classic film noir in the complex form of its narrative, in characterization and in the duality of its black-and-white and colour aesthetic. *Memento* also contains marks of some of the significant changes that are characteristic of the history of noir. This is a film that intervenes in a chronological mapping of film history by identifying its influence in both the classical phase and in 1970s neo-noir. *Memento* complicates the presentation of memory in film, in how images not only support memories but also produce distorted memories, how film also functions as memory and how it presents memory as subjective truth. *Memento* complicates the ability of celluloid to register the index. Here, the sign is elusive. It points to elusive memories, revealing the slippage between the sign and the object that it points to. Indexicality is deceptive in neo-noir. *Memento* is a film about memory loss. It is filmed on celluloid, the medium that is thought to have the potential to inscribe the index and imprint details within the photochemical surface of the film. This material base is also used to support experimentation with instantaneous photographic technologies. This is evident in the regular use of the Polariod camera, taking 'instamatic' images that develop within seconds, fixing memory. It is precisely this method of inscription that is under investigation from all angles in this film.

Memory falls into the invisible spaces of *Memento*. It is invisible, but influential, elusive, but permanent. Memory is literally 'lost' by Leonard whose condition is described as 'anterograde memory loss'. For Leonard, short-term memory is inaccessible, at best fleeting. However, longer term, comforting and traumatic memories remain accessible. This casts a shadow of unreliability onto all of Leonard's decisions and actions. In a revision of the singular focus of the classic hard-boiled detective, Leonard sees memories in contrast to facts or histories. His memories are distorted; they 'can change the shape of a room, can change the color of a car'. With such dialogue he is noting the vulnerability of memory, specifically how time alters the recollection of colour, shape, perhaps also scale. Rooms distort in dimension, colours might be more or less vivid, or they can change entirely. Leonard says that 'everything fades', particularly his short-term memories. His last memory is of his wife

up until the moment of her murder. Leonard has little sense of time. He is not sure how long his wife has been gone for; he sometimes feels that she might somehow return, a delusion that is a common response to loss. Nolan depicts the dissolution of Leonard's memory not only in the continual circularity of Leonard's repeated words, but also in gesture. Leonard repeatedly pulls a door that he needs to push, an indication of his inability to retain the detail of small rituals that structure everyday life. Nolan also has Leonard address familiar people, like the receptionist of hotel that he lives in, in the same formal way that he does each time as if it's the first. At other times, his memory is evoked via touch. We see it in the gesture of Leonard feeling the warmth, signifying the recent presence of Natalie's body in the bed. This gesture recalls how he also reached to touch the space that would have been occupied by his wife. As a post-noir detective Leonard has a distant past, but struggles to recall the details of his present.

Without a short-term memory, Leonard is forced to create and document clues in innovative ways. One of the strategies that he relies on to help remember is to photograph details using an instamatic camera. The photograph offers an (almost) instant reflection of his reality. When it was developed in 1948, the Land Camera was revolutionary in allowing direct access to photographs. In terms of temporality, the instamatic was not actually instant; it took a minute or so until the photographic image came into focus on the surface. This time frame is compressed even further in *Memento*. The Polaroid is the perfect memory substitute for Leonard. *Memento* uses photography to register and to recover traces of presence. Leonard's immediate history is pieced together using both instamatic photographs and still images. Not only can the camera capture an indexical reflection of the moment, something that will be elusive for Leonard, but the images are virtually indestructible. The instamatic camera would seem to offer an immediate indexical reflection of a current situation for Leonard. The photographs provide fragmented indexical signs to referents that he can use to solve the puzzle of his wife's death, to replace his memory loss. Leonard's instamatic photographs resemble the least visible and most basic unit of the cinema, the still, single frame. *Memento* highlights the invisibility of these single frames of 35mm Panavision film stock transitioning at 24 frames per second. However, the combination of instant images and celluloid film that is alternately colour and black-and-white, unfolding both forwards and backwards, does not result in a narrative that shows a distinct lack of faith in indexicality and truth. Whilst the photographic image might indicate 'truth' or reality, the opening images of *Memento* offer a disarming and elusive impression of the instamatic image in reverse. *Memento*'s credit sequence begins in reverse. Traces of detail captured by the instamatic camera are erased as the film begins. The narrative is established with the erasure of clues. This is a post-noir film in which narrative progression is retrospective. It mirrors the mosaic, circuitous structure of memory and complicates celluloid film's reliance on its own indexical base in photography to fix memories.

The narrative of *Memento* also attempts to stabilize memory with the use of text. This type of text is permanently marked in the writing that appears across Leonard's body. For Leonard, tattoos are 'useful'. Clues to the crime become inscribed onto his body. However,

here the tattoo is a marker with a twist. The tattoo around Leonard's chest that provides a clue to his wife's murder is written backwards. He needs to remember that it is there, create some distance and reverse the image before he can see the words and clues to the crime. The tattoo becomes one of many fragmented, complex, reversed indexical inscriptions that attempt to reclaim lost memories. Leonard creates memories from photographs, tattoos, maps, official documents, car registration papers, stories from those surrounding him (Teddy, Natalie), from notes on scraps of paper, drink coasters and post it notes, via talk and through re-enactment. Leonard's collection is a personal *lieux de memoire*. However, not all of these inscriptions help to replace his memory loss. With his specific type of amnesia, Leonard is stuck in a cycle of repetition without retention. His voice-over narration, which at times is spoken to someone on the other end of the telephone, helps to provide fragments of information from his perspective, but is unreliable. Leonard's internal focalization problematizes remembered events. He is not sure if his gesture of pinching his wife's thigh was just that, or if he was helping her by injecting insulin. He tries to retain memory by buying and directing a performance of a recollection. Leonard hires an escort to read his wife's book, to pose and perform in a way that helps him to remember, all to little effect. His lost memory complicates the deictic language that supports the index. The multiple indexical fragments point in many directions. *Memento* continues to highlight the false referent that the indices point towards. However, the solution is shown throughout the film. Leonard literally points to the solution, repeatedly gesturing to his chest throughout the film. What he is pointing to is not revealed until the final frames of the film. It is only at the resolution of *Memento* that indexical gesture reveals Leonard as the culprit.

Memento operates as a meta text for noir. Classical and neo-noir cinematography, colour and black-and-white, style and narrative inheritance supports Leonard's dissociation. Christopher Nolan is a filmmaker who insists on using celluloid at a time when digital is more accessible and affordable. He relies on black-and-white celluloid to heighten the connection to memory, allowing the materiality of the film to 'remember' tropes of classical noir. He understands that celluloid is the material best placed to be able to remember, to re-animate the past. Post-noir filmmakers like Nolan use celluloid to acknowledge the complexities inherent in film history.

Intersecting Cultural Histories: *In The Mood For Love*

In the Mood for Love explores memory as a way to reconnect to histories that are lost, or unspoken. Images, sounds and particularly the silences of this film weave Wong Kar-wai's personal memories with official, collective histories. *In the Mood for Love* is a film that was in production twelve years prior to the handover of Hong Kong to China and it was released three years beyond this pivotal moment. This is a film that remembers the effect of historical dislocation and expresses it wordlessly, in gesture, look, aesthetics and in the arrangement of its neon noir spaces. Built from a matrix of lived histories, memories of dislocation are

displayed in the rituals of everyday life. Dislocation is also hinted at via the luscious lighting design and highlighted in the intertitles that structure the temporal dis-order of the narrative. In the structure of its narrative, in its dazzling aesthetic and in its reliance on obfuscated communication, *In the Mood for Love* explores the anticipation of change and the potential impact of transition. At the centre of this film is a complex investigation of time, transition and an apprehensive movement towards the unknown. It is a film that repeats moments of dissociation, expressing histories that unfold from the peripheral position of its characters, each existing at the edge of exile.

The pivotal meeting between Mr Chow and Mrs Chan is not a chance encounter, rather something that seems to be predestined. The 'too late' is key to the temporality depicted in this film. Often, Mr Chow is just behind Mrs Chan, trying to secure a space in which to live, buying some noodles, passing one another on the staircases. The numerous shots of waiting, gazing out windows, highlight this sense of anticipation. However, this film features a reversal of the traditions usually ascribed to gender. Mr Chow waits by the phone, he is the one who returns to retrieve his umbrella, he gets wet in the rain whilst Mrs Chan seems immune to the torrential downpour. A montage of rapid paced editing highlights the hesitation, reticence and desire for change as Mrs Chan enters Mr Chow's hotel, moving in a range of directions, including up to the rooftop. Her furtive movement is emphasized by her breathless anxiety, an expression of her indecision about whether to go ahead with this affair. Dissociation is depicted in the difficulty of movement through spaces as characters edge their way along narrow corridors, escape into and out of rooms, up and down stairways, often into subterranean spaces, sometimes in slow motion. The repetition of furtive, difficult movement reflects anxieties of dislocation.

The design of intersecting spaces of *In the Mood for Love* is based on labyrinthine interiors that collapse boundaries separating public and private. This is particularly apparent in the constricted spaces of the apartment where it is sometimes difficult to discern the Chan apartment from the Chow apartment. Both characters inspect the apartment on the same day, they move in on the same day and their possessions are confused. Both are new to the building, new to the exiled community. Mrs Chan's movements are closely scrutinized. She is questioned, tracked, watched and her movements are noted. Mrs Chan and Mr Chow talk about how 'one can't put a foot wrong' in this environment. Their neighbour, Mrs Suen, comments that Mrs Chan has been out a lot lately, offering advice on the correct behaviour for a married woman. Named in relation to her invisible husband, Mrs Chan is constantly invited to eat with the neighbours, but mostly she refuses. She is seen to be 'too polite', but she is maintaining her distance, resisting becoming part of the ritualistic life of that community in exile. The rituals of the community are ultra-present in this space. Specific foods, seasonal vegetables and games appear as implicit connections to the past. These are performative attempts to reinstate memories of a previous time and space for the exiled Shanghainese culture. Mrs Chan is disinclined to share these memories. Distancing herself from the community, and choosing not to behave according to custom and gender expectation, Mrs Chan is doubly exiled.

In the Mood for Love offers Mrs Chan and Mr Chow a new community of unspoken, possible illicit relationships that include a possible affair between their respective spouses and the relationship between Mr Ho and his mistress. Secrets and memories are key to the neon noir narratives created by Wong Kar-wai. The spaces of the apartment are incredibly close and a sense of claustrophobia is emphasized by a mobile camera that glides past walls that divide rooms. Vertical lines dominate the apartment and divide the spaces. These are evident in the doorframes, in the patterns on walls, in the walls that border spaces and in a tendency to frame characters as they stand in the corridor looking into a room. Often there is no establishing shot, only a brief indication of the labyrinthine space via its corridors. Characters are pushed out to the extreme edges of shots, disrupting an omniscient view by framing the composition to dissociate the spectator. Such fracturing results in a fragmented view, one that is not afforded a broad perspective. Some neighbours are visually excluded from the frame, but included in the soundscape. Their presence is signified by sound. Space is confused with the use of mirrors that distend and extend the illusion of space, emphasizing the possibility of seeing, but the difficulty of clarity and perspective.

In The Mood For Love develops a counterpoint between proximity and distance to create a strong sense of longing. The spatial cacophony and the impossibility of direct communication result in silences that resonate with unfulfilled desire. Longing impacts on temporality, extending it so that it becomes time felt by characters. It is with a hint of regret that Mrs Chan talks about the complexity of marriage generally, the inherent difficulties in the change from being single to being part of a marriage. This seemingly personal, introspective perception becomes a rhetorical statement, spoken into the ether, as is characteristic of the communication in this film. Mrs Chan and Mr Chow's relationship is one of expressive silences, averted gazes and a heightened physicality of the slightest gesture, the back of the hand skimming clothing, gentle hand holding in the back of a taxi. In the film, sexuality is repressed in deference to marriages that are flawed. Desire is expressed in separation, in waiting on the other end of the telephone and ultimately, later, in the memory of one another that extends the narrative more than ten years into the future.

The memory of noir is expressed across the *mise-en-scène* of *In The Mood For Love*. It is revised and renewed in costume, props and surfaces. Excessively hot in his formal western suit, Mr Chow retains classical noir costuming against the extreme humidity of Hong Kong. He is identified by the cloud of smoke that fills the frame, smoke that seems to be exuding from the heat of his body. This might be a metonymic displacement of desire, but it certainly is an emblematic sign of film noir. Simultaneously, cosseted in her cheongsam, Mrs Chan is barely able to slip into her slippers. An unexpected transition of time is signified by the repetition and variation of dialogue, schizophrenic cinematography and details like the change in fabric (but not the style of the clothes) as both characters amble home from the diner wearing clothes that differ from the previous scene. This disruptive continuity destabilizes coherent temporality. The introduction of jump cuts extends an impression of time beyond the single evening. The hyperconscious symbols of noir are all in play here: the smoke; the repressed desire; even a neon-inflected chiaroscuro; but *In The Mood For Love*

positions memory as history. This is a noir-nostalgia film where the past is remembered through the richness of its surfaces. The most evocative elements of *In The Mood For Love* are the fabrics, textures and design of the curtains, bedding and clothes. Costume design retains the cut of the cheongsam, but emphasizes the transformation of its prints, colours, the floral prints, the green-and-white diamond grids, the parallel lines, all referencing a 1960s western fashion. Pam Cook notes how the cheongsam is a symbol of dual perspectives in this film. Cook writes, '[t]he cheongsam encapsulates opposing forces of tradition and modernity, revealing a feminity at once sexualized and constricted, and it is no coincidence that it features prominently in popular culture as an emblem of the personal and social dilemmas faced by women' (2005: 10).

The lighting design of *In the Mood For Love* uses harsh fluorescent and neon to sharpen and colour the high contrast of classical noir. The neon inflection uses noir conventions to indicate the artificial. There are no natural lighting sources in the Hong Kong images; rather, the space is illuminated by artificial light. The fluorescent white light that appears in the corridor of the apartment dominates the image so heavily that it forces the downward constriction of the space. It also increases with intensity across the narrative culminating in a shot that begins with the concentrated white light filling the entire frame. We catch a glimpse of the ropey cables that deliver the light in one of the film's 'external' shots, but this is a film where both interiors and exteriors are illuminated by artificial sources. Lamps occupy the foreground and they are sometimes offered more space in the frame than the characters. The lamp with the forest design that appears in numerous shots is an ironic counterpoint to the high-density urban cityscape. An image of trees illuminates the apartment where there is otherwise little evidence of the natural world. The red filters that are used to illuminate the corridors of Mr Chow's hotel saturate the space with the intensity of its colour. The ambiguity of the symbolism associated with red in eastern and western cultures also heightens the uncertainty of this latter sequence. The hyper-stylization of the lighting design recasts the sensations of the noir diegesis as neon affects.

The pace of character movement appears slowed. Stillness becomes evident, so much so that it appears that the film might have stalled. Film theorist Raymond Bellour argues that the freeze frame is the agent that corrupts narrative progression, standing in opposition to the nature of the illusion of cinema when he suggests that, 'the interruption of movement [is] the decisive instant when cinema seems to be fighting against its very principle' (1991: 99). The femme fatale occupies that privileged instant as she is afforded a longer duration of stillness. This stillness destabilizes the insistence on progressive time. Taking the notion of kineticism as crucial to the cinema, perhaps by curtailing movement using an illusion of the freeze frame, films like *In the Mood for Love* produce an anti-cinematic effect, more common to photography. Jameson writes that the postmodern crisis in historicity dictates a return to the question of temporal organization. He argues that the subject has lost its capacity to organize past/future into a coherent experience (Jameson 1984: 25). In the film, temporality is organized according to memory fragments as if the whole narrative is recalled as an achronological series of impressions. The hyperextension of lighting and the use of

stillness within such a dynamic medium create a memory space that references the past and the present simultaneously. The stillness and freeze frame remind us of the 24 frames per second that animate the images and also obliquely reference the temporal distress that surrounds the history of celluloid.

In the Mood for Love is an example of globalized noir as film noir signifiers, forms, aesthetics are borrowed and transplanted to create pastiche neon and rain-filled schematic impressions of noir across remembered cityscapes. These spaces include Hong Kong in the early and late 1960s, Singapore and then Cambodia in 1966. These are spaces created and perceived in nostalgic terms, cities that are re-made using an extreme noir style. This is a film that uses hyper-stylized lighting and design to re-make, remember locations, to offer dreamlike impressions of history as memory. It is also a noir film that signifies the importance of lighting, contrast and shadows that sculpt impressionistic spaces. It is a noir film that foregrounds lights as objects, sometimes ironically, within the *mise-en-scène*. *In the Mood for Love* draws from the foundations of noir and revises it by inserting memories of displacement by introducing stillness and silence, by intensifying movement and tinting this remembered world with artificial fluorescent lighting and neon colours.

Neon Noir: *Drive*

Nicholas Winding Refn's film *Drive* (2011) is a digital post-noir film that positions itself at the edge of the fantasy/reality divide. It recreates noir as a series of noir impressions or sensations. Drawing from the obfuscation of a modernist narration, *Drive* invites viewers to create coherence from the impressionistic performances, sounds and spaces that signify the memory of noir within *Drive*. The ocularcentricism of classical noir declines as digital noir illusions come to the fore. The world created within *Drive* is one that situates the noir universe within uncanny spaces. *Drive*'s world is built using pathways towards unidentified spaces, temporary destinations, barely furnished hotel rooms and sparse apartments that stand in for homes. These transitory spaces construct an impressionistic picture of Los Angeles, a series of tenuously connected spaces that are mired in a deep darkness that is at times punctuated by artificial neon light. The opening sequence is built from a memory of an earlier heist film, Michael Mann's film *Thief* (1981). In the ten-minute opening sequence the driver of *Thief* utters only the single word 'clear' before ferrying criminals through the rain-soaked L.A. streets to an unassuming garage where the getaway car is hidden and swapped for another. Refn uses similar visual sensations to open *Drive*. Here, the driver is completely silent, the getaway drive is narrated by disembodied voices transmitted through the police radio and sports commentary. The voices of the police reveal the unfolding surveillance and help to situate threat for the driver. The radio commentator counts down the seconds before the basketball match is complete and he can drive into the Staples Centre car park, pull on a L.A. Clippers cap and blend with the crowd, escaping undetected. Disembodied supra

diegetic sounds emerge from radios that transmit external voices, a soundtrack that is escalated by the silence of the interior of the car.

Drive also remembers classical noir characters, the alienated detective and the femme fatale, but it intervenes in the stereotype by actively intersecting and blurring the distinction that separates their roles. The character played by Ryan Gosling, a character who is labelled by his area of expertise rather than his name, takes on some of the stereotypical traits of the smouldering, unattainable femme fatale. The distinction between gender roles is diminished by the use of language. Dialogue is quietened with the use of characters who refuse to specify their positions. They are neighbours, but also lovers, criminals, but seemingly innocent. Silences dominate connections between characters. Much more than merely aesthetic revisionism, *Drive* is a film that extends the disconnection characteristic of classical noir. The elevator sequence illustrates some of the cinematic strategies that Refn uses to re-make noir within a digital ecology. Within the confines of the elevator, the pace of movement is slowed. The overt stillness of the three characters within the elevator raises momentary doubts about whether the digital image has failed. The elongated pause accentuates a sense of anticipation and expectation. The use of slow motion renders the movement of characters as a slowed glide, an image of beauty used to depict violence. Such scenes highlight the postmodern aesthetic of digital post-noir film, challenging and revising conventions, re-making its gender politics and consequently revealing the prejudices inherent in classical noir. By foregrounding stillness and silence, moments that are antithetical to the insistence on sound and narrative in classical noir *Drive* test the boundaries of cinematic specificity.

Digital post-noir films contain spectral impressions of celluloid noir. These films are apparitions that revise, re-make and skew definitions of noir. The connection to noir is envisaged clearly in the excess of style, narration and stereotypes that have foundations within classical and neo-noir. Digital post-noir reveals a heightened awareness of its foundations, draws upon it and transforms it in revision. Rather than suggesting that this specific phase of noir is beyond, or past film noir, it identifies its debt to its history, carrying traces of its heritage in the continuity of visual style, narrative form, characterization, stereotypes, dialogue as well as in the ways that the films recreate, revise and distance spectators from the films. Digital noir is a remembrance of noir in its myriad forms, histories and movement(s) across times and spaces. It is transgeneric as R. Barton Palmer suggested in 1994, and it is transtechnological and intermedial. As Cowie suggests, it is also an inflection, but in this instance, it conjures up characteristics of classical noir just to rewrite them.

Digital Noir

Noir becomes further deconstructed when it is projected in the gallery space. *The Fifth Night* (2010) is a multi-screen noir installation by the Chinese born cinematographer and filmmaker Yang Fudong. These images were shot on 35mm celluloid and transferred to digital. It situates wandering characters in a dreamy, black-and-white noir space. Sequenced

across seven screens, this fragmented noir mystery unfolds from various vantage points within a studio noir setting. *The Fifth Night* borrows the aesthetic, mode and tone of classical film noir and disperses it across seven screens, each offering a differing view on the scene. Whilst each camera position displays a distinct vantage point, mobile characters and objects appear across multiple screens. A car drops off characters, they fall out and scurry to pick up their suitcases. This establishes a repeated pattern of characters landing in unfamiliar locations. The car moves across the screens, highlighting the intersections of distinct spaces. Whilst the screens are positioned next to one another, each operates on its own durational time frame. The split between digital and celluloid is fragmented further across seven screens and their differing durations. The installation encompasses the movement of characters across the screen's shared spaces, but the viewer can also imagine movement in the negative spaces between screens. Individual screens show cyclic narratives, each of a differing length, such that intersections between screens become an effect of chance and random synchronization across screens. Characters are coded nostalgically noir in the formality of their costume and in the mystery of their movements, actions and interactions. Noir is atomized in these divided, interconnected screens where detective figures pace expectantly and femme fatales move up and down stairs. In movement, gesture and in their expressions, each character displays anticipation. Pacing, looking into the distance and waiting imply imminence. Something is about to happen. This multi-screen noir disarticulates noir narrative structure. It invites the viewer to reconnect narrative threads by recognition of characters, objects and movement that is continued across screens. It tests the boundaries of classical noir narrative form by presenting moments without clear connections, sensation without context. *Fifth Night* displays a myriad of perspectives and possibilities.

In Fudong's durational installation, the sensations of film noir are disarticulated and spread across seven screens. However, this screen work highlights the intersections of each screen in the connections of hybridized materiality (photographic emulsion and pixels), in the mobility that connects the seven screens, in the dual layers of diegetic industrial sounds piercing the non-diegetic orchestral soundtrack and in the nostalgic play with a dreamily performed noir style. The fragmented characteristics of noir are expressed across these screens requiring audiences to piece the narrative together and to consider narrative connections between Hollywood and Shanghai, present and past, celluloid and digital, classical noir and the individual perspectives that are entwined within this multi-screen installation.

Contemporary digital noir contains spectral impressions of its history. As an extension of a Deleuzian circulatory system of cross-references, temporalities and aesthetics collide and crystalize in images that remember noir. Noir born, or recast digitally, catches and scatters impressions of celluloid within its own properties of light. With its capacity to recreate the noir aesthetic in high-definition, digital noir becomes an extended illusion of noir's shifting patterns of darkness and light that were originally projected through celluloid. Digital is built on celluloid so that the new film becomes an array of remembered filmic references, direct memories, false memories, collected memories and prosthetically adopted references, allusions of illusions. Digital noir highlights the 'post' of noir as it exists as a memory of noir,

a digital illusion of celluloid noir. It cleans up its surfaces to reduce the grain, replacing it with glinting pixels that offer an illusory shimmer of noir. This recasting might be seen to be in contrast to the aims of classical noir cinematographers who intended to use chiaroscuro expressively, to hide details in the dark, textured surfaces and to emphasize the grain of the celluloid by combining the blackest blacks in night for night shooting with the silvery patina of photochemical surfaces. Rather than dismissing post-noir as a surface impression, it amplifies the triggering of sensations that Krutnik identified, and the strange and violent tone that was described retrospectively by Borde and Chaumeton. Digital post-noir offers a hyperconscious 'un-making' of noir, representing it as a constellation of artificial surface impressions and sensations of celluloid noir.

Chapter 5

Cutting: Shock and Endurance

The attraction is every aggressive moment in it, i.e., every element of it that brings to light in the spectator those senses or that psychology that influence his experience-every element that can be verified and mathematically calculated to produce certain emotional shocks in a proper order within the totality.

(Sergei Eisenstein 1957: 231)

Material forms of celluloid and digital film are inextricably related to one another in the approach to editing. The cinematographic principles and language of cuts, dissolves, fades, wipes, graphic matches and superimpositions that were used in early cinema continue to hold currency more than a century beyond the initial experiments in editing. Early experiments in editing show how it can be imagined vertically, as a sequence of paradigmatic possibilities. Sergei Eisenstein conceptualizes montage as method and affect, poetry and rebellion (1957). For Eisenstein editing is a highly visible, powerful force for changing the way in which spectators are impacted by cinema physically, intellectually and emotionally. Eisenstein edits for dynamic collision and shock, producing a montage of attractions (1957: 232). In his films and accompanying theory, Eisenstein argued for the development of a conscious production of volatile cinema and consequently, an actively politicized viewer. Eisenstein creates rhythmic structures and cuts for intensity and frequency to attract the view and to provoke the audience. Eisenstein notes that montage elements 'touch literally every sense – except that of taste, which is, however, present in implication' (1957: 73). The active viewer registers the edits across the senses, feeling these sensations as discordant sounds or editing rhythms that seem to pulse within the body. To use language asynchronous with Eisenstein's experiments with montage, but indicative of his continuing influence, his editing style is self-reflexive and hyper-stylized, attracting and drawing attention to the cut, visualizing a technique that was to become an invisible aspect of continuity editing style in mainstream cinema.

Two pivotal sequences in films that were made in the same year from distant regions and distinct political cultures across the European continent signal the complexity of editing and the depth of its impact on the spectator. Both of these editing experiments use the cut and the juxtaposition of imagery to create a spectacle, one visualizing the invisible forces of montage, and the other compelling the viewer to look away. *Man with a Movie Camera* (Vertov 1929) literally depicts the editing process, extending to include a range of images that visualize the cut. The expansion of cutting surrounds and

creates the most horrible and beautiful graphic match in the surrealist film, *Un Chien Andalou* (Buñuel and Dali 1929). In both instances, visible and invisible editing styles force attention towards the cut – on screen, within the film and potentially in the body. The second pivotal moment takes place 30 years later. The challenge to the senses that George Franju offers the spectator in presenting detailed facial surgery sequences in *Eyes Without a Face* (1959) is contrasted with the shock that films like *Psycho* (Hitchcock 1960) rely on to construct aggressive moments of virtual assault. This chapter ends with an examination of Christian Marclay's films edited from 'found footage' and returns to early cinema with a consideration of Edwin Porter's *The Great Train Robbery* (1903). The focus of this chapter is on the various ways in which violence in cutting are expressed and entwined on celluloid film and in its digital revisions. Cutting, juxtaposition and sequencing of celluloid continues to influence digital filmmaking practices, each cut existing as a spectral reminder of the presence of the materials of celluloid in digital form. This is evident in sequences that present editing in the mode of attack. In this chapter I begin with a consideration of the impact of cutting to provoke shock in film, looking at some horrific sequences across three divergent moments of film history that use editing to alarm, attack and dissociate the spectator. The processes of cutting the material of the film mirror the content as eyes are sliced, skin is dissected, bodies are stabbed. Content provokes form. In this chapter I am interested in looking at self-reflexive patterns of editing in cinema, techniques of editing that are used to build sequences of violent assault in both celluloid film and digital installations.

Looking directly and in detail at images that intend to provoke the spectator to look away allows for the identification of a constellation of sequences of assault montage from the earliest experiments in filmmaking to recent work with digital installations. Digital cinema draws on the language and pre-existing approach of celluloid editing, but some of the processes differ as the drag and drop, composting, non-linear, non-destructive editing and rendering perform the work of the cut, splice and tape. The principles of the editing process are maintained and transcribed into digital and online editing systems. The touch of celluloid, the scalpel, the splice and the tape transforms into options that include select, click, drag and drop, which are used to create sequences where flesh touches computer hardware, where pixels touch pixels.

Soviet Cinema: Experiments with Rhythm

In Soviet montage cinema editing motivates the juxtaposition of the shots and highlights its rhythmic visual structure. Eisenstein measured and cut his films to establish metric, rhythmic and temporal patterns. Other cuts were motivated by patterns of light and darkness across two shots, creating transitional patterns of luminosity. He conceives of overtonal montage as the synthesis of metric, rhythmic and tonal montage. Intellectual montage emerges as a product of the juxtaposition of shots to create an abstract idea, one that is not present in a single image, constructing a poetic, political cinema. Graphic matches retain the impression of an image

across a division. Eisenstein's editing produces dynamic 'collisions', temporal and spatial relationships organized for dynamism rather than coherence. He constructs cinematic affect from a powerful dialectical montage where meaning emerges from the collision of opposing, or subtly different shots. Eisenstein's constructivist method conceptualizes narrative in terms of the assembly of individual units. Rather than aiming for verisimilitude, constructivists experimented with the representation of reality, providing an opposition to 'realist' strategies by deconstructing and recomposing individual shots. The purity of the indexical association is tested by dialectical montage that relies on a lateral or vertical plane of associated shots.

Eisenstein understands vertical montage as comprising polyphonic, multiple sounds and voices. This is a style of editing of silent film modelled on the verticality of a musical score. Like music, montage is built from paradigmatic possibilities selected to maintain cohesion and others that are contrapuntal and create a series of oppositions. Individual shots are linked by a range of aesthetic and narrational elements and advancing multiple lines, each maintaining independence, each contributing to the total compositional course of the sequence (1957: 75). These lines are imagined with an expansive creativity that connects cinematography with sensation. Lines that Eisenstein describes include: lines of heat, changing close-ups, mounting ecstasy, intensity, voices, movement, gesture and counter currents (1957: 75). Correspondences between multiple lines motivate the edit. Vertical montage produces an interweaving of diverse themes into a unified movement where each 'montage-piece had a double responsibility – to build the total line as well as to continue the movement within each of the contributory themes' (1957: 76). This polyphonic structure relies on the dual requirements of the microcosmic and the macrocosmic, understood here as the shot and the montage sequence. Eisenstein says that this final form depends just as much on the character of the film sequence, as the shorter film strips containing photographic images (1957: 76).

The result of vertical montage is that 'we no longer have a simple horizontal succession of pictures, but now a new "super-structure" is erected vertically over the horizontal picture structure' (1957: 76). All forms of editing, including the overlap of superimposition and double exposure, become part of the vertical montage and is based on the optical processes involved in watching film (Eisenstein 1957: 79). Eisenstein writes,

[t]his technique of "double-exposure" has merely materialized this basic phenomenon of cinematic perception. This phenomenon exists on the higher levels of film structure as well as on the very threshold of film illusion, for "persistence of vision" from frame to frame of the film strip is what creates the illusion of film movement.

(1957: 79–80)

Vertical montage expands outwards towards the viewer to incorporate the persistence of vision as a crucial aspect in the synchronization of images and the interpretation of montage. However, Eisenstein emphasizes the potential for the power of dissonance in creating montage, noting that it is vital to 'keep in mind that our conception of synchronization does not presume consonance. In this conception full possibilities exist for the play of both

corresponding and non-corresponding "movements", but in either circumstance the relationship must be compositionally controlled' (1957: 85). Eisenstein conceptualizes montage at a time of technological transition. His perspective identifies the continuity and difference of approaches to editing across histories and technological transformations. Eisenstein writes, 'the transition from silent montage to sound-picture, or audio-visual montage, changes nothing in principle' (1957: 69). The principle of juxtaposition, creating montages of associations, whether they are constructed from continuous or discordant associations, remains key. Vertical montage and the lines of syntagmatic and paradigmatic choices provide a superstructure that can be extended to investigate the impact of editing on spectators and bodies experiencing projected illusions through celluloid and digital materials.

Experiments with editing in early Soviet Cinema establish a level of creative and intellectual sophistication that precedes the erasure of its present in continuity editing systems. The reflexivity of cutting film is represented within *Man with a Movie Camera* (Vertov 1929) as the film's editor, Yelizaveta Svilova, who cut and supervised the editing of approximately 1,775 separate shots, is shown editing the film itself. The film references the act of cutting within the image and in the production of a vertical montage according to lines of thematic associations. In *Man with a Movie Camera* shots of washing sheets, cutting hair, shaving using a cutthroat razor and details of a manicure surround sequences of Svilova editing celluloid. The sequence includes washing, sharpening, cutting, buffing, sewing, counting, folding and looming with both hand and machine. These sequences both symbolize and reveal the work of editing. The editor is shown involved in the process of editing the film that is simultaneously screened for the spectator. Past becomes present in this montage. For Vertov and Svilova this reflexive revelation of the editor placed at the centre of an associative vertical line uses an image of editing to destabilize the illusion. The hand cranking of film through the camera continues a vertical, associative line that incorporates splicing, segmenting, gluing and fixing film frames. Touch and cutting are crucial to each of these actions. Variations of touch and cutting are evident in the rough touch of fingers lathering shampoo into a scalp prior to the haircut, lathering shaving cream to lubricate the cut throat razor shave, in the hand cranking of celluloid through the camera, a sequence that is complemented by the precision of Svilova's selection and segmentation of celluloid. Flesh and machine interact in each of these shots, highlighting the role of touch and cutting in editing celluloid material. *Man with a Movie Camera* creates anti-illusionistic sequences to re-present the touch of the editor in the process of cutting film. The images of Svilova needed to be filmed and edited as well and effectively this becomes a *mise en abyme* of the process of editing and the illusion of montage. The analogy of editing is bifurcated and split into visible and invisible images of cutting. Across this sequence, cutting is literalized in imagery depicting visual cuts, in shots showing an illusion of editing practice, and finally in the cuts that distinguish the barely perceptible spaces between the shots within Svilova's montage. To borrow Eisenstein's language, cutting forms the superstructure of this vertical montage.

Figure 6: Yelizaveta Svilova, *Man with a Movie Camera* (Vertov 1929).

In the same year as *Man with a Movie Camera*, an exchange of dream imagery resulted in the most famous and brutal editing sequence in early cinema. With *Un Chien Andalou* (1929), Luis Buñuel and Salvador Dali's image of the moon segmented by a cloud dissolves into a close-up of an eye that is slashed by a cutthroat razor. The resulting graphic match creates a powerful, vertical connection between otherwise tenuously linked symbols and an assault on the very organ and sense that we rely on in viewing film. This sequence is constructed from a collision of the most beautiful and horrible shots, synchronized graphically and kinetically. There is no logical or causal rationale for this montage; instead, it depicts the brutality and free association of a nightmare. The graphic match relies on continuous horizontal movement to dissolve the differences between exterior and interior, moon and eye, cloud and razor. The vertical superstructure at work across this graphic, graphic match is literalized in the line that connects locations, the night sky and the balcony. Verticality is also evident in the ways that objects of the natural world are illuminated: the cloud, moon, eye. The dissolving graphic match that blends the disparate shots is also part of the vertical structure, a graceful transition that belies the violence of its imagery. In this nightmare sequence, a vertical gesture of opening the eye gives way to horizontal movements. The cloud dissects the moon, the razor slashes the eye. The cut shuts down vision for the victim and for the viewer. With this graphic match Buñuel and Dali challenge the empathic audience to witness violence, to keep their eyes open amid the terror. Such surrealist film images are described by Sandy Flitterman-Lewis as 'a shock designed for the eyes, a shock founded […] on the very substance of the gaze' (1996: 114). What we witness with this

beautiful/horrible montage is the power that arises from the juxtaposition of illogical, unusual, incomprehensible images. There is little regard for spectatorial safety. There is no possibility of immersion into the film. Interest instead lies in creating unease, confusion, unpredictability and shock. This montage is designed for sensation, to attack the eye and disorient the spectator, who may find it difficult to return to an objective contemplation of the remaining narrative.

Across *Un Chien Andalou* verticality is particularly evident in the ways that the film exploits temporal possibilities. The film begins with an illusion of a linear chronology, situating itself amid the fantasy of a fairy tale by opening with the intertitle 'Once Upon a Time...'. Beneath the fantasy time frame, there is no certainty, continuity or stability. Within the fantasy of the fairy tale, time is shuffled and segmented into chapters with title cards that announce 'Eight Years Later', but it seems that nothing has changed. Characters are unnamed archetypes, their bodies are sites of unexpected transformation. Ants emerge from the palm of a hand, an armpit becomes a sea urchin, a mouth disappears and the sound of a doorbell is signified visually as a martini shaker. A woman who lays out clothes onto a bed creates (or reincarnates) a man to fill those clothes with flesh. Illogical temporal shifts and transformations remain unaddressed, unresolved. Editing, for Buñuel and Dali, was the preeminent method of provocation and dissociation, the condensation of the depravity that surrounded them. The self-reflexive use of editing from Soviet cinema to surrealist interventions extends a darker line of intent in the way that these sequences position the body for assault. A later experiment in assault montage is evident in George Franju's film *Les Yeux Sans Visage (Eyes Without a Face)* (1959).

A surprisingly brutal assaultive montage is also evident in the surgery sequence of *Eyes Without a Face*. The horror here is both spontaneously shocking and relentless. It tests the spectator's endurance. It is a starkly visual horror, but it is also an aural horror. Franju and his editor Gilbert Nator create a suspenseful horror and a surprise attack. It's a horror that confronts with intricate details. In creating the surgery sequence montage, Franju seems to be both aligning the spectator with the attacker and the victim. The point of identification oscillates alarmingly. Throughout this sequence Franju and Nator use a rhythmic approach to vertical montage to test the limitations of the spectator's endurance. Dr Génessier transfers his veterinary skills to the human subject as he experiments with a facial transplant on his daughter Christiane. Desperate to make good on the damage that he has caused after his car accident, Dr Génessier and his assistant Louise lure young women like Edna to their isolated country estate and sedate them with chloroform, in preparation for a facial transplant.

The rituals of an imagined surgical procedure are organized within a vertical, rhythmic range of possibilities. The selection and juxtaposition of shots gradually reveal the brutality and dehumanization. Framing and editing develop sequences that establish and then collapse the objective view, gradually revealing the viewer's proximity, perhaps also complicity, within this sequence. Signalling the beginning of the ritual for surgery, Dr Génessier covers his mouth with a surgical mask and then holds the strings out to either side with his fingers fanned out in a gesture of delicacy that belies the brutality that unfolds across the

sequence. He remains central to the frame as he wiggles his fingers inside rubber gloves and steps towards the operating table to begin the procedure. He begins to outline the face. The camera settles back to frame the doctor, patient and assistant in a medium shot. Space is extended momentarily as Dr Génessier turns slightly to see Christiane who lays sedated on an adjacent bed, her face covered in cloth, ready to receive the transplant. The soundtrack consists of Dr Génessier's breathing, the movement of his scrubs, the call for surgical instruments and later the sound of clamps clicking. Sound and image conspire to provide an intimate experience of surgery. This sequence alternates in the way that Dr Génessier is depicted as orchestrating the surgery in graphic detail, checking on the blade of the scalpel before incising skin, and then transitioning to a tighter framing that eradicates most of his body, leaving only his hands to signify his presence. Subsequent shots focus on the victim and further marginalize the surgeon, his activity concentrated around seemingly, but increasingly, anonymous hands performing the deed. As the perpetrator is gradually excluded, the responsibility for violence is disseminated broadly. Moments later Franju reconnects the three characters by creating a sequence of eyeline matches that link the doctor's eyes with Louise's eyes and then to the cuts made around Edna's eyes before he calls for forceps to lift the skin from its foundation. Images of those looking on to the surgery are occasionally answered by longer shots that include the patient as her skin is flayed. Individual takes of the surgery seem to be extended in time, whilst the rhythm of Dr Génessier's breathing intensifies. Franju and Nator's vertical framework encompasses the use of framing, shot duration and rhythm on the soundtrack to highlight the difficulty of looking onto this dehumanizing image. The viewer's hesitation to witness is reflected in increasingly elongated medium shots of those performing the surgery. This is countered by shorter, wider shots revealing the full extent of the situation for all involved as the skin is prised from the flesh. The ultimate reimagining of dehumanization is preceded by Dr Génessier's gesture of bringing scissors into the frame and then his proclamation that is translated into the English phrase 'here we go', a warning to the spectator of the extended and singularly detailed view of brutality of skin lifted from musculature. For the first time, the camera becomes mobile and lurches in, moving towards the victim, excluding the perpetrators. The camera movement that moves in mirrors the gesture of assault on the flesh of the victim. Independent of any point of view, the autonomous camera that increases proximity to the victim just as suddenly fades to black. The fade signals the limits of what can be seen on film.

This assaultive montage sequence encourages an engagement based on fascination and repulsion. We might look at the surgery sequence directly, or with some distraction, intermittently and sometimes through our fingers. In this extreme montage sequence *Eyes Without a Face* contrasts the desire to see with the problem of witnessing. It also reflects the capacity to visualize the body beyond the surface as X-ray technology was joined by ultrasound, a way of revealing the interior of the body during the 1950s. The desire to imagine the metamorphosis of the face was also influenced by the post-war increase in experimental plastic surgery. Michel Foucault describes the clinical gaze as one that is

not just about reading visible signs, but uncovering secrets, a gaze that 'burns things to their furthest truth' (2012: 147–48). Foucault's clinical gaze is characterized by an analytic, penetrating look that de-identifies and focuses on the body. It prioritizes sight, but also touch and listening. Foucault's clinical gaze opens out to become multifaceted in the surgery sequence as Dr Génessier's presence is centralized and then excluded as his perspective is offered to the spectator. It also augmented by the counterpoint image of Edna waking to the horrific reflection of her denuded face, a shot that begins blurred and then snaps into focus shocking the victim and the viewer.

The sense of objectivity attributed to Foucault's clinical gaze is complicated by the recognition of the ambivalence of looking at and in *Eyes Without a Face*. It establishes a contrast between the magic of cinema and its ability to document and depict distress, even if in the context of fantasy. Walter Benjamin notes a similar duality contrasting the proximity of the surgeon with the distance of the magician when he writes:

> The surgeon represents the polar opposite of the magician. The magician heals a sick person by the laying on of hands; the surgeon cuts into the patient's body. The magician maintains the natural distance between the patient and himself; though he reduces it very slightly by the laying on of hands, he greatly increases it by virtue of his authority. The surgeon does exactly the reverse; he greatly diminishes the distance between himself and the patient by penetrating into the patient's body, and increases it but little by the caution with which his hand moves among the organs. In short, in contrast to the magician – who is still hidden in the medical practitioner – the surgeon at the decisive moment abstains from facing the patient man to man; rather, it is through the operation that he penetrates into him.
>
> (Benjamin 1936: 233)

In initially opposing and then interlacing the magician with the surgeon, Benjamin draws an analogy with the practice of editing in the production of magic in the cinema. He connects the grace of the fleeting superficial touch with the severity of the indelible cut. Franju's surgery sequence negotiates precisely this distance in favour of proximity. The illusion of Dr Génessier's cut into the flesh is doubled and presented by the splice into the celluloid strip. Benjamin suggests that the magician remains hidden in the surgeon, a similar precision and spectacle emerge from the practice of editing.

Eyes Without a Face highlights the problem of an overload of vision, bearing witness without being able to respond or react. Adam Lowenstein calls *Eyes Without a Face* shock, homeopathic horror, a small dose of what is essentially a poison that works to promote resilience in the body. He argues that this film functions in a similar way to the way in which simulated loss assists in overcoming trauma in the processes of mourning. Loss, Lowenstein argues, is integrated by processes of remembering and the repetition of the memory of loss in symbolically and dialogically mediated doses (1998: 48). However, an empathic identification is complicated by the masking and erasure of the Christiane's face.

She remains hidden behind a plastic moulded mask for much of the film, and her face, when it is shot directly, is either uncontained flesh and bone, or melting like wax. Without proximity to the face, empathic identification is reliant on her gesture, posture, movement and dress. Empathy, here, is created by identification with the broader notion of tragedy. In Lowenstein's view, *Eyes Without a Face* becomes a barely concealed metaphor for the atrocities of the holocaust and a recognition of the dehumanization of torture. Christiane's light, elusive character carries a deeply symbolic weight.

The character of Christiane is layered with shiny plastic and synthetic materials. The moulded white mask and her wig have a deliberately synthetic appearance. The fabric of her coat is a shiny, nonorganic material, setting her apart from the natural world. Surrounding the women of *Eyes Without a Face* is a dual focus on glimmering, tight, often contrived, artificial surfaces repelling and displacing the desire to see what lies beneath. Trauma is tightly held beneath their glossy surfaces. Franju's dialectic contrasts surface with the detail of musculature, shifting from surface to depth, synthetic to flesh. The gloss of the surface is registered within the frame, whilst the layers of the body are gradually exposed in processes of editing. Lured by the glint of surfaces, looking quickly becomes shocking as processes of dehumanization are revealed. Joan Hawkins reads these surgery sequences as veiled references to the culture of *le rèsistancialisme* (2000: 70). Hawkins writes that, 'in cinema rèsistancialisme was promulgated through careful editing and censorship of certain images' (2000: 70). She writes that in post-war France, 'bad memories of the war and of patriarchal guilt were initially exercised by (temporarily) destroying the looks of women' (2000: 71). In *Eyes Without a Face*, it is the face of the woman that is repeatedly brutalized. Rosalind Galt sees the process of '[s]licing up eyeballs as a way of guarding against the aesthetic danger of women' (2009: 2). Editing is used to destabilize vision and, as Galt describes it, the seduction of the aesthetic is 'countered with violent measures against the image itself' (2009: 1). The indignity of such historically specific marking is reflected not only in the brutality of the surgical incisions but also in the hopelessness of Christiane's dissolving face. The montage of her facial disintegration links the magical, cinematic compression of time with the horror of melting, decaying flesh. The montage begins with an image of Christiane's pale, symmetrical face framed in close-up. The series of still images that follow are seamlessly connected by dissolves. The dissolves compress time, gliding between shots that depict the traumatic affect of disintegration of the face. The dissolves also match the disintegration of the flesh, suggesting that there is no possible recovery. In contrast to the surgery sequence, this montage appears to elide the cut, disguising it as superimposition. The deleterious affect of the surgical cut appears as an edit blurred by the layering and transitioning of multiple images. In this sequence the use of the dissolve from one image to the next results in the unnerving destabilization of binaries including the real and the artificial, rationality and irrationality, power and guilt, science and magic.

In establishing dual lines that frame beauty and then cut it up, Franju's surgery sequence extends the musical aspect of Eisenstein's vertical montage. This imaginary barbaric sequence is built by creating rhythms of sound, duration and scale of shot. However, the

reliance on rhythm also includes escalating and receding patterns of anticipation as detail is obscured and revealed. Franju's horror relies on an extension of temporality, pushing time beyond chronological flows, creating suspense and challenging spectatorial endurance. This is a particular type of vertical montage, one that is deeply connected to its own history, but also provides multiple possible connections to the present. It is a particular approach to experimentation with montage, evidence of a cinematic historical lineage that appears in the late 1920s and again at the end of the 1950s. The final celluloid example of the paradigmatic choices that shows a distinctly cold-blooded approach to vertical montage is the shower scene from *Psycho* (Hitchcock 1960). Also produced at the turn of the decade, this is a film that reflects a pivotal moment of significant industrial and cultural change. Released at the end of the 1950s, films like *Psycho* overtly and obliquely test the boundaries of censorship practices and acceptable boundaries in the depiction of violence on screen.

The shower scene is most famous montage in film history and one of the most controversial. Hitchcock and Saul Bass (who is credited as the pictorial consultant) created this experimental and confronting intellectual montage. The sequence extends to incorporate moving and still images, sound, rhythm, cuts, point-of-view shots and ends with a spiralling graphic match. The montage begins with an invitation to share Norman's voyeuristic point of view as he peers at Marion through a hole in the wall that separates his parlour from her hotel room. The killing also comes at a turning point for Marion, after she has made the decision to confess and return the money. In framing and in editing, an excess of style is used to produce shock. The shower scene itself is coded in deliberately sexual terms. This montage offers an exploration of personal insecurities. Inside the shower Marion is at her most vulnerable. She is naked, caught within a confined space, her hearing is impaired by the sound of the water, her vision is limited and she has no means of defence. Again we note an assault on the primary senses that are activated in film viewing, vision and hearing. The screeching violins on the soundtrack signal alarm. The addition of discordant sound in Bernard Herrmann's violins surrounds and expands the impact of the score. Visually and within the soundscape, there is no escape – even if we close our eyes. This sequence is built from graphic patterns including the folds in the shower curtain, the grids of the tiles, the door and window frames, all reminiscent of the parallel lines of Bass's credit sequence. These lines collide and contrast with spirals. The spiralling pattern of the water that winds down the toilet and then the sink is augmented by the spiralling movement of the camera that creates the illusion of the spiral in Marion's eye. The eye is the central line that connects all aspects of this vertical montage.

Psycho was one of many horror films about cutting and incision, films that provoke and attack the spectator, imagining the audience as the victim. Released at the turn of the decade and into the 1960s, films like *Psycho* and *Eyes Without a Face* are augmented by Teshigahara's *The Face of Another* (1966) and Michael Powell's *Peeping Tom* (1960). These films exist at the crossroads of cinema marking the turn towards the intensification of vertical montage as editing invites the spectator into the film, offering a kaleidoscopic array of potential points of identification including the point of view of the perpetrator, its victim and with

the rhythm of the montage itself. Whilst we note the brutality of attack on the spectator in silent and sound cinema, it is extended in recent work with creating montage cinema from found footage. We begin with an example that highlights the intersection between old and new cinema.

The contemporary media artist Christian Marclay develops an innovative approach to vertical montage by constructing new films from old. His 'supercuts' rely on pre-existing, found footage that is accessed, excised and juxtaposed, creating new films where the shot and the cut hold equal weight. In each of Marclay's found footage films, new narratives are created from fragments of existing films. Rather than being filmed, edited and exhibited, Marclay's cinema is searched, accessed and thematically curated. David Bordwell identifies this type of filmmaking as built on a 'collage principle', noting how these films can 'pry images from their narrative context and call attention to their poetic or graphic qualities' (2011: n.pag.). A digital vertical montage dominates the style of films created by Marclay. Marclay's cinema prioritizes repetition and variation, building upon thematic associations, mapping and revising films using a mosaic framework. His films are more about the selection of shots and their juxtaposition than the image itself. It is in the dialectical juxtaposition and sequencing of images that new meanings emerge from vertical associations. The sequencing creates associative, vertical montage, new forms of existing films. Marclay's particular type of cinema ranges from studies of communication, or intersecting dialogue across distinct films, to immersive installations that force a dramatic, violent affect. Lev Manovich might envisage Marclay's approach as relying on a database aesthetic; however, he perceives database and narrative as 'natural enemies' (2007: 44), but with *Telephones* (1995) Marclay develops a self-reflexive montage built from the silences and moments of waiting that would otherwise stall classical narrative progression.

Telephones relies on found footage of varying moments of telephone communication (and silence) in Hollywood films to create a new dynamic from existing conversations. Opening sequences are organized to foreground repetition in the form of sounds, images and gestures. Here we see phones in booths on busy streets and in corners of clubs, public sites where the micro-rituals required for telephonic communication are performed. Some of these gestures include dropping coins into slots, hearing the sound of the rotating dial, restricted movements as listeners hold receivers that are wired to the body of the telephone and finally those moments of hesitant silence as characters anticipate connection. In these moments temporality is accentuated through the performance of stillness in silence. The duration of temporality is extended noticeably at the beginning of *Telephones*. This may well be retroactively elongated in comparison to the contemporary experience of diminished time dedicated to dialling telephones. Dialling is almost redundant in the experience of everyday life for many. It is a performance of a redundant detail in film. More concise narratives would imply such detail. Additionally, the importance of memory in telephone communications is evident in this sequence as phone numbers are remembered or recorded on paper.

Whilst the individual shots that constitute *Telephones* exist well before this supercut, the narrative that emerges from the associations reveals both surprisingly coherent

correspondences. A vertical framework constructed as an illusion of an overarching conversation unfolds gradually, with pauses, interruptions and silences throughout the film. This beautifully sequenced narrative begins with clips from individual films showing numbers being dialled, then a series of phones ringing (with differing tones) in spaces that seem devoid of human presence. The phone rings, but no one is at home. These shots are pauses in the play of cause and effect. Included gradually are sequences of phones ringing, with characters reacting to the sound. Across a short sequence the shot is cut just as the receiver is lifted, before the phone is answered. This early sequence introduces a dissonant approach to editing, interrupting the shot and playing on the viewer's anticipation and voyeuristic desire to see and hear the conversation, an expectation that is thwarted by the imposition of a premature cut. This sequence then extends to include a range of 'hellos', with Errol Flynn's utterance seeming to carry the most annoyance. The film excerpts become sequenced into a dynamic characterized by a call-and-response pattern where questions are answered by characters in divergent films, where expressions of love and desire seemed to be given and received by characters who are the unintended recipients.

Telephones exposes moments of anti-cinematic illusionism. The motionless state of the *mise-en-scène* and cinematography of still, empty, silent shots reflects back a sense of pure time, the spectator's own time, from the relative stillness on screen. This impression of temporality opposes the imagined, compressed, fictional time of the supercut, a heightened compression of fragments of fictional moments within a medium where time is so deeply inscribed in the progression of images and facilitated by the apparatus itself. Circumventing spectatorial omniscience, the silence of listening is included here with those on the ends of conversations quietly hearing detail that is not available to the viewer. In these shots Marclay deliberately and evocatively creates associative sequences of non-diegetic sound and stillness. The stillness of bodies is evident in slight movements like the deepening of breath or minute turns of the head. This effect is multiplied by static lighting and cinematography combined with silence and seemingly stalled movement, a rare incidence in mainstream cinema. This stillness amplifies and magnifies a range of imagined conversations within the film. Minuscule expressions on faces, particularly eyes, tell the story here, but it is a story of blank silences for the viewer to decipher. It could be anything.

Telephones aligns its own ending with that of the telephone call. The final sequences present a compilation of end points to discussions, stuttered endings, incomplete conversations, exchanges that seem to end too soon with the weight of the unheard words often signifying an indelible affect, point of no return for the listener. In this sequence, screen time is devoted to a collection of responses as receivers are hung up and connections are cut. The rhythm of the montage increases with these ends, as does the drama of the responses. At this point the sound dominates as receivers are replaced rapidly, some slammed down in rage with the proclamation, 'Get Lost!'. The sequence is cut to prioritize the rhythm of sound at this point, a contrast to the silence. *Telephones* ends with Barbara Stanwyck in *Crime of Passion* (Oswald 1957) struggling to hear and be heard, hanging up the phone in a public phone booth precariously positioned on the edge of a footpath, too close to a road. In the final

shot of *Telephones* (which falls at the halfway point of *Crime of Passion*) Stanwyck remains in the booth whilst the camera tracks back, leaving her isolated and unprotected within the glass phone booth. Marclay's work pays homage to classical narrative principles and simultaneously exposes the artificiality of its contrived patterns.

Marclay's epic supercut, *The Clock* is an expression of the potential for editing to reflect time. David Bordwell shares this view, suggesting that, '*The Clock* isn't just about clocks; it *is* a clock' (2011, original emphasis). Diegetic time is carefully synchronized with the local time of the installation. Whilst it emphatically presents the formal quantitative chronos time, it can be experienced as kairos time, a kind of chrono-sensory, 'felt time'. I saw *The Clock* in Venice, jet lagged after a long flight across the globe and my sense of time was skewed. The person sleeping on the chair in front of me, however, might have failed in his attempt to sit through the entire film. Marclay's film provides a constant reminder of the certainty of time in Venice, doubling its proscribed temporality and measuring it in the duration of its shots. Against my lived experience of time, Marclay's 24-hour installation synchronizes literalized filmic representations of time with the Coordinated Universal time zone proscribed by the location. *The Clock* makes time visually manifest. This single-screen installation depicts continual reminders of time with the inclusion of analogue clock faces, ticking second hands, the falling numbers of digital clock radios, time lit as glowing red LED numerals. Time is depicted and kept by machines that inscribe time, but it is also read according to the forces of nature. Repeated and varied utterances emphasize the anxiety that surrounds discussions of time. At 2.20 Mick Dundee from *Crocodile Dundee* (Faiman 1986) looks up at the sun. The camera follows and offers a vision of his point of view. The succeeding image is one of the sun slightly skewed and doubled by the lens flare. Without a watch, he announces the time accurately and this is double checked and confirmed as Sue Charlton and Walter Reilly glance at their watches. However, this film also contains additional footage that lies between the literal depictions of clock time. Some sequences swell well beyond the necessary iteration of time. This footage can extend the sequence leading up to, or away from the moment that time is depicted visually or in dialogue. *The Clock* seems to hold on to a specific temporal reference whilst manipulating it within a single sequence.

The Clock makes great use of many sequences from Harold Lloyd's elongated state of peril as he hangs precariously from a clock at the top of the International Bank Building in Los Angeles in the silent comedy *Safety Last!* (Newmayer and Taylor 1923). Its 2.45 when he reaches the clock, but he grabs hold of the hands and winds them back, reversing time to protect his fall. *The Clock* registers the 2.45 timeline as the actual time of the film even after Lloyd's character pushes the clock face back to read 11.30. Whilst *The Clock* is strictly chronological, *Safety Last!* reverses and manipulates time as the sequence progresses. The image shows time in reverse; the film continues to project the events as they progress. As a medium with a foundation in experiments with time, early cinema complicates Marclay's approach to the forward progression of time registered on film and its insistence on a linear chronology. David Bordwell understands *The Clock* as influenced by traditions of Structuralist Filmmaking, particularly in the tendency to incorporate references to time within the image itself (2011). He notes the

difference in time as it oscillates from its implicit visualization and overt representation within the diegesis and time felt and experienced by the spectator when he writes,

> [a]s we get captivated by clock-less images and follow their development within a scene, the arrival of a timepiece reminds us of the structuring principle. The appearance of a clock creates something like a punchline, while also letting us realize how loose our sense of duration in a movie usually is.

(2011)

Marclay's supercuts are built on Eisenstein's and Vertov's constructivist approaches to filmmaking. This is self-reflexive constructivist cinema that relies on extreme paradigmatic organization as a superstructure to align borrowed content.

The most brutal of Marclay's supercuts is the four-screen, surround sound installation, *Crossfire*. Here, violent images and sounds of gunfire target the spectator and present a rhythmic and sometimes seemingly relentless assault on the body. Whilst *Crossfire* is projected on a loop, it does have a rise and fall pattern, beginning in silence and gradually escalating in intensity until all falls quiet and the loop begins again. Anticipation builds at the beginning as the viewer surrounded by the four screens of the installation looks around to see which screen will light and which will fade. *Crossfire* begins playfully as a game of anticipation. Initial shots show gunmen approaching, guns being loaded in detail with the menacing hard black metal of a handgun lit to emphasize its design. Guns are positioned in profile, then front on, ready for the attack. Detail is highlighted as fingers curl around triggers and bullets start to fly. The focus on detail also marginalizes context. The spectator is shot by actors including Takeshi Kitano, Arnold Schwarzenegger, Jamie Lee Curtis and Samuel L. Jackson, with the presence of the actor eclipsing the names of the characters or the films from which the shots are drawn. Everything is stripped back here. At the height of the attack shots are fired from four screens, with each screen cutting to black momentarily, in the blink of an eye.

Surrounding the spectator with four screens and inciting a seemingly random pattern of screens that light up with violent images makes us aware of the limited scope of our vision. It also provokes the spectator to shift, back away, or spin in anticipation of the next assault. Targeted directly towards the spectator, she must decide if it is preferable to witness the virtual assault, to imagine her own demise, or to stand back and view as many screens as possible, as objectively as possible. The spectator is positioned to highlight her vulnerability. Gunshots distract and divert attention forcing the spectator to reel, spin or at least glance around and behind in anticipation of, or response to the gunfire. The particular type of subjective engagement is both anticipatory and vigilant. In *Crossfire* spectatorship is both immersive and reactive. However, the initial attack and its extension into a virtual barrage of gunfire by fictional characters brandishing a range of guns seems to subside as the rhythm of the soundtrack and a pattern of sound and silence, image and blackness begins to dominate the narrative. The horrific beauty that characterized the graphic match of *Un Chien Andalou's*

Figures 7 and 8: Justus D Barnes shoots the spectator and disappears in *The Great Train Robbery* (Porter, 1903).

eye slice is reinterpreted here as the rhythm and pace of *Crossfire*'s editing dares to suggest a rhythmic elegance behind the initial shock of the violence that is represented and repeated. Here, as in earlier examples, the edit is used to facilitate attack. Towards the end a character yells 'Hold your fire!' and the sequences decline in intensity. Guns are re-holstered and the orchestrated cacophony of gunfire subsides.

The violence of *Crossfire* reveals another intersection between digital film installation and early cinema. The violent direct address of the multiple performers who face the camera and shoot are elaborate responses to Edison's experiments with shooting images of gunmen shooting directly out towards the camera/audience in *The Great Train Robbery* (Porter 1903). In this early film, Justus D. Barnes performs a dramatic virtual attack on the audience. He closes one eye briefly as if to take careful aim before shooting six bullets seemingly directly into the camera lens and tries twice more, after the magazine has emptied. Bullets and smoke that arises and increases in density with each gunshot punctuate this single shot, acting as a form of editing transition, or dissolve, within the frame. The image blurs and the shooter becomes clouded and obscured by the effects of his own gun.

Even though this image is silent, the sound is implied by the rhythm of gunfire and then the click of the trigger against the empty magazine. The shot of gunfire in *The Great Train Robbery* usually appears at the end of the film, but as was the culture of early film exhibition, it could also have been inserted at the beginning. The narrative variability and interactivity that is thought to be reserved for the contemporary film experience is a feature of *The Great Train Robbery*. There is little hope for escape for the spectator watching the images projected onto the screen in 1903 and surrounded by four screens in 2007. Positioning the shooter for direct address, looking straight at the imagined audience means that the implied assault is also direct, but virtually so in each instance. Whilst Marclay relies on digital editing, multiple screens, multiple points of attack, the single image of Justus Barnes confronts the spectator directly. Both screen images attack directly and use sonic patterns evocatively. *Crossfire* is constructed according to a loop; its rhythms include blackness, relative stillness

and relentless assault. Viewers of *The Great Train Robbery* are confronted by an imagined shooting at the start or at the very end of the film.

It is a mistake to imagine that the impact of vertical editing was not available to early audiences. The perspective and effect of editing was not new to visual culture, or to moving image history. Magic lantern slides also created illusions of transitions in dissolves, superimpositions and fades. These transitions were possible in a variety of pre-cinematic optical devices. The editing of celluloid touches, impacts and affects the spectator. This is achieved in the dynamic connection between the duration of the shot and the rhythm of cutting. Celluloid film uses the cut to position the spectator as anticipating what might follow. One way that the spectator feels the cut is in delaying editing, creating a sense of anticipation produced by duration, waiting for the cut. Crucial here is the literal, physical cutting of celluloid film with individual shots in between the cuts counted or felt as a particular rhythm. Editing is felt by the editor as she cuts the celluloid, splices and attaches. It is also experienced by the spectator in the exposure to a pace of editing that competes for attention with the shot. The spectator who struggles to endure shots that are difficult to watch may desire the cut.

As Eisenstein wrote with reference to the transition from silent to sound cinema, although there is evident change, the principle remains. Eisenstein argues that montage is built from, 'the visual, the dramatic, the sound' (1957: 70). In editing digital film, the principle of juxtaposition, the creation of associations that blend seamlessly, continuously, invisibly and those images set to clash remain indebted to the visual, the dramatic, the sound. Within a digital media ecology, editing shows its foundation in traditions established by early experiments in montage. Nowhere is this more evident than in sequences where the cutting of the film itself is reflected by images of incision in film. The scalpel, knife and gun duplicate and augment the processes of editing in film production, allowing the virtual cut to be felt in the body. Assaultive montage sequences use modes of vertical montage to impact the spectator's 'every sense', as Eisenstein suggested (1957: 74). These vertical sequences are built around polyphonic compositional elements creating lines that repeat moments of cutting. Eyes are sliced, hair is trimmed, whiskers are shaved, faces are outlined, incisions are made with a scalpel, skin is removed, bodies are stabbed and shot. The correspondences between these lines indicate the perpetuation of Eisenstein's theory of vertical montage. Image, processes of editing and the experience of the assault felt by the spectator interweaves various approaches to cutting into a unified whole. In these sequences, the very sense that is prioritized in viewing film, the eye, is slashed on the screen. The rhythm of the montage extends the aural response to the film beyond the conventional soundtrack. Silences are used to make the viewer aware of their own discomfort. They might become aware of their own breathing, movement or shifting in their seats. They may well respond by backing away, moving towards or even spinning to avoid an imaginary bullet inside a four-screen installation. This constellation of attack sequences shows that audience attack continues to be direct and confronting from 1903 until 2007 and perhaps beyond.

Chapter 6

Screens, Scale Ratio: Vertical Celluloid in the Digital Age

All the things I am attracted to are just about to disappear, more or less.

(Tacita Dean interviewed by Marina Warner 2006: 15)

Visually, what I wanted is a factory to make babies. It's mechanical, like Charlie Chaplin's *Modern Times* (1936) – a big machine at the beginning of the twentieth century. Like one to print newspapers – a big machine to create babies.

(Christian Boltanski interviewed by Lucy Rees 2014: n.pag.)

Celluloid film production would come to an end in 2017, anticipated D.N. Rodowick (2007: 9). Whilst celluloid hasn't been eradicated entirely, movement towards the substantiation of Rodowick's claim is evident in the shift to digital production, distribution and exhibition in mainstream cinema. Films that are 'born digital' are copied onto celluloid for preservation. Celluloid has proven to be the most stable material. A combination of factors contribute to the change, or disruption, in the ways that film has been created and experienced a little more than one hundred years beyond the initial screenings. The diminution of celluloid film culture is a direct result of the closure of its 'bricks and mortar' infrastructure. The scarcity and escalating expense of film stock, the closure of film processing laboratories and the limited technologies for projection provide a disincentive for filmmakers to use celluloid film. However, some filmmakers who are dedicated to the use of celluloid are creating new ways for audiences to see and interact with film. What is not lost in the diminution of celluloid is a recognition of the value of filmmaking, particularly in its specific processes of creation. The grain and texture that defines the materiality of projected celluloid and the experience of film viewing has been recreated in extended forms and alternative exhibition spaces. The first decade of the new millennium has revealed a range of filmmakers who extend screens well beyond standard proportions to highlight both the materiality of celluloid and the precarity of film culture. The transformation of screen scale and ratio and the necessary reconfiguration of film history and spectatorship are identified by Anne Friedberg who writes,

[n]ow, a variety of screens – long and wide and square, large and small, composed of grains, composed of pixels – compete for our attention without any arguments about hegemony. Not only does our concept of "film history" need to be reconceptualized in light of these changes in technology, but our assumptions about "spectatorship" have lost their theoretical pinions as screens have changed as have our relations to them.

(2009: 450)

If film and the spectator are discursively created, how might film history imagine multiple or extended screens?

Historical significations of beginnings and endings can provoke intense experimentation and compelling redefinitions of older media. In a letter to 'Gentlemen of the Academy', Sergei Eisenstein notes the significance of the 'great historical moment' that saw the introduction of widescreen cinema (quoted in Leyda 1970: 48). Eisenstein celebrates the 'opportunities for a new screen shape' that would return the focus towards the spatiality of the composition and it would afford filmmakers, 'the possibility of reviewing and re-analysing the whole aesthetic of pictorial composition in the cinema which for thirty years has been rendered inflexible by the inflexibility of the once and for all inflexible frame proportions of the screen' (1970: 48–49). Entitled 'The Dynamic Square', Eisenstein's letter proclaims his avid support for scaling up screens, but his preference is for vertical, rather than the horizontal cinema promised by widescreen technologies (1970: 48–66). He writes, '[i]t is my purpose to defend the cause of this 50 per cent of these compositional possibilities which have been banished from the light of the screen. It is my desire to chant the hymn of the male, the strong, the virile, active *vertical* composition!' (Eisenstein quoted in Leyda 1970: 48, original emphasis). He immediately retreats, announcing that, 'I am not anxious to enter into the dark phallic and sexual ancestry of the vertical shape as symbol of growth, strength or power. It would be too easy, and possibly too offensive for many a sensitive hearer!' (48–49). Eisenstein notes the movement from the 'dynamic', central square frame, 'to the all embracing, full sized square of the whole screen' (1970: 52). His letter details what is at stake in the shift towards the widescreen frame. The additional horizontal space necessitates a reconsideration of approaches to the conceptualization of space, editing and screening practices and spectatorship. Eisenstein describes the phenomenon of the 'perceptive auditor' as 'dynamism in perception. In horizontal dimensions of the eyes and vertical of the head' (1970: 61). Scaling film up, horizontally or vertically, produces dynamic screens and perceptions.

Debates about endings can also inspire beginnings, perhaps even a reconsideration of the importance and magnitude of earlier media forms. Twisting the frame from the horizontality of landscape and towards the monumentality of the portrait whilst exposing the apparatus (re)introduces celluloid, its materials, the intricacy of its processes and its machinery, providing a (re)newed experience for audiences who might otherwise be surrounded by digital screens. It also creates a time-slice that intersects current film with cinema of the past, the new with the old. Escalating scale, extending screen ratios and exposing the dimensions of the apparatus itself are reminiscent of the lack of standardization in the earliest forms of exhibition. Contemporary experiments in film revise familiar ways of seeing and experiencing the cinema. Extending screens beyond the expectations of binocular vision requires spectatorial interaction that is sensuous, immediate and often compelling.

This chapter is dedicated to a consideration of the impact of the escalation of film scale, specifically in the extension of screens that are stretched beyond standard dimensions. It explores the increase in scale as a gesture showing some of the processes of creation and

experiences of reception reminiscent of early cinema. It is both a reflection of the present and an acknowledgment of loss in the transition to digital culture. It is also a re-inscription of reverence for the value of celluloid itself. Older and newer films are interlaced here within a history of evolving coherences in Siegfried Zielinski's phrase, or connected by contingencies, to borrow Mary Ann Doane's framework. Such a historical consideration opens up new pathways that reveal diachronic intersections between early and late cinema across time. Whilst coherences imply sticky similarities, contingencies highlight necessary dependence. Late film depends on the pre-existence of earlier innovations; it carries traces of film history as it creates itself anew. In recent film exhibitions some filmmakers are resisting the ubiquity of digital materials, relying instead on celluloid, the techniques and mechanics of the filmic apparatus. Both Tacita Dean's *Film* and Christian Boltanski's *Chance* are seen here as celluloid interventions that have been scaled up significantly and designed explicitly to counter the prevailing digital ecology. Each intercession reinstates the value of early experiments in filmmaking as these uncannily familiar illusions are presented within a scale that emphasizes its magnificence.

Film and Celluloid

Berlin based, British born artist Tacita Dean's majestic cinematic projection *Film* (2011) is an emphatic assertion of the presence of celluloid within a media ecology that feels crowded by digital screens. Dean names her artworks for what they are. *Film* is an emphatic assertion of celluloid materiality. It is also an installation that places cinema as metonymy, an experimentation with materials, technologies and processes that represents both the fragility and endurance of celluloid film. Made for the Tate Gallery, London, *Film* was designed to be site specific. Dean reveals that,

> I basically turned the Turbine Hall into a strip of film. And it was fighting for film, fighting to keep it alive as a medium, which we need to do of course. It's very touch-and-go whether that is going to be the case. It's another working material, it's another medium, and I don't understand why the world is getting rid of it – because it is different from digital, it is completely bloody different.
>
> (Yeoh 2013: n.pag.)

In both scale and spectacle, *Film* attempts to resist the end of celluloid culture and to offer a reminder of its enduring influence. *Film* is a deliberate effort to isolate the specificity of celluloid materiality, exerting the magnificence of its presence to counteract the threat of its obsolescence. In scale and spectacle, *Film* resists the depreciation of celluloid culture. Just as Dean values photo-chemical materiality, she also invests in the uncertainties of celluloid film stock and processes of filmmaking. This is a film that relies on past innovations, as faithfully as possible reproducing experiments in colour, tinting, aperture gate framing and

editing. As Dean remarks, 'using all that invention and energy that surrounded the new medium' (2013). In creating *Film,* Dean takes a direct approach, revising the experiments of early film pioneers in intensifying the look and feel of celluloid, countering predictions of its demise. Perhaps surprisingly, Dean says that her film work is about the present, that her approach is not nostalgic (2013). *Film* shows celluloid as a living, transforming material, one that remains influential, even within an imposing digital ecology. This is an example of the sustained influence of established film techniques. Ironically, the production of *Film* also hints at the potential for digital to support celluloid film production.

This initially appears to be a silent film, but more accurately, *Film* presents a complex use of sound to signify the hidden processes of sound cinema. There is no sound strip, or recorded sound track accompanying this film. The soundtrack to *Film* emerges from the projector itself. The spectator can hear the clatter of the apparatus, the repetitive movement of the machine parts – its spinning wheels, the whir of the engine, the Maltese Cross measuring time as it claws through the sprocket holes. Alongside the clack of the projector is the sound of the audience as they shuffle in, whisper in hushed tones, some who at times touch the screen and perform in front of the light beam. On one visit to view *Film* at the Centre for Contemporary Art in Melbourne, I noticed some young children wander in, lift up their arms and stretch out their fingers to feel the beam of light. I also watched as they began to hit the screen, working out the difference between the immateriality of the projected light and the texture of the screen that caught it. Hands and fingers were used instinctively to catch the light, to touch the film. This elusive luminosity emerges from the projector and its exciter bulb. The visible beam of light forms an important element of the experience. This is another way of visualizing the technologies that are usually concealed. Part of the exhibition of *Film* invites the emission of light falling on, absorbed by and reflecting off surfaces including the body. Dean uses projectors, the projected light and the shadows cast by bodies in the full articulation of her film installations. Jennifer Barker writes that, '[t]he average viewer's body will not need to be convinced that the film's various textures actually press against, caress, wrap around, or come into direct contact with the spectator in any real way' (2009: 30). This is the most pure filmic sound and clear connection to time, a direct reference to early forms of exhibition where the technologies share the screening space. Here, they can be heard and seen, projecting as well as measuring rhythms and time. Without a classical cause and effect-based narrative form and without conventional sound, *Film* communicates using light, supradiegetic sound and magnificent scale.

Sprocket Holes

Initial impressions of *Film* reveal the magnificence of its scale. In this installation Dean's 35mm film is rotated 90 degrees with the projected illusion extended to create an elongated, framed portrait of film itself. The anamorphic lens minimizes the image in shooting and unfurls it in projection. Without a conventional soundtrack evident at the edge of the film, the whole image appears to be visible and visual. The lateral edges of the frame feature sprocket holes within the image, making the less visible aspects of film itself the focus of the

spectacle. To achieve this affect Dean masked the centre of the celluloid and filmed sprocket holes at the edges of the film. When projected, these sprocket hole borders are unnervingly still. Dean creates a layered illusion by juxtaposing the immobile edges with the moving images within the frame. These still sprocket holes are insistent reminders of the materiality of celluloid film. The juxtaposition of stillness supporting the illusion of motion returns the viewer to the photographic origins of the cinema. The illusion of the sprocket hole border achieves the flicker fusion threshold, an affect of movement that emerged from experiments in motion conducted by filmmakers like Eadweard Muybridge. *Film* produces an illusion of stillness at the edges, supporting the dynamically transforming moving image in the centre of the frame.

Less visible aspects of the film frame become visible in this portrait of cinema. The film strip contains circular symbols, markers reminiscent of the earliest forms of sprocket holes that appeared between the frames of 17.5mm film. Films featuring central perforations were developed as early as 1898 in London by Alfred Darling and Alfred Wrench. These circles provide connections to the history of film. They also create new metaphors within sequences. Descending escalators are retained within these circular, cut-out shapes as the rest of the shot changes. They also display the effect of layering and superimposition. These are portholes to a time that has recently passed. *Film* offers an impression of past and present layered into a single image. The illusion created suggests that the entirety of the film strip is on display. However, as an experiment with and on celluloid, the actual filmstrip passing through the projector also needs sprocket holes. The spectral illusion is tripled in the sprocket holes that are visible at the edges of the frame, within the frame and finally in the film as it passes through the projector within the installation space. Visualizing the invisible and magnifying it on a large screen reverses the diminishing presence of celluloid as it survives the threat of displacement by the seemingly more dominant and less visible digital format.

One of the clear themes animated by *Film* is nature, particularly weather. Fog at the base of a mountain appears to billow towards the spectator, some eggs drop into this miasma, a soft landing for their fragile shells. *Film* includes repeated images of water. We notice this in the falling rain, water descending from a waterfall as well as across rocks, ripples of water that catch and reflect sunlight and waves that crash towards the sand. Framed by those strangely still sprocket hole borders are images of escalator steps descending, bubbles floating, feet ascending stairs and an analogue clock registering time with an alarmingly rapid pace. The latter image offers the clearest impression of time running out. Time is depicted in a precarious state for humans, machinery, the natural world and for celluloid film. The metaphor of time continues alarmingly moving into reverse as a green grasshopper takes a backward step and water begins to flow upwards in the middle third of a sequence.

Film re-animates early approaches to filmmaking to emphasize the magnificence of the cinematic illusion of cinema. By tinting frames, Dean is evoking history through the sensation of colour by reviving early film processes. Dean uses pink, watery tinctures to tint mushrooms, producing images that are at once enchanting, but also potentially poisonous. The process of painting directly onto the celluloid results in Mondrian-inspired

colour blocks, extended spectacles of modern art in the moving image. In other images the intensification of the vibrancy of 'natural colours' is achieved with a play of contrasts and connections as the orange of oranges is opposed to its own deep green foliage. In another sequence the naturally pink Sweet William flowers reflect the pastel palette of early film, reminding us that these colours can be compared to similarly wild hues in nature. Here, we can recall Tom Gunning's assertion that colour helped to support a culture of sensationalism, something that was based in sensual and emotional intensity and dedicated to inciting desire rather than orderly behaviour (1996: 25). Images evoking deeper historical references are evident using colours from the edge of the spectrum with the inclusion of a black-and-white meteorite that hovers, seemingly magically mid-frame, an image of archaic time. Dean relies upon the spectacle of colour to connect time and cinema through fictional references as well as in diachronic references to historical moments.

Colours, recolouring and contrast are used to repeat, vary and reiterate images, and to create analogy. The image of the mountain takes many forms here, but the most startling is in the contrasting use of a vivid red landscape against a deep blue background. Saturated primary colours heighten contrast, denaturalizing the landscape. This luminous mountain almost takes the appearance of three-dimensional illusion, at the very least resembling the depth achieved by the stereoscopic imagery in the Lumière Brothers' travelogues. These are polyphonic indices that reach into film and literary history to reference both the Paramount Studio's insignia and Mount Analogue. Paramount Studios maintained this iconic image of its mountain ringed by stars, a logo that has announced all of its films since its inception in 1917. However, this is also an image representing industrial change as Paramount was the studio forced to end their approach to 'block booking' and pre-selling films. This signalled the demise of broader monopolistic practices of vertical integration which became known as the Paramount Decree (1948). The Paramount insignia introduces the collision of art and industry, offering a broader consideration of the necessity for film to negotiate both aspects of this cultural spectrum. Positioned firmly within the space of the art gallery, *Film* comes down unequivocally on the side of art.

Whilst *Film*'s mountain has a distinctly cinematic heritage, it is also linked to fantasy, offering an image of escape. Dean's mountain images are explicitly drawn from *Mount Analogue: A Novel of Symbolically Authentic Non-Euclidean Adventures in Mountain Climbing*, a book that Rene Daumal wrote during the occupation of Paris in 1944. Daumal had previously been a mountaineer, but this book was written whilst he was suffering tuberculosis, an illness that he did not survive. The book depicts an imagined climb and ends in chapter five, mid-sentence, with characters on the ascent. Dean describes Mount Analogue as higher than any known mountain, its snowy peak reaching into the sphere of eternity. It remains hidden from normal view, only visible when the sun sits on the horizon at dawn or dusk, at a certain moment, in a certain place, by certain people (2011b: 27). Dean says that 'Mount Analogue exists for those who do not doubt the possibility of its existence' (2011b: 27). However, it is not only the repeated symbols of *Film* that provide the spectacle or drive the narrative, it is also the element of chance.

Film and Light: A Relationship of Contingency

Part of the inspiration for *Film* emerges from Dean's interest in exploring the connections between celluloid, light and time. *Film* is not only illuminated by light, it offers a glimpse of light in its most ephemeral form. Dean talks about setting up her camera on a beach in Madagascar alongside others with video cameras, waiting and hoping to see, the flash of green, *la rayon vert* (2013). This green ray is an illusory, ephemeral affect, or flash, across the horizon that can appear just as the sun sets. Dean tells us that the colour green is just slower than the red or yellow rays of the spectrum so it is possible to catch a glimpse of this final ray as an illusion of the setting sun as it refracts and bends beneath the horizon (2013). A view of this illusion is said to be a harbinger of great change, or fortune in the life of the beholder. *Le Rayon Vert* (*The Green Ray*) was also the name of Éric Rohmer's 1986 film, a film that attributes this rare vision only to those who are truly in love. Dean insists that she saw the flash of green on the beach in Madagascar, however those standing next to her did not. They provided instant video playback as proof. As Dean says,

> [b]ut when my film fragment was later produced in England, there, unmistakably defying solid representation on a single frame of celluloid, but existent in the fleeting movement of film frames, was the green ray – having proved itself too elusive for the pixelation of the digital world.
>
> (2013)

For Dean, the apparition of the green ray and film's ability to register this ephemeral illusion across celluloid extends to the act of filming. Capturing a glimpse of ephemeral light is about faith and belief in perception and the specific capacity of film to capture such an illusion. This was one of the reasons that she accepted the Tate Gallery's commission to make *Film* for the Turbine Hall in 2011.

Film was made 'in camera' and as Tacita Dean describes it, involving a level of blindness, experimentation and chance (2013). The process allowed her to experiment with aperture gate masking techniques, effectively filming and re-filming shapes, patterns and effects. She constructed the film basing her work on an additive approach as the celluloid was masked, sections were filmed and then the film was threaded through the camera again. Such a process of addition and repetition meant that Dean could not be sure of the final outcome. Dean remarks that,

> [w]hat I like about the masking is that it's so close to collage and drawing, but it's actually imprinted, and there's no post-producing in this. It's like a highly layered image but all born inside the camera so you don't know what you are going to get. It's a very anti-digital project. I wanted to make a film going back to the origins and invention of filmmaking.
>
> (quoted in Yeoh 2013: n.pag.)

One of the most significant differences between film and digital cinema is that the latter is situated in a known world, producing immediate impressions of the image captured, whilst film processing means that there is a necessary reliance on the unknown. The unknown of celluloid filmmaking involves a different temporality from the known of the digital. Whilst digital promises immediacy through available playback or even synchronous filming, it can return with surprising effects.

Light is inextricably connected to time in *Film*. It is seen in the way that celluloid captures those ephemeral expansions of light in the slowing down of movement. This is noticeable in the image of a bubble that floats and drops, expanding and extending time. Light refracted in the bubble is referenced symbolically as an image of a window frame shimmering on its liquid surface. The duplication of reflective surfaces (in the window, the bubble and in the celluloid) creates an intimate connection between the image and the materials that capture it. But whilst the time referenced by the bubble might seem elongated, ultimately, this symbol of light references a more ephemeral temporality. This is explicit in the lifespan of the bubble and perhaps less obviously a reference to the lifespan of celluloid film. As Royoux writes: 'Few bodies of work have been so thoroughly shaped by the question of representing present time as Tacita Dean's. Throughout her work, the issue is always our time' (2006: 50). *Film* references time extending from the primeval era of the meteorite that hangs mid-frame, through late nineteenth-century experiments with the moving image to the temporary, fragility of the evanescent bubble. The present tense of *Film* intermingles with the past that it relies on, references and re-makes. Past and present point to the question of the future and perhaps hope for the continuity of celluloid film.

The triangular shape that looks like a dog-eared page, as if the film is peeling from its source, pushing the material to the foreground might appear to be a mistake. Actually, it is another sign pointing back to experiments with the potential for early cinema to mobilize movement. As an evolving material, celluloid retains the impact of light in its fading colours or contrast. It carries scratches, tears, bubbles, channels and a brittleness that can threaten the movement of the film through the gears of projection. *Film* carries illusions of deterioration into the image and it is here that the connections to silent film are clearly evident. Risk is a common aspect in the production of celluloid film. Those chances can produce moments when the technique reveals itself, where the effects of experimentation can be seen and felt. The most compelling example of this type of alchemy is the flash frames evident in *Film*. These flash frames are unanticipated effects of celluloid film production, part of the alchemy of photochemical processes. Brief flashes of light emerge between colour transitions as the light of the projector hits a clear frame. Dean maintains these flash frames, making them key to the film. Within the film, flash frames designate a temporal rhythm. Whilst Dean usually edits to the narrative of time, in *Film*, an alternative approach is adopted where the accidental light of the flash frame signals the edit (2013). Rather than being edited out, the flash frame carries the narrative. This ephemeral illusion structures the film, affording it the significance of deliberate, consciously created effects. In *Film* chance produces moments when the material and techniques rise to the surface. These accidental moments connect back to early cinema. They might be noticed in the flash of white light at the beginning of films, or as the projectionist exchanges reels. This flash is an effect of celluloid, a sign of cinematic specificity.

Rosalind Krauss understands the flash frames as an indexical sign of the specificity of film (2016). She sees these evanescent sensations as illusions that parallel Dean's experience of seeing and registering the refracted light of the green ray on the beach in Madagascar (2016). Whilst *Film* carries flashes of light as traces of the indice, it is part of an overall indexical language. Writing on *Film*, Mary Ann Doane points out that: 'What is being indicated, indexed, brought to our attention is the frame itself, as border between everything and nothing, as the cinematic equivalent of the "this"' (2007a: 140). The diminishing border between contemporary film and early cinema is also compromised by the practice of experimenting with early film processes and its effect. Effects are shown in the tones, tints and hand-painted frames. We might also notice them in the circular symbols that centralize the sprocket holes, or reveal the ways that superimposition can produce illusions of worlds within worlds. The border is both evident in the illusion of static sprocket holes on the screen, and it is concealed in the celluloid that passes through the projector. Finally, the border that might otherwise exclude risk is compromised with the inclusion of the flash frames. Markers of the index also include the presence of the projector, its sound and the interrelationship between movement and time, all pointing back (as indices do) to a broader history outside of the frame. Indexicality also has specific resonance for film history, with the particular ability of a light sensitive material to adopt the imprint of time and history. Doane writes,

[t]he photochemical image is an inscription, a writing of time, and it produced for its spectator, a respect for the resistances and thereness of historicity, for that which leaks out and cannot be contained within the notion of semiosis. Its promise is that of touching the real.

(2007a: 146–48)

On celluloid, the ultimate indice points to the position of *Film* within the history of cinema, as one film within a collection of intersecting moments along a historical timeline. Indexicality becomes aligned with historical memory in this context, memory of the film, its era, the role that it takes in contributing to its own history. Doane highlights the importance of a reconsideration of the index in the interstice between celluloid and digital cultures. Doane argues that,

indexicality has become today the primary indicator of cinematic specificity, that elusive concept that has played such a dominant role in the history of film theory's elaboration, serving to differentiate film from the other arts (in particular literature and painting) and to stake out the boundaries of a discipline.

(2007a: 129)

This reconsideration is particularly interesting considering that *Film* is not exclusively an analogue film. Dean's singular concession to digital culture is the 3D printed masking devices that she used to block parts of the frame so that the film can be passed through the camera multiple times to inscribe images, building constellations of various shapes, animations, photographic images and filtered colours. Dean writes about working with the

architect Michael Bolling to invent the range of masks required, revealing that, in the end, they invented 'an aperture gate that worked as a sharp, precise mask, the like of which has probably never been seen before in film' (2011b: 29). The advantage that Dean and Bolling had over early cinema was digital technology. In *Film* the index is intensified using digital tools to create an illusion of celluloid specificity.

In concept, aesthetic and most prominently, in the grandeur of its scale, this is a majestic affirmation of the continuation of celluloid in the digital age. Exhibited in the gallery space, viewers are invited to walk in and look up at this projection and apprehend the magnificence of its scale and dimensions. Here, the mobile spectator selects from a range of options including proximity to the screen, projector and audience. They can begin watching the film mid-way, see it in snippets or in full and repeated on the loop. They can watch the projector, listen to the clatter of the machinery, notice the celluloid as it glides through the apparatus and connects up with the receiving reel. The film itself produces a kaleidoscopic aesthetic because there is so much colour, detail and movement on the screen. The gaze is provided with a range of possibilities, including variations of colour, abstract patterning and the layering of the image. At one stage Tacita Dean's own eye looks back at us from the screen. Spectators can walk through the beam of light and our shadowy outlines can be reflected on the screen. The enormity of scale is further established in comparison to a diminished impression of a human outline. As a print made specifically for a thirteen-meter tall screen to be exhibited in gallery spaces, *Film* might be said to re-inscribe the presence of the aura, something that Miriam Brutu Hansen's reconsideration of Walter Benjamin's work suggests is possible (2012: 104–31). By identifying the broader context of Benjamin's comments on the aura, Hansen reveals how the aura has the potential to 'appear in all things' and is deeply connected to perception, rather than something that emanates exclusively from a singular, original artwork (2012: 104, 107). We might extend this notion of auratic perception towards apperception, where the spectator not only sees, feels and is touched by the installation, but perceives the aura of *Film* in the present and as the intersection of past and present. Hansen also notes how Benjamin understood the potential for the aura to carry with it a sense of foreboding, or a 'premonition of future catastrophe' (2012: 107). In scale, visible technologies and in materials, *Film* offers a vision of awe and wonder. It is also cautionary. Celluloid is used here as an intervention. It affirms the presence of film in contemporary screen culture (in the escalation of screen dimensions in IMAX, circular, dome or panoramic screens), revealing that the techniques, aesthetics, rhythms and flows of early film continue to inform contemporary screen content. It also warns against its obliteration.

A Present Haunted by a Past and a Future

Historical materialists, as Walter Benjamin argues, perceive 'the 'zero hour of events' and 'explode a specific epoch out of the homogenous course of history' (1940 : n.pag.). This is more than a mere reflection of a desire to communicate with the past; it is a reintegration of the past as present. Exploring the confluence of the past and the present helps to reconceive

film history as a dominant element of an exchange. Hal Foster writes that Dean's archival objects, 'serve as found arks of lost moments in which the here-and-now of the work functions as a possible portal between an unfinished past and a reopened future' (2004: 15). He understands Dean as an artist whose work points 'to an archival impulse at work' (2004: 3). He writes that: 'In the first instance archival artists seek to make historical information, often lost or displaced, physically present. To this end they elaborate on the found image, object, and text, and favor the installation format as they do so' (Foster 2004: 4). They also challenge and provoke viewers. Foster writes that, 'these artists often aim to fashion distracted viewers into engaged discussants (here there is nothing passive about the word "archival")' (2004: 6). To consider *Film* as archival is to recognize the historical imprint of the experiments, films, aesthetics and technologies that provided the context for Dean's film. *Film* is made in direct response to the increasing dominance of the digital ecology, or more specifically, to the diminished activity in analogue film culture. It makes us aware that the 'finished past' of celluloid is an illusion. *Film* was constructed and exhibited on a grand scale in an effort to shore up a celluloid future. Whilst the film explicitly references the loss of celluloid, the disappearance of processes, or more specifically, the archiving of the materials and technologies contingent on celluloid film production, it also emphatically states the importance of celluloid in its conception, in its vast scale and in its exhibition in art galleries. It supports an approach to history that prioritizes cycles, rather than an evolutionary progression of time built on replacement, redundancy, obsolescence. This approach re-animates film history, revealing the dynamism of early film experiments. *Film* is a film that draws from the deep history of optical experimentation and consciously stands, in fact looms, against the perception of history that anticipates the obsolescence of celluloid.

Chance and Scale

Another contemporary moving image artwork that increases the dimensions of the screen as well as the projection apparatus is Christian Boltanski's *Chance* (2011). This installation uses image and apparatus to expose the ways in which chance can define lives. It also reveals a clear debt to specific ways in which early filmmakers used the image and the mechanics of cinema to parody modernity. Boltanski examines how chance impacts the very beginnings and ends of life. He says,

> [y]ou are what you are because your parents made love at that exact moment, and if they made love one second after you would be different. The fact that you were born means that there are no other children born because of you – you've killed them in a way.
>
> (Boltanski quoted in Rees 2014: n.pag.)

Image and apparatus are scaled up beyond human dimensions to emphasize the overarching impact of chance on human lives. Media forms are interconnected here as Boltanski collects

Figure 9: *Chance* (Boltanski 2011).

photographs drawn from newspaper archives and builds a machine that invites comparisons to film experiments by the Lumiere brothers, and the chaos of Charlie Chaplin and Buster Keaton's cinema. Each of the three parts of *Chance* subject the viewer to a structure that is overwhelming in scale, but pointed in the way that it reveals the significance of time, particularly chance and coincidence in defining lives.

Chance comprises three interrelated parts. The first and largest is titled *Wheel of Fortune*. This colossal installation built of metal pipe scaffolding takes up the majority of the space inside the French Pavilion at the Venice Biennale (Boltanski 2011). The scaffolding creates a conveyor belt pathway through which zigzags an enormous ribbon of material that looks like celluloid. This frame evokes the mechanical processes of the printing press, or the kinetoscope, perhaps even the twists and turns that celluloid makes as it snakes through a projector. All of these machines move photochemical material through the intricate mechanics with precision and force. However, there is no mass-produced material resulting from the rapid movement within the installation; instead, *Wheel of Fortune* highlights the process of projection through the enormity of its structure and the magnificence of the machine. The spectacle usually reserved for the projection booth is now distributed across the grand scaffolding structure that invites a detailed view of the apparatus.

Figure 10: *Chance* (Boltanski 2011).

A ribbon of what appears to be celluloid blurs photographs of 600 babies drawn from birth announcements in Polish newspapers. When *Chance* was exhibited in Sydney, Boltanski announced: 'At home I have 6000 Polish babies [...] Very quiet' (quoted in Juchau 2014: n.pag.). As Pedro De Almeida notes, these images of new life are 'shrines in veneration of lost souls', a common theme across Boltanski's *oeuvre*, images emerging from an artist who he describes as 'the most ecclesiastical of non-believers' (2014: 18). Most of these babies are photographed with their eyes closed, a reminder of their inability to focus at birth. With still images of babies with eyes closed, they not only represent new life, but hint at the dreadful possibility of death. De Almeida points out the effect of the eyes, 'eerily inviting comparisons to the nineteenth-century custom of post-mortem photography, a vernacular we no longer dare speak since the clinical elimination of sentiment from science' (2014: 18). At unexpected moments an alarm sounds and the machine gradually falls silent. Image catches up as the conveyor belt slides to a halt, rendering individual images clear, projecting a single image of a baby onto a screen. The image of the baby suspended, escalated in scale provides an unnatural image of stillness within necessary movement, a glimpse of death haunting life.

The relationship between movement and stillness in *Chance* is characterized by interruption as the alarm disrupts the continuous, kinetic flow of machinery, images and

numbers. When the bell of what might be an old fire alarm sounds, *Wheel of Fortune* slows and eventually stops to rest on a specific image. The gradual slowing and stopping on a chance image is reminiscent of a poker machine or a prize wheel that attracts a hopeful gaze as it glides to a halt. The resulting stillness means that the blur of multiple images becomes visible as an individual photograph. What might at first seem to be a fault in the machine turns out to be a pivotal moment of time selected randomly causing the machine to halt momentarily. Stillness produces visibility in framed images that become visible when the machine stops at various times throughout its continuous movement. Christopher Allen describes the duality of *Chance* as a combination of irresistible force and surprising serenity (2014: n.pag.). It is exactly this binary that simultaneously enchants and destabilizes the viewing experience.

Image gives way to numbers in the second element of *Chance*. Titled *Last News From Humans*, this section features a counter that dizzyingly connects the intersections of life and death. The green lit numbers count births whilst the red lit numbers signal the number of deaths across the globe. This element of *Chance* presents an illusion of real-time counting, a powerful and clear depiction of the way that public media discourse reduces cycles of life and death to numbers. Boltanski presents these numbers as a stark reminder of the 20,000 more births than deaths in a single day. Like the images, the numbers are an illusion of real-time accounting, a retrospective representation of numbers that have been calculated from an algorithm that calibrates the births and deaths worldwide over a single day. A broad and specific focus intersects here in the numbers that are depicted side by side, numeric reporting of enormous scale and magnitude.

The third element of *Chance* features an interactive touch screen divided into three horizontal bands. In *Be New* found images of 60 Polish newly born babies connect with 52 photographs of deceased adults from Swiss newspapers. Spinning images of beginning and ending lives come together in the third element of this installation, an interactive screen that intersects facial features of each at the press of a button. Fate and chance are at play as the face is seen in terms of resemblance, an indication of genetic connection and inheritance. This is a living memorial. As Boltanski suggests, '[b]y reanimating your late aunt's aquiline nose, or your grandmother's Cupid's bow, your features can call up past generations' (quoted in Juchau 2014: n.pag.). The past is evident in these facial hybrids, clearly expressed in a recombination of inheritance and individuality. Visitors 'playing' *Be New* stand one in 10,000 chance of landing on an individual, lived face. The ironically titled *Be New* emphasizes how reference to fate or fortune disguises a more specific consideration of scientific, genetic rationalism.

Chance also relies on the conjunction of stillness and mobility to transform the experience of spectatorship. The experience of the installation is interrupted by the alarm, surprising viewers, halting their movement. Not only is the spectator halted, their sense of security is destabilized. We are mobile then still, alarmed by the alarm and by the stillness of the machine. Arising from this shock is a moment of omniscience for the spectator as one image of a baby is illuminated on a large screen. The size of the spectator is diminished in contrast to the magnificence of scale in both the apparatus and screen. We look up at the image and

the machine; we try to catch a glimpse of a single frame as movement blurs detail. Sound impacts vision as the alarm functions to narrow and direct our gaze. The broad scope of the all-encompassing view narrows into a specific beam of light and single, projected image as movement gives way to stillness. Once we understand that *Chance* relies on the interruption of movement, the spectator becomes alert and apprehensive, waiting for the next alarm.

The spectator is intuitively guided throughout Boltanski's installation. This is not a spectator who is positioned for omniscience. She is not supplied with cause and effect scenarios; rather, she is asked to consider the intersections between each of the components of the multimedia installation. Her pathway throughout the exhibition is rhizomatic rather than linear. She is offered a new type of suture that does not position her at the centre of the action; rather, it offers a maze to negotiate architecturally and emotionally. The spectator is not the imagined third part, or voyeur, of an intimate discussion. Her position is not one of mastery of the space, or images, instead it is one where she is created at a distance and by a seemingly random pattern of movement and stillness, continuous mechanical sound that is punctuated by the alarm. It might be an experience of mobility and disorientation, a kaleidoscopic view of 26,000 lives, beginning and finalized. With its invitation to negotiate the pipe scaffolding, to try to capture individual images amid the rapid pace of their circulation, *Chance* pushes the senses and emotions to the edge. It is an apprehension of movement, alarmingly interrupted.

Chance makes no presumptions to originality, nor does it situate itself as a spectacular display of the latest digital technology. Instead it relies on and references film and media culture that precedes it. It literally references the Polish newspapers that carry the images of babies at their birth. *Wheel of Fortune* borrows these images, blows them up to dimensions well beyond the limitations of the newspaper, in excess of life size. On the surface, the black-and-white photographic images carry traces of the newspaper print in their combination of low definition and high contrast. The black-and-white photographs resemble individual frames of early cinema, broadly referencing the intersections of photography, newspapers and the cinema as they evolve and expand into mass media. The transferral of the image from the newspaper to the film screen reveals the intermedial slippage from printed to visual media. Boltanski's installation recognizes the contingent relationship between traditional and modern media forms.

Barthes dedicated his book *Camera Lucida: Reflections on Photography* exclusively to photography, noting that in 1980 he 'liked photography *in opposition* to the Cinema' (1981: 3, original emphasis). When considering whether the trigger of the punctum, or 'what I add to the photograph and *what is nonetheless already there*' is possible in film, Barthes concludes with a question and an answer: 'Do I add to the images in movies? I don't think so; I don't have time in front of the screen' (1981: 56, original emphasis). For Barthes, the punctum was not possible in the cinema precisely because it is a medium that relies on movement, one that is subject to 'a continuous voracity' rather than encouraging a pensive view (1981: 56). Laura Mulvey explains, '[f]or Roland Barthes the cinema was unable to activate the *punctum* that he found so moving in the still photograph, that is, the presence of reality, of death, the detail overlooked

by its photographer and visible to its viewer' (2006: 182, original emphasis). Mulvey proposes an alternative view arguing that contemporary delayed cinema deconstructs the flow of time, reinvesting the moving image with the potential to evoke the punctum. Mulvey writes,

> [h]alting the flow of film splits apart the different levels of time that are usually fused together. In detaching the time of the index from the time of fiction, the delayed cinema dissolves the imaginative power of the fiction, as well as the forward drive that, Barthes argues, obscures the cinematic *punctum*.
>
> (2006: 183, original emphasis)

Extending this logic we might be able to experience the punctum represented not only in delayed cinema, but less viscerally in the abstract as traces of time that both *Film* and *Chance* carry on their surfaces. This type of indice would be recognized as part of a deictic semiotic code as similar sensitive points, or signs that are speckled across the surface, rising up as insistent reminders of time and history. Just as the punctum provoked a visceral experience of the convergence of two different temporalities, if we perceive indices like the colours and techniques of early cinema, or the photographic image as pointers to time on the surfaces and depths of celluloid, we can suggest that they exist to point back to celluloid time in digital display, a time that appears to be outside of its own history, but is at the same time deeply connected across a historical spectrum.

Tacita Dean's *Film* responds to this moment of industrial and cultural change by producing film itself and extending it well beyond traditional dimensions. Dean prioritizes film history in her revivification of earlier technique, in the insistence on scaled-up exhibition, in form and content of the film itself by retaining the technologies and materiality designating cinematic specificity. She draws from the past to impress upon the spectator the enduring significance of celluloid history in the present. Elsaesser includes Dean amongst a range of artists/filmmakers who,

> gave a new impetus to reflect about cinema in a multimodal, cross-media, trans-historical context. Hence, the elaboration of a vocabulary that speaks of intermediality, of hybridity, of expanded and even "exploded" cinema to retain a sense of difference in texture and voice, of a clash of associations, emotions, and intensities; of the effects of shock or surprise associated with a mixture of film-based and digital techniques.
>
> (2013: 30)

Here, we're in the realm of celluloid and extending the definition of the index beyond an inscription of the real and towards the spectacular. Whilst one aspect of the debate around the index characterizes it in terms of an ability to register and reflect the real, here, that direct connection is blurred, or open to change in its chemical processes. As Dean says, she is not exactly sure what she'll get with each registration of colour, or when the film is

returned to her after processing. The unknown is very much a part of the production process of *Film*.

Christian Boltanski also uses scale to expose the development of earlier media forms, to emphasize the mechanics of his work *Chance*. Here, steely cold machinery supports the figuration of lives beginning and ending. The design of the apparatus (the *dispositif*) affects an experience of *Chance* that can be described as varying from awe to shock. Both Dean and Boltanski are filmmakers who magnify celluloid illusions and project them onto screens that are so large that they require spectators to perceive and ultimately to experience them differently. In each instance the films foreground aspects of film history to 'bare the device' as neo formalist theorists might define it, defamiliarizing the effect of cinema to renew our understanding of it (Thompson 1988: 10). In each case celluloid is used as an intervention into the (invisible) omnipresence of digital culture. Form, technology and scale in both *Film* and *Chance* borrow, repeat, revitalize traditional forms and early innovations in cinema. There is a hint of digital at the edges of these large-scale films. Digital technologies facilitate celluloid projections both literally and culturally. In *Film* this is evident in the 3D printed framing devices and metaphorically in the forced and imminent change that inspired the production of these works of expanded cinema. Juchau suggests that,

> digital technology is the quintessential medium through which delusion, unreality and deception are manufactured and distributed today [...] digital technology conceals the process by which illusion has been contrived. It is in this context that Boltanski's choice of technology is particularly suggestive. His massive construction creaks and rattles with the old-fashioned and unfamiliar sound of reality.
>
> (2014: n.pag.)

Chance (like *Film*) is intent to protect and preserve the memory of early technologies into the future. Dean does this by reproducing techniques and processes of early filmmaking whilst Boltanski's approach is to deconstruct the machinery of early cinema. Both filmmakers demonstrate the importance of film by inflating their moving images to a scale that highlights the magnificence of the cinema. Both filmmakers are also archivists. Dean recreates the experiments of early filmmakers, Boltanski uses found images as celluloid and relies on the technologies of exhibition to give them new life. Each image and apparatus retains the spectre of film in its most innovative phase of establishment. Interestingly, each filmmaker incorporates an element of chance. The process of layering images onto the celluloid in *Film* resulted in the accidental flash frames that we see in this film, reminders of the essence of light that illuminates all cinema in celluloid and digital forms. *Chance* is also built around the concept of fate in the rhythm of projection, its interruption and in the sequences of image slices that become visible as the film slows to a halt. Both films and filmmakers understand the intersection between celluloid and digital cultures as a key moment of exchange on the historical continuum. Each can be woven into a history of

cinema that has benefited from, and endured, significant change in scale. Returning to a consideration of the dynamic square, Eisenstein notes that these new screen dimensions provide,

> us with such a gigantic new agent impression as the rhythmic assemblage of varied screen shapes, the attack upon our perceptive field of the affective impulses associated with the geometric and dimensional variation of the successive various possible dimensions, proportions and designs.
>
> (1970: 65)

Eisenstein emphatically welcomes in the 'new montage possibilities of Grandeur film never hitherto envisaged or imaginable' and proclaims, 'vivre le roi!' (1970: 65).

Section III

Cinema Beyond the Frame

Chapter 7

Hallucinatory Framing and Kaleidoscopic Vision

Suddenly something clicks, everything vanishes and a train appears on the screen. It speeds straight at you – watch out! It seems as though it will plunge into the darkness in which you sit, turning you into a ripped sack full of lacerated flesh and splintered bones, and crushing into dust and into broken fragments this hall and this building, so full of women, wine, music and vice. But this too, is but a train of shadows.

(Maxim Gorky 1996: 1)

The nearer the engine comes the larger it appears, the dark mass on the screen spreads in every direction at a tremendous pace (a dynamic dilation toward the margins of the screen), and the actual objective movement of the engine is strengthened by this dilation.

(Rudolf Arnheim 1957: 60–61)

The spectators in the Grand Café involuntarily threw themselves back in their seats in fright, because Lumière's giant locomotive pulling into the station seemingly ran toward them.

(Lotte Eisner quoted in Loiperdinger 2004: 90–91)

These descriptions of the exhibition of the Lumière Brothers film *L'arrivée d'un Train en Gare de La Ciotat (The Arrival of a Train at a Station)* (Lumière and Lumière 1895a) identify two aspects existing in tension in the imagination of early film exhibition. These impressions of the 'first' film screenings identify time expressed as movement and the potential danger of the permeable frame. The illusion of continuous movement implies the instability of the frame, particularly in its inability to contain the image on the screen and away from the viewers in The Grand Café. Whilst this film is commonly, perhaps mistakenly, considered to be the first moving image to be screened publicly, the mythology that surrounds this screening shows repeated instances of speculation about the illusion of movement on the screen and its potential to impact the audience. Hayden White identifies how historical chronicles are written to include events within a 'hierarchy of influence by assigning events different functions as story elements in such a way as to disclose the formal coherence of a whole set of events considered as a comprehensible process with a discernible beginning, middle and end' (1975: 7). As White writes, such a chronicalization of significant events provokes questions designed to investigate the connections between events, and significantly, this calls for 'a synoptic judgement of the relationship between a given story and other stories

that might be "found", "identified" or "uncovered" in the chronicle' (1975: 7). The historian's task is to intervene in the spaces between the discovery of stories and their invention. An analysis of the frenzied reporting on the 'first' screening may well provide a hint of the potential for films to incite hallucination of the corporeal impact of film technologies. An intervention would include a careful investigation of the stories and of film itself, followed by a consideration of the position of the spectator. It might also look at how some aspects of this spectatorship continues and is transformed by films exhibited outside of traditional screening spaces.

The movement of the train provides an illusion of dilation (in Arnheim's words) of the engine towards the boundaries of the frame (1957: 61). In Gorky's vivid description the speeding train threatens to penetrate the frame, lacerating flesh and splintering the bones of its female viewer (1991: 1). Gorky's description provides a warning to viewers. 'Watch out!' he proclaims as the locomotive threatens to 'squish' viewers (Gorky 1996: 1). His words highlight the perception of imminent danger as the 'machine of iron and steel will burst out into the darkness of the room and crush everything' (Gorky 1996: 1). Gorky expresses his surprise at the limited colour range and the wall supporting the shifting materialization of the illusion. He writes, 'having appeared from the gray wall, the locomotive disappears behind the footlights of the screen, and the chain of wagons stops [...] Gray people mutely yell, silently laugh, noiselessly walk, kiss without a sound' (Gorky 1996: 1). Gorky describes the world of this film as one filled with phantoms and eternal silences (1996: 1). It is an illusion that both highlights extremes of movement and danger, and subtracts colour and sound. The effect of this is that Gorky's nerves become stretched to their limit. Weighing up the potential impact on bodies and senses by such technological innovation, Gorky writes, '[t]his invention, in light of its amazing originality, can unerringly be predicted to proliferate widely. But is its productivity great enough to compare with the costs in nervous energy?' (1996: 1). Gorky's description of watching the Lumière films provides an early example of the perceived threat that the illusion holds for the spectator who imagines the moving image penetrating the boundaries of the frame, feeling the anxiety of the threat touch his skin and penetrate into his bones, impacting his nervous system. For Gorky, the motion within the frame and its potential to break its boundaries is felt as dangerous.

Eisner's description highlights the spectator's spontaneous, visceral response to the illusion. However, Eisner's words are literally illusory, they appear and disappear. As Martin Loiperdinger explains, Eisner's original German description is missing from the English translation of her book *The Haunted Screen* (2004: 90–91). All descriptions of the experience of early cinema are multi-faceted and slippery. Across diverse historiographies of early cinema, these descriptions appear, disappear, are repeated, contested and dismissed in spiralling patterns that diverge from and return to origin myths. However, a consideration of the subtleties and complexities of movement in *L'arrivée d'un Train en Gare de La Ciotat* is often eclipsed, in favour of the imagination of the onslaught of the train.

A play with stillness and movement characterizes *L'arrivée d'un Train en Gare de La Ciotat*. The motion that distinguishes film from photography also produces wonder, expectation

and anticipation for the viewer. Movement becomes spectacle as the train travels towards the station (and cinematograph), it slows down gradually, eventually halting as passengers alight and embark. The panoramic landscape is dissected by the automotive as it arrives, expands into and crosses the space of the frame. The depiction of space transforms dramatically as the train cuts across it diagonally. The frame is darkened by the machinery. The shining black metal automotive replaces the light and texture of the landscape. The diagonal movement of the train is multiplied by the flows of passengers who move in opposite directions, towards and away from the doors of the train. The film abstracts them into a blurred mass emphasizing the transition between the first image and the last. Before the minute is up and the film stops rolling, the frame has been filled with movement in all directions. Martin Loiperdinger notes the distortion of time with this illusion writing that, '[t]his cinematic effect makes the approaching and seemingly rapidly growing locomotive on the screen appear to be accelerating while, in reality, the locomotive arriving at the station is slowing down' (2004: 104). The impact of dynamic time and movement on static space creates this optical illusion, or afterimage. Some versions of *L'arrivée d'un Train en Gare de La Ciotat* contain a flickering white light, an additional effect of the disintegration of the film which exposes the light that remains at the core of the celluloid print, even after it has been digitized.

Jonathan Crary describes the early nineteenth-century understanding of the optical phenomenon of the afterimage as a 'new objectivity' that marked a movement away from the category of the spectral, towards a more subjective optical truth (1992: 98). Crary points to some of the significant implications that arise from this shift. The first is the notion that the afterimage can be understood as sensory perception, or sensation that remains beyond the stimulus provided by the referent (1992: 98). It is an autonomous vision existing in the eye and beyond, a sensory hallucination. As Crary argues, of equal importance 'is the introduction of temporality as an inescapable component of observation' (1992: 98). If the nineteenth-century observer is understood as subjectivity experienced in time, the addition of the dynamic movement of objects, bodies, of the cinematograph (and the film itself as it dissolves into light) offers an array of spectacular attractions that both extend and challenge subjective optical truth. Crary's research understands the nineteenth-century observer as informed and sophisticated. This stands in contradistinction to the alarmist descriptions of the spectators in The Grand Café.

Tom Gunning also refutes the characterization of the spectator as naïve, suggesting that, '[t]he terrorised spectator of the Grand Café still stalks the imagination of film theorists who envision audiences submitting passively to an all-dominating apparatus, hypnotised and transfixed by its illusionist power' (1995: 115). In such assertions of confusion, audiences of early cinema have been underestimated. Gunning makes the important qualification that, '[r]ather than mistaking the image for reality, the spectator is astonished by its transformation through the new illusion of projected motion' (1995: 116). Astonishment, writes Gunning, 'derives from a magical metamorphosis rather than a seamless reproduction of reality' (1995: 116). Experimentation with the aesthetics of early cinema produces spectacles that often address the audience directly, eliciting a highly conscious mode of viewing, one that is

both curious and excitable. The apprehension of projected motion remains a fundamental element of the experience of viewing the moving image, particularly in films projected outside of the cinema. These experiences encourage movement of the body and a broad and diverse visual perspective, extending beyond the physical immobility and assumed directed gaze of film viewing within the traditional theatrical space. The mythology surrounding the initial viewing of *L'arrivée d'un Train en Gare de La Ciotat* that emerged from the descriptions of this phenomenon by writers like Gorky, Eisner and Arnheim shows early attempts to imagine interactivity and embodiment. In differing ways, each writer suggests that celluloid has the ability to touch, impact and physically activate the spectator who feels the illusion of movement with astonishment and curiosity. Each notes the terrifying ways that this spectacle tests the limits of the film's frame. Theorists like Crary and Gunning understand the potential for the moving-image illusion to impact audiences sensually, emotionally, physically and intellectually. They recognize the importance of the interrelationship between film and spectator, in a process of exchange and discursive creation.

Phantom Ride

Daniel Crooks's installation *Phantom Ride* holds *L'arrivée d'un Train en Gare de La Ciotat* at its core, extending the illusion of movement in new directions. Lumière's train becomes Crooks's camera as he uses mobile framing to invite the spectator to ride and to experience multiple, dislocated viewing possibilities. In *Phantom Ride* the screen is the point through which time passes, forming a threshold between past and future. In this dual screen projection the camera takes the perspective of a traveller at the front and the rear of a train as it moves along its tracks. The camera presents images of transit, both to and from a destination. One side of the screen provides the illusion of forward movement as the camera enters new spaces, whilst the other shows the reverse, a departure from spaces. The consistent elements are the parallel tracks and the drifting pace of the dolly. Gliding towards and away from diverse landscapes, *Phantom Ride* frames a series of spaces around the train tracks, with the new spaces beginning as smaller frames and expanding to gradually fill the dimensions of the frame. The reverse side of the screen shows landscapes decreasing in size to seemingly vanish into the distance. The series of divergent spaces include expanses of dry, rural landscapes; urban bridges tagged with graffiti; mountains of gravel from a mine; lush, green pathways; isolated industrial areas and dark tunnels. Whilst these spaces seem to exist without signs of human presence, they are inscribed with residual traces of human impact. The locations are unnervingly still, almost photographic, and the camera's fluid movement accentuates this as it glides on rails. *Phantom Ride* builds a range of composite landscapes, adding and subtracting spaces within the larger frame. Sometimes multiple versions of these spaces exist within a single frame as a composite, multi-dimensional world.

 Phantom Ride extends the single-shot illusion of *L'arrivée d'un Train en Gare de La Ciotat* into framed fragments of diverse and multi-dimensional realities. Crooks describes the

Figure 11: *Phantom Ride* (Crooks 2016a).

affect as an awkward moment where the portal coming towards the spectator transforms from the framed picture, moving into their reality, enveloping and unsettling the spectator (2016b). The afterimage that remains on the screen gradually diminishes and vanishes into the centre of the image. On the reverse side it expands, exceeding the confines of the frame. Instead of the train moving into a static location as it arrives at a station, *Phantom Ride* offers a gliding movement into and away from landscapes. The subtle movement is designed to destabilize the viewer. Crooks describes it in this way: 'Between worlds there are still these areas where [...] amongst the nearly infinite expanding realms of possible worlds, that there might be these sort of solid streams or threads that come back and tie places together' (2016b). Renaissance perspective is implicit as the parallel train tracks offer an illusion of potential convergence. Spaces that emerge from the edges of the frame disappear into the central, vanishing point. The same principle is modified on the reverse side of the screen as new landscapes emerge from the central point, resonating outwards. Eyes widen, pupils dilate and the perspective broadens as the frame extends, eventually merging with the edges of the screen itself. One side of the screen indicates the continued influence of Renaissance perspective, whilst the other reverses this, offering new visions and worlds introduced with multiplying frames. This may be seen as a recasting of Anne Friedberg's 'multiple windowed screens', images that she describes as digital multiples or, 'gravity-defying digital effects [that] change the physical and temporal laws of the computer-rendered environment. If the digital image is postphotographic; the digital moving-image is postcinematic' (2006: 193). However, the notion of 'post' in Friedberg's claim is understood in relation to *Phantom Ride*

as indebted to its cinematic history, in fact, built from it, whilst advancing to develop new perspectives.

As much as it experiments with the illusion of movement, framing and perspective, *Phantom Ride* can also be compared to experiments with stereoscopic and three-dimensional illusions created by the Lumière brothers in the 1930s. In both instances the films produce images of new worlds extending the possibilities of the illusion. *Phantom Ride* offers an array of transforming patterns, colours, surfaces and aesthetics. There is consistent momentum, either forwards or backwards through a range of polyphonic spaces that are connected by consistent parallel lines. If the limitations of the frame are distended in *L'arrivée d'un Train en Gare de La Ciotat, Phantom Ride* offers a dual view of expanding and contracting frames, expanding and diminishing views of spaces and screens with intersecting histories. This comparison establishes the parameters for this chapter, one that will investigate some of the ways that the image is revised and reframed, potentially even escaping the frame in projections of the moving image. It explores the exhibition of film beyond the traditional cinema, examining the changes to film and to the experience of the viewer within open exhibition spaces. It tracks some of the possibilities of spectatorship as the viewer becomes more mobile, attracted to fleeting impressions of flickering light within these near dark spaces. Having explored the changing frames in *L'arrivée d'un Train en Gare de La Ciotat* and *Phantom Ride*, we can note how the illusion offers differing aesthetics of mobility to astonish the spectator. We can then move on to examine the still and moving images that recreate Hitchcock's cinema as evidence of the enduring desire of cinema to escape the confines of the theatrical frame. Finally, this chapter will investigate The Pompidou Centre's exhibition *Le Mouvement des Images* (2006) to consider how sound, light and image bleeds beyond the frame in the gallery, altering the experience of the spectator and influencing the spaces of the exhibition itself. First, let's situate this discussion in the context of 'the rules' for exhibition. This will allow for a consideration of how they might be broken.

The Rules: Seeing Differently

Adrian Martin explores the changing rules of the game of film in gallery exhibition in his discussion of 'The Rise of the *Dispositif*' (2014: 179). He traces the debate back to '*la querelle des dispositifs*' in the work of Raymond Bellour (Martin 2014: 185). Martin and Bellour explore the shifting status of the classical conventions of film viewing, and the subtle differences in reception as films are seen on computer or mobile phone screens, on screens in public spaces and within the art gallery (Martin 2014: 185). Martin defines the *dispositif* as a game with rules, where the execution of moves and cultural rituals *generates* outcomes, results and sometimes surprises (2014: 179). The *dispositif* includes the rules, technologies and spaces of exhibition. For Martin the *dispositif* is, 'the arrangement of diverse elements in such a way as to trigger, guide and organise a set of actions' (2014: 179). For Martin 'each medium has its own broad *dispositif* – arising from a mixture of aesthetic properties and

social-historical conditions – and each particular work can create its own rules of the game'
(2014: 189). The *dispositif* is also dependent upon change, the 'eternally mutable' in Martin's
words. This is particularly true in instances of early film exhibited beyond and across
histories, using a range of technologies that these films may not have been born into. This
changes how films are seen, understood and experienced at each iteration of their projection.
Visual style, sound, pace, colour and aesthetic can change according to the specific projector,
form of projection, degree of luminosity and of darkness in the exhibition space. Changes in
biology and chemical receptors in the eyes of the spectator also dictate how the images are
received. The rules of the gallery disposition are varied and variable. As Martin suggests, the
gallery *dispositif* offers variations in individual spectator experience, where the visitor is
mobile and must choose pathways and moments to pause, focus and concentrate (2014: 181).
The exhibition of film in the gallery invites a pattern of viewing that extends the view to
incorporate a kaleidoscopic range of images and sounds, extending perspective to include a
visceral and sensory mode of engagement.

In tracing the history of the observer, Crary asks, '[w]hat is the relation between
the dematerialized digital imagery of the present and the so-called age of mechanical
reproduction?' He extends this to wonder, '[h]ow is the body, including the observing body,
becoming a component of new machines, economies, apparatuses, whether social, libidinal,
or technological? (1992: 2). His response suggests an inextricable connection between
culture, subjectivity and observation. Crary writes,

> [m]ost existing answers to this question suffer from an exclusive preoccupation with
> problems of visual *representation*; the break with classical models of vision in the early
> nineteenth century was far more than simply a shift in the appearance of images and art
> works, or in systems of representational conventions. Instead, it was inseparable from a
> massive reorganization of knowledge and social practices that modified in myriad ways
> the productive, cognitive, and desiring capacities of the human subject.
>
> (1992: 3, original emphasis)

It is Crary's express argument that any history of vision depends on much more than change
in representational practices. It is inclusive of the range of possibilities within the visual
field, the techniques, institutions, spaces, cultures and processes involved in the creation of
subjectivity (1992: 5). For Crary, the observer as a historical product, combined with the
cultural practices and institutions that surrounds and defines vision, influences the history
of vision. He also notes some continuity in viewing across time. Crary writes, '[o]bviously
other older and more familiar modes of "seeing" will persist and coexist uneasily alongside
these new forms' (1992: 1–2). At the same time Crary is responsive to the precession of the
non-indexical, virtual sign in contemporary visual culture. Crary writes that,

> [m]ost of the historically important functions of the human eye are being supplanted
> by practices in which visual images no longer have any reference to the position of an

observer in a 'real,' optically perceived world. If these images can be said to refer to anything, it is to millions of bits of electronic mathematical data.

(1992: 2)

The persistence of familiar patterns of spectatorship co-exist alongside new ways of seeing. We note a variation of the implied 'rules' for viewing. Whilst Crary selects the term observer over spectator, I would suggest that such terminology implies a distance and objectivity that may not quite account for the array of attractions, choices, sensations and feelings created by both the spectator and the moving image within the Grand Café in 1895 and watching *Phantom Ride* in the gallery now.

In her analysis of the transition of films into the gallery, Erika Balsom asks what is at stake in the contemporary integration of cinema into the museum and in the claiming of this space for the exhibition of film history (2013: 30). Key questions that Balsom poses include: 'How does this integration produce a new conception of cinema? And how do the specific characteristics of the gallery space change cinematic spectatorship and open a space for a new kind of moving image practice?' (2013: 30). The transition of film into the gallery and its necessary revision of form, along with new modes of address and spectatorship are central to this chapter also. The spectator viewing films in the gallery apprehends the image in a more expansive way than in theatrical film viewing. Spectatorial mobility changes what is viewed and how it is received. Moving images exhibited in the gallery can be condensed to offer a focused view as an excerpt; it can be exhibited to offer a surveying view; it can encourage interactivity, touch and immersion. Spectators move through the spaces at a pace determined by the viewer. Exhibiting film in the museum potentially introduces an element of chaos. Lines of sight and engagement between bodies and moving images can be interrupted by other participants and even by other exhibits. Participants might position themselves at a peripheral angle to the exhibit as they avoid breaching the invisible, intangible, but often powerful space that links spectators to the image. The importance of the field of vision, of the projection of light and sound, of the range of choices shapes the apprehension of, and defines the experience of, viewing films in the gallery. In the gallery, the commitment to the single focus, temporal duration of watching a film is replaced by mobility, choice, seeing film in fragments and often in association with other films. Friedberg describes this as a virtual mobilized gaze, where spatial and temporal fluidities are represented by an 'elsewhere and elsewhen' (2006: 88). As a seer of virtual sights, she may be a version of Giuliana Bruno's 'siteseer', one who voyages through spaces, encumbered by the power differential that a voyeuristic view entails (2002: 15–53). Her senses are activated as are her critical faculties. Shifting patterns of light, colour and movement can extend beyond the visual towards sensations of touch, imaginary smells and tastes as well as the experience of movement, time and duration. The spectator becomes a perceiver, apprehending a broad array of images and sounds, feeling them across and within her body, rather than a single synchronization of these fundamental aspects of cinema. Viewing film in the gallery offers a specific type of vision that can be described as kaleidoscopic. Kaleidoscopic vision builds

from this to describe mobile patterns of apprehension and experience. Kaleidoscopic views recognize the importance of movement and the multiple vistas that become available within the spectator's perspective. It coalesces varying spaces and times, acknowledging the adjacent images and sounds that contribute to the experience. It is broad enough to encompass the range of senses including hearing, touch, smell, perhaps even the sense of taste that Eisenstein suggests is implicit in sensing cinema (1957: 73). This kaleidoscopic view begins with the anxious, imagined audiences described by Gorky and extends to incorporate audiences who might recognize the constellation of film references, one who can respond to and create digital projections.

Hitchcock in the Gallery

The cinema of Alfred Hitchcock was amongst the first to be recast, reimagined and even disarticulated for the gallery space and audience in the new millennium. John Orr perceives Hitchcock as 'matrix figure', a director who produces films that are transferable beyond the cinema and across visual forms (2006). The 'pure cinema' created by Hitchcock has been shown to be equally receptive to exhibition on gallery walls. Specific moments, or intensities, in Hitchcock's film work provide ruptures or limit points, moments of narrative excess where the aesthetic overwhelms the plot and reveals itself as a self-contained artwork. These excesses of cinematic spectacle include: *Marnie's* (1964) red suffusions; *Vertigo's* (1958) animated falling, spiralling sequence; *Spellbound's* (1945) eye slicing nightmare; *Psycho's* shower scene; *The Lodger's* (1927) multiple exposure superimposition of feet walking on the ceiling and *Suspicion's* (1941) painted backdrops with eerily still trees. These sequences are moments that rupture the narrative and reposition the view of the spectator as a hallucinatory vision, an attraction, rather than a sequence of narrative fragments caught and discarded in the service of narrative progression. Transferred to the gallery where they are isolated and repeated, such spectacular scenes may well provide the temporal moments that Barthes could not capture, nor subjectively 'add to' when writing about film's diminished potential to present the punctum (1981: 56). Cleaved, excerpted, isolated or slowed, some of these effects signal a return to the type of contemplative views that are characteristic of viewing photographs.

Writing on Hitchcock's cinema in 1999, Emil Stern argues that *Marnie* is 'a stunning film, messy and always seemingly on the verge of explosion' (1999: 30). Stern understands Hitchcock's films as enacted dreams, oneiric forces where spaces are defamiliarized and temporalities are estranged. He sees this in the impressionistic, sublime red suffusions of *Marnie's* subjective hallucinations, in the static painted gigantic illusion of a ship that forms an uncanny, surreal presence at the end of the street. These moments of abstraction sit within and above the narrative. It is exactly these hyper-stylized, excessive images that position Hitchcock's cinema in an interstice between film and art, moving and still image. With specific reference to Hitchcock's framing, Tom Gunning identifies a 'double logic' in

films that separate the image from the surrounding space, 'creating a fantasy of a window, a portal onto another world' (2007: 29). Gunning specifies that these spaces,

> recurringly open onto another space, onto energies that remain beyond the grasp of the visual and beyond the limits of the frame. If their source remains by necessity unnameable and beyond the configuration of the visual, we can nonetheless locate their destination in the reverse angle of the screen, in the eye of the viewer who receives the projected and reflected beam of light.
>
> (2007: 30)

Spectators who are created in a discursive relationship with the film text are born from destabilization. They are aware of the potential for imminent change.

Traditional film exhibition is redefined as kaleidoscopic display when Hitchcock's cinema leaves the theatrical screening space and is curated for gallery exhibition. Within the gallery space, Hitchcock's films are compressed; other times they can be extended beyond their original duration with the intention of exposing the otherwise implicit methods of creation and construction. It offers a series of choices, attractions and a mobile, expansive mode of engagement. Martin writes that,

> cinema depends, as many have argued, on the locked-in, sat-down position of its average (or ideal) viewer – in place for the start of the film, and (hopefully) still there at the end. The fixed duration and linear unfolding of a film matters, and this is precisely what the situation of the gallery cannot guarantee – that is, unless it completely overturns the normal protocols of art exhibition.
>
> (2014: 185)

The transfer of the moving image into the gallery reduces feature length films to specific sequences, artefacts and even single composite impressions of a feature film. Conversely, the digitization of Hitchcock's cinema also results in moving-image installations that extend time well beyond the director's intention. It is in Hitchcock's cinema that we notice the slippage between pure cinema on celluloid and digital materiality, modifying the 'rules' governing film viewing in the gallery.

Exhibiting Hitchcock's Cinema

Jim Campbell's photographic image, *Illuminated Average #1* (2000) is built from condensing all of the frames that comprise Hitchcock's *Psycho*. It compresses time and space into a single image, reducing the 109 minutes of *Psycho*'s duration into a single impression of stillness. It is an image that obscures the detail of the film into patterns of light and dark. Movement and objects are elided, whilst a white mist obliterates specific detail. This still

image projects a ghostly, veined, white amorphous shape in the middle of the frame, an indication of the density and centrality of *Psycho*'s lighting design. Some objects are barely visible in the darkness at the edges of the frame. The spectral impression of a lamp in the top right corner is compositionally balanced with a jug diagonally opposite. The details etched with light invite the spectator to look into the image, searching for more clues to these clouded forms. *Illuminated Average #1* shows photography attempting to capture the elusive moving image. The photograph compresses the distances of imaginary spaces travelled, from the hotel room in Phoenix, Arizona to the swamp in Fairvale. It also collapses materials, beginning with its original 35mm celluloid film and ending with a pixel-based, digital image. However, rather than reducing the film, the photograph averages out light and dark, condensing detail and keeping what it doesn't capture in the darkness. This indexical image points to all of the details that it eschews, including the road trip, the sense of threat, the shock killing. By reducing *Psycho* to a photograph, digitizing the celluloid, Jim Campbell is attempting to produce an 'electromagnetic memory', one that carries time and details of *Psycho* on its surface, but the darkness also provokes memories of the film. Campbell's photograph points to the history of the film

Figure 12: Jim Campbell, *Illuminated Average #1* (2000).

itself, the controversy, censorship and mythology of this film and Hitchcock's cinema. More broadly, this single image points to the role of photography in facilitating the first moving images. *Illuminated Average #1* recalls the work of early filmmakers who built illusions of movement from still images.

24-Hour Psycho

If *Illuminated Average #1* compresses time into a fragment, Douglas Gordon's *24-Hour Psycho* (1993) does the opposite, expanding time well beyond the duration of the film so that viewers can see details that might be missed in the progression of the film projected at the usual 24 frames per second. In Gordon's installation, *Psycho* is extended from 109 minutes to 24 hours, emphasizing movement, gesture and expression. Gordon uses celluloid for the softness that results from the distance between the projector, the screen and the eye of the spectator. Intricate movements that might otherwise be invisible are rendered visible by slowing time. The crane shot that begins *Psycho* by gliding through the window of a hotel room appears stilted and fragmented in *24-Hour Psycho*, heightening the hesitation of this voyeuristic view. The display of bodies extends in time, further highlighting the voyeuristic nature of framing. The movement of characters is stilted and unnatural. Whilst still in the hotel room, Marion moves into the frame from the bottom, right corner, ascending into a shot that centralizes Sam's shirtless body. Gordon also defamiliarizes the movement of objects like windscreen wiper blades that seem to impede, rather than clarify, Marion's vision as she drives. Slowed shots through the car windscreen take on their own visual style and become abstracted from the narrative. The blackness in the fades is expressed clearly, identifying editing transitions that are usually hidden. This version of *Psycho* reveals more detail than is perceptible when the film runs at its regular pace. Marion's slight eye movements whilst driving in rainy conditions on the highway intensify the danger of her situation. Inside the shower, her vulnerability and then the brutality of the stabbing movement is heightened as it is projected slowly and in intricate detail. The act of killing seems more deliberate than frenzied in this version. Slowed projection revealing otherwise invisible, intricate detail offers an apprehension of the interstices of *Psycho*. These new visions of the aesthetic foreground some of the ways that it is created. It offers contemplative views of framing, disarming detail of the composition of shots and editing transitions. Mulvey notes the importance of this slowed pace for an expanding definition of the cinema, noting that,

> Gordon's own discovery of another dimension to the film image as he slowed his machine to examine a highly self-reflexive moment of voyeurism, can stand symbolically for the shift in spectatorship. *24-Hour Psycho* may represent an elegiac moment for the cinema, but it also marks a new dawn, the beginning of an 'expanded cinema', which will grow in possibility as electronic technologies are overtaken by digital ones.

(2006: 102–03)

Expanded cinema offers a new experience of space and consequently, new modes of engagement, spectatorship, identification and subjectivity. The single image of *Illuminated Average #1* requires the spectator to pause and look into the image to see the spectral indexical traces that point back to the film itself. *24-Hour Psycho* asks the viewer to commit to the screen images, slowing their own sense of time down to focus on those invisible details of the film that rise to the surface.

Both *Illuminated Average #1* and *24-Hour Psycho* are clear examples of the intersection that connects the materialities of newer and older cinema, resulting in moving-image displays of metacinematic art. However, as manipulations of the film for display in the gallery, they reconfigure the rules of cinema and of spectatorship. The rules that applied to viewing *Psycho*, the original conditions of exhibition where viewers were locked inside the theatre, are replaced by a viewing contract that reduces and intensifies the memory and the affect of the 1960 version. By offering obscured fragments of *Psycho*, *Illuminated Averages #1* requires spectators to recall past memories of the film and fill in the gaps that the indexical traces within the photograph provoke. By displaying the less visible details of *Psycho*, *24-Hour Psycho* unravels the flicker fusion threshold that usually produces the illusion of movement. It confronts the spectator with a temporal disruption and an intensification of the experience of the film itself in the present time.

Exhibiting film in the gallery creates new visions, perspectives and definitions of film as art. However, it also provokes a reconsideration of the limitations of spectatorship. Walter Benjamin writes,

> [l]et us compare the screen on which a film unfolds with the canvas of a painting. The painting invites the spectator to contemplation; before it the spectator can abandon himself to his associations. Before the movie frame he cannot do so. No sooner has his eye grasped a scene than it is already changed. It cannot be arrested.
>
> (1968: 231)

If Benjamin's claim that the audience is unable to fully grasp, arrest and contemplate the moving image due to celluloid cinema's rapid frame rate, the revision of the moving image for open plan gallery spaces may well allow the spectator the time for such abandonment. Film transitioning from theatrical exhibition to the gallery rarely does so in the same form of its mode of theatrical exhibition. Inside the gallery, film is deconstructed, compressed or slowed. Time is stalled, exposing details that would otherwise be invisible at 24 frames per second. Exhibiting film in the gallery reveals the otherwise invisible processes of its creation. Concomitantly, modes of spectatorship transition from a single, static viewpoint, a view of light projected across a screen in a darkened cinema, to multiple, polyphonous visions, views of film, both kaleidoscopic and transhistoric. The movement into the gallery space impacts the shifting cultural formation of spectatorship roles as seated viewers become mobile spectators and the single, directed focus transforms into kaleidoscopic viewing patterns as the viewer moves through the gallery setting. This is true of films that have been

re-made as gallery installations, but is it also the case for the exhibition of structural materialist films in gallery spaces?

Film as Exhibition

Film enters the gallery promising an embodied, physical, sensory, temporal, kinetic and immediate experience. One of the first sustained attempts to exhibit this time-based, moving-image art form in the gallery was the Pompidou Center's exhibition *Le Mouvement des Images* (2006). This multimedia exhibition comprised moving and static arts including painting, sculpture, photography, architecture and design. All exhibits pointed towards significant moments in the history of film, when structural materialist, avant-garde, experimental films and installations produced new visions of the history of cinema. Instead of an obvious, chronological historical line connecting individual exhibits, each is placed on a rhizomatic map that invites intersections between the multimedia works and the films. The films displayed in this gallery create new opportunities for viewing and new associations by breaking down dominant evolutionary histories. Accordingly, as the exhibition curator Phillippe-Alain Michaud argues, it becomes necessary to 'redefine' both the films themselves and how they are viewed within these spaces. Michaud argues that,

> [t]his model of entertainment, borrowed from the theatre, whereby a film is projected from beginning to end in a room for an immobile spectator, is no longer the only option for a cinematographic experience. It has become necessary to redefine cinema and the way in which it has been accepted in terms of experience over the last century.
>
> (2006: i)

The elongated passageway is the dominant space of *Le Mouvement des Images*. Whilst the pathway is straight as an arrow, screens are positioned adjacent to and diagonally across from one another allowing for an intermingling of their effects. Visitors walking into the gallery see multiple screens blinking at them, displaying dazzling colour, intriguing black and white, sounds and moving images that call for their presence. Many of these screens show familiar images in surprisingly new ways. Some are projections of sequences excised from feature length films; others condense entire films into one image, or show the intricate detail that is only available from films extended well beyond their original screening duration. Conventional screen definition is disrupted in the museum. Visitors are invited to make up their own narratives from the sequence of exhibits on display.

Richard Serra's 1968 film *Hand Catching Lead* introduces themes of ritual, anticipation and expectation. Serra is known for his work with sheet metal, emphasizing its weight by highlighting scale, velocity and material. *Hand Catching Lead* displays time based on chance as the hand repeatedly attempts to capture the falling lead. The heaviness of the metal is contrasted with the soft flesh of the hand. Focus on the disparate range of materials can extend further to consider the camera and filmmaker, another less visible iteration of metal

and flesh. Repetition and ritual connects *Hand Catching Lead* to the strobe lit illusion of two fused bodies in Paul Sharits's *Piece Mandala (End War)* (1966). Lighting projections, blocks of colour and the frenetic pace of editing in this flicker film impacts and bounces off the surrounding screens. This extended flicker effect results in the projection of colour and an additional level of dynamic movement for *Hand Catching Lead* and Marcel Duchamp's *Anemic Cinema* (1926). Sharits's film recreates the illusion of movement, the flicker fusion threshold and extends this beyond the frame as its light touches other screens. The ephemeral impact of the projected images of *Piece Mandala (End War)* on the swirling concentric circles and enigmatic text of Duchamp's film adds an additional element of serendipity. Similarly, the strobing imagery of Rose Lowder's *Bouquets 1 à 10* (1994–95) impact adjacent and opposite film exhibits. Colour impresses upon black and white, with the dynamic strobing effect lighting up the darkness. This bleeding of sound and image creates a kaleidoscopic vision that includes rhythmic time, sound and lighting effects unique to this exhibition space, unique to one spectator's experience of the constellation of images, sounds, light, space and movement.

To create a renewed approach to structuralist cinema, *Le Mouvement des Images* exhibits both the machines and materials that were used to create and project film. Paul Sietsema's *Empire* (2002) exhibits the apparatus itself, presenting dual views of 8mm film passing through the projector and the spectacle that it creates. The celluloid, projector and beam of light are afforded equal status to the image projected. Peter Kubelka's *Arnulf Rainer* (1958–60) exhibits structuralist film as art. The film as well as its component parts is on display in the gallery. Parallel lines of celluloid filmstrips are framed and hung in the gallery. Each of these metric lengths of film indicates a measure of time for both image and sound. The score is written up on paper and exhibited separately. The darkness of the black frames sits next to light, white frame in reverential acknowledgement of both celluloid and light as pivotal in cinema's material and immaterial foundations. *Arnulf Rainer* exhibits the materials of the film as art forms in their own right. In the exhibition of the film itself, light flickers from black to white, image sequences are separated from the sound track and the film unfolds as a series of elemental oppositions. The rhythmic patterns of the black-to-white flickering montage are sometimes joined by the sounds of static. Such abstract minimalism reinstates the powerful impact of flickering light and sound in the formation of the illusion in Kubelka's films. Dan Graham's *Cinema 81* (1982) appears as an architectural miniature model of a multi-story building, but when a button is pushed, a cinema in a corner of the ground floor level is illuminated. This offers the spectator a view of both the projected beam of light and the screen projecting light back onto the mini audience who watch the film. *Cinema 81* provides another perspective on conventional film viewing, one that expands to uncover the apparatus, rendering visible the materials of the cinema, including the projector and the silver screen. *Cinema 81* is a self-reflexive reminder of the hidden technologies that are at work in the dark in projecting film. This kaleidoscopic, all-encompassing view provides a vision that would be impossible at human scale. It also hints at the focused state of traditional exhibition and the new forms of cinematic interactivity that surround this exhibition space.

The inclusion of Joseph Cornell's film, *Rose Hobart* (1936) is a reminder of the influence and continual presence of early cinema in gallery exhibition. Cornell constructed this film by splicing together existing 16mm film stock that he discovered in warehouses in New Jersey. Most of this stock was from a 77-minute B film called *East of Borneo* (Melford 1931) that Cornell combined with found documentary footage. Cornell cut and spliced both films, reducing the combined sequences to nineteen minutes. He then teamed the film with the soundtrack 'Holiday in Brazil' by Nestor Amaral and reshot the film through a deep blue filter, further defamiliarizing the original and producing a dreamlike effect. The film was edited to focus on the star Rose Hobart, extricating her from the narrative of the Pre-Code film by centralizing her image and emphasizing her gestures and expressions. *Rose Hobart* begins with people looking off screen and then introduces an image of Rose Hobart walking arm in arm with a man, her face expressing trepidation. These images are interrupted by sequences of blue leader. After this prelude, the camera advances rapidly on Rose who appears to be sleeping, her face framed between diaphanous curtains. Further sequences show her dressing, undressing, looking into the distance, rehearsing speeches, responding to her interior thoughts, drinking and watching a volcano. These sequences are selected and spliced together to disrupt logical representations of time and space, foregrounding an atmosphere of hesitation and anticipation. What was once a more classical narrative is now a series of shots that centralize Rose Hobart's image, devoid of context. Editing sequences according to Rose's expression means that the film itself conveys a diverse range of emotions, none of which are consistent from one sequence to the next. *Rose Hobart* concludes with a solar eclipse and a white ball falling into a pool of water in slow motion. All of these light-based attractions: the subtle hints of the film's celluloid material; the blue, other-worldly aesthetic; Rose's enigmatic facial expressions; her hesitant movements and the incomplete sequences are a microcosmic reflection of the kaleidoscopic affects of the broader exhibition. Cornell premiered *Rose Hobart* at a surrealist exhibition in 1931 to such great acclaim that Salvador Dali accused him of stealing his dreams and advised Cornell to continue making boxes.

Valstar Barbie (Lévêque 2003) projects an intense illumination of neon pink, an extreme illusion such that the eyes first widen and then squint to adjust to the intensity of the light. Inside the sealed room that houses *Valstar Barbie,* the viewer's eyes reset to pink before they can apprehend the degree of saturation presented by illuminated neon pink light. The hermetically sealed pink space features billowing pink curtains and walls lit with pink neon lighting. Even the infrastructure is bathed in light so pink that it reflects blue. Hyperreal pink hues are also reflected back by the billowing satin lining the walls and the polished concrete floor mirroring pools of pink. This is the space of fairy tale, with hyper fantasy elevated by both the intensity of the coloured light and the scale of objects. Objects intersect with light throughout the room, a giant jewelled ring flashes off and on, a glittering giant red stiletto sculpture intensifies the seductive hallucination of infantile femininity. The combination of this plastic, hyperscaled fantasy, the wooden floor and the music compelled one young woman to abandon her bag and leap, ballerina like,

Figure 13: *Valstar Barbie* (Lévêque 2003). Photograph: Simon McLean, 2006.

across the floor when I was there. The colour, sound, scale and space of this room inspires performance, something that would be suppressed in conventional exhibition. This type of movement becomes possible when film is reconceptualized as artificial projections of coloured light. But whilst this exhibit is enclosed it also impacts adjacent spaces. Inside *Valstar Barbie* spectators can imagine that they are inside the film itself. Light suffuses surfaces and is projected by the objects themselves. Outside, sound escapes from this otherwise enclosed room and bleeds across other art and film exhibits. New pathways and connections between sound and light offer a prismatic view of the intersections, provoking thematic links across the exhibits, creating new historical contexts. However, it is not only the exhibits that reference the materialities of film, but the spaces that change the films themselves, reminding us of cinema's foundational element, projected light. In *Valstar Barbie* this light is neon, flashing, refracted and frameless.

Galleries are the ultimate examples of a heterotopia. In this enclosed space the visitor is offered a spatio-temporal experience outside of the here and now, emerging from an array of art/artefacts representing disparate times, spaces, ideas, possibilities. Heterotopia privileges

connection, not necessarily the object, art or image. It creates a network of connections and interpretations where meaning is constructed by association, by juxtaposition. Heterotopia, according to Michel Foucault (1984: 4) is the interpretive construction of a reality through fragments. It is a construction of a utopia beyond time and space. Often this is the function and the effect of exhibition in the gallery and in the cinema. A constructed, artificial, mediated and machine projected experience of the present is inextricably linked to the past and often the future. The digital revolution draws from screenings of early film to redefine cinema and alters its mode of exhibition, inviting it into a specific gallery space, collapsing histories and creating new pathways through thematic connections. Innovations in exhibition technologies revise the intentions of structuralist-materialist filmmakers who prioritized filmic materials, particularly film stock, light and sound. Space, design and exhibition combine to create an experience that is linear and spiralling, generating an engagement characterized by a prismatic, kaleidoscopic spectatorship. Film history is reconfigured within the spatial dynamics of the gallery, creating a prismatic view and, ultimately, a mode of kaleidoscopic spectatorship.

Intersecting Histories

Whilst gallery exhibition is distinguished from theatrical exhibition, an examination of the relationship between these divergent spaces reveals the spectral presence of the cinema in the gallery. Lynda Nead is unequivocal about the spectral presence of moving images in its illusions, transitions and imminence when she writes: 'The gallery, it is clear, is haunted by the possibilities of life and imminent movement' (2007: 1). Here, movement includes both illusory movement on screen and the actual mobility of the spectator visiting the gallery. Such movement defines the specific experience of the gallery. It extends and interweaves the history of film from the pre-cinematic to the post-medium. Nead offers a history that similarly links film across pivotal historical moments, separated by almost a century. She writes that,

> [i]n the last years of the nineteenth century and the first years of the twentieth century, the transformation from stasis to movement and the varieties and velocities of motion possessed all forms of visual media, from high art and art criticism, to still photography and magic lantern slides, popular optical toys and projected film.
>
> (Nead 2007: 1)

Movement is the consistent variable of the cinematic illusion; it transforms spectatorship in the gallery. In the post-medium era moving images return to the gallery as historical objects worthy of exhibition due to their age and cultural heritage and due to the recognition of film as art. Film renews the possibilities of exhibition as it is sliced up into pivotal sequences that are highlighted by isolated projection, or juxtaposed with details revealing the conditions of

production that are often rendered invisible in theatrical projection. Nead extends this to consider the influence of temporality on the spectator. She writes,

> [t]he experience of the viewer is also radically changed. No longer whimsical, self-determining individuals who can choose how long to look at a picture, whether to linger in a state of extended contemplation, or to pass straight by, the audience's time is now machine time and they are subjected to automated periods of viewing, controlled by the speed of the wheels.
>
> (Nead 2007: 10)

Gallery viewers are lured by, and can be lost to, the duration of the moving-image exhibit. There is no more obvious indication of film as a time-based medium. However, mobile spectatorship introduces an accentuated mode of temporal experience. The spectator must either wait until the film returns to the beginning, or catch it in fragments, watching asynchronously from middle to end and then perhaps returning to view the film from the beginning. Spectators in the gallery space often encounter images *in media res* and achronologically, a kaleidoscope of both images and temporalities.

It is the moving image itself, elongated or compressed, depicted in miniature, or visualizing the invisible, that confirms the element of time as the continuous link for all forms of film exhibition. Taking Raymond Bellour's point about the *dispositif* into the broader realm of film history, Adrian Martin announces,

> [l]et me be perfectly clear here: I do not believe that the cinema, as we have known it, is dead or dying; or that the medium of film has deserted projection halls once and for all in order to be completely absorbed into galleries, museums and digital archives. My contention is at once more modest and more inclusive: that the contemporary workings of *dispositifs* can offer us a new entrée into rethinking the field of film aesthetics, in a way that *mise en scène*, on its own, has not always invited or encouraged – especially whenever we doggedly hold on to its purest and most classical definition.
>
> (2014: 185)

An expansive history would suggest that the cinema is not dead; instead, it would see possible correlations between varying forms of materialities and technologies, and it would look at the interconnections between innovations and experiments with the moving image during moments of transition. Spaces and screens might transform, but the essential elements of the cinematic experience remain. The beam of light and the reflective screen that captured projections of the Lumière Brothers film, *L'arrivée d'un Train en Gare de La Ciotat*, and is projected onto both sides of the screen in *Phantom Ride* provides evidence of a lively and dynamic history.

An examination of the experience of the spectator and the projection of film in the gallery allows for a consideration of the deeper historical intersections and productive

interrelationships between films exhibited in café, theatrical and gallery spaces. Looking at the practices of gallery exhibition at specific moments in time helps to cleave histories from the dependence on evolution and technological progress, considering it instead as dynamic and achronological. Nead summarizes the issues in this way,

> [a]t the end of the 1890s, in the first years of film, time seemed itself to haunt the new medium. The beam of light, created by the film projector, bore a new kind of historical archive – detailed, authentic and comprehensive – which seemed to fold time in on itself. If history was conceived as a linear progression, with key points or moments, located at fixed positions, then the film archive could capture the image of the past for the future and could draw the dead into a dynamic synthesis with the life of the present.
>
> (2007: 2–3)

Following White's 'metahistory', a new approach to the historical chronicle requires an investigation of story and events. It questions beginnings and ends and it examines presumed interrelationships between events. A metahistorical approach to the ways that film history is narrated requires a reconsideration of origins, and replaces this chronology with an intermedial examination of pre-cinema and post-medium film. It both values historical contexts and understands history as narrative, one where what might be obscured within the folds hold equal significance to existing, written accounts.

Chapter 8

Ephemeral Screens: The *Muybridgizer*

A few years ago the news of the successful photographing of a galloping horse was received with incredulity […] Then, by combining them in a much-improved kind of zoetrope – the zoopraxiscope – the horse can be made to go through the action as perfectly as though he were actually galloping before the eyes of the audience […] This has been done for the horse, and other animals, athletes, gymnasts, and even for birds.

(*Knowledge* [London], 14 April 1882, quoted in Eadweard Muybridge, *The Human Figure in Motion* 1907: 6)

For the materialist historian, every epoch with which he occupies himself is only a fore-history of that which really concerns him. And that is precisely why the appearance of repetition doesn't exist for him in history, because the moments in the course of history which matter most to him become moments of the present through their index as 'fore-history,' and change their characteristics according to the catastrophic or triumphant determination of the present.

(Walter Benjamin 1999: 474)

Muybridgizer and Muybridge

128 years after the editor of *Knowledge* described the incredulity of his encounter with the ways that the Zoöpraxiscope allowed Eadweard Muybridge's photographic images of horses to fly, The Tate Gallery in London commissioned the design of an app called the *Muybridgizer* (Watson and Gobeille 2010). The *Muybridgizer* was developed to revise Muybridge's innovations in chronophotography for the digital age. Its primary aim was to capture time and locomotion, chronophotographic images on the small screen. This app offers a creative, digital application of pre-cinematic photographic experiments, extending the influence of pre-cinema into the present. Whilst it might initially appear as an ephemeral, digital object, one that repeats the moment of transition between photography and film, the *Muybridgizer* is conceptualized here as a portal that both provides access to history and relies on the present to determine the past. To frame this in Walter Benjamin's terms, the app appears as the fore-history of earlier chronophotographic experiments. It exists as neither repetition, nor simulation, but a critical lens through which the past can be magnified and recreated in the present. An exploration of the intersections between the twenty-first century app and the late nineteenth-century motion studies allows for an

investigation of the role of new technologies in the creation of images. It encourages an interrelationship between science and art and it reveals some of the deficiencies of histories that rely on claims of originality.

The *Muybridgizer* is built on a grid of stills, a framework reminiscent of the mode of presentation common to Muybridge's photographic sequences. Users select grids of nine or sixteen images in sepia, black and white or cyanotype. The grid framework invites users to begin to create short films at the endpoint for Muybridge's motion studies. Selecting the grid also reminds the user of the important role that multiple views and cameras had in the production of motion studies. The app reverses the relationship between firsts and lasts, production and exhibition. It begins with the earlier design that Muybridge used to exhibit his motion studies. But whilst the app is influenced by the history that is written around Muybridge, it is also created as a pastiche, one that simultaneously quotes and critiques Muybridge's photographic processes. A hint of the potential for the app to destabilize a simple understanding of Muybridge's experiments can be seen in the numerical formatting of multiple frames. In the app, numbered frames highlight the importance of sequencing and suggest a logical flow of movement. Ornate numbers count to seven or eleven or twelve on each short film. But these numbers appear strangely achronological. Some sequences begin at three, others at six or seven. The numbers not

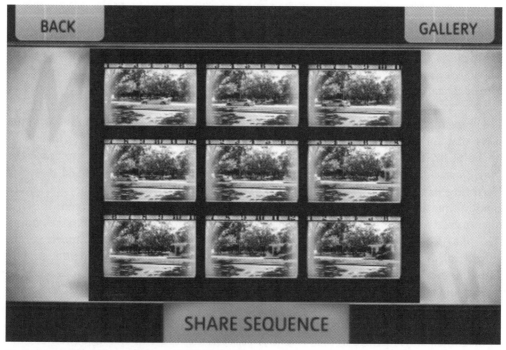

Figure 14: The *Muybridgizer* (Watson and Gobeille 2010).

only attract attention, but also cause confusion as they seem to be positioned randomly. This is just one example of the combination of nostalgia and illusion that the creators of the *Muybridgizer* have built into its design. Another aspect of this nostalgic, illusory design is seen in its colour palette.

In the black-and-white mode, the edges of the frame are blurred white with black dividing lines. The white, spectral blur at the periphery directs attention towards the centre of the frame; the focus falls on the background spatial plane. The combination of blur and focus is designed to create the appearance of the varied definition associated with early photography and film. The colours selected for the *Muybridgizer* reflect retrospective understandings of the imagined colour spectrum of photographic and pre-cinematic images. The sepia option shows a heavy division between the frames and a light grid pattern, another faint reminder of the reliance on the grid structure of Muybridge's photographic series. The sepia colouring traces a pathway from the *Muybridgizer's* crystal and glass surface to Muybridge's reliance on sunshine and liquids for capturing images of locomotion and landscapes. The *Muybridgizer* produces a similar colour affect, transforming the recipe of liquid chemical bromides, sulphur, paper and sunlight into capacitive screens that use tiny cameras combined with glass surfaces and a network of miniscule wires to respond to the electrical charge delivered through the touch of a finger.

In the blur of the edges of the frame, in the use of low-definition images that are inscribed into a high-definition digital ecology and in the achronological numbering of still shots and in the use of metonymic symbolism, the *Muybridgizer* simulates and significantly revises Muybridge's original motion study experiments. The *Muybridgizer* wouldn't exist without its reference point, that is Muybridge's experiments with photography's potential to capture intricate impressions of motion. This is not an attempt to simulate the earlier experiments, rather embedded in its design are hints that demythologize some of the broader historical claims about Muybridge. The *Muybridgizer* is a contemporary signifier that is resolutely tethered to innovations in photography and its impact on early cinema. In Benjamin's terms, it is a 'fore-history' of Muybridge's photographic work. It is a recent moment that reaches back into the prehistory of cinema, identifying particular experiments in photography dedicated to capturing movement, developing colour and creating an impression of instants and sequential time in the still image. As a 'fore-history', it shapes a contemporary understanding of its referent, critiquing some of the assumptions surrounding Muybridge's experiments with photography and film. To investigate how the app uses an illusionistic nostalgic aesthetic to re-inscribe Muybridge's motion studies further, first we have to outline how these experiments have been historicized.

From 1867 Eadweard Muybridge began a series of photographic experiments using multiple cameras and developing processes. Although he worked as a landscape photographer, Muybridge's most famous experiments were designed to capture instants of time in the flight of human and animal locomotion. He used multiple camera set-ups

against high-contrast background planes to record intricate images of animals and humans in motion. Hans Christian Adams understands Muybridge's work as an amalgamation of arts and sciences, 'capturing in succession the "frozen moment"' (2004: 6). Time and image combined in an impression that was rapidly inscribed onto photographic plates. Adams identifies three breakthroughs associated with Muybridge's work. These are the development of a faster photographic process that could capture motion, the creation of successive images that reconstituted an impression of movement and the reanimation of single images in sequence as a moving picture (Adams 2004: 19). Additionally, there were two substantial insights provided by Muybridge's experiments. The first involved the dissection of motion and its presentation in a photograph of seemingly impossible movement of the horse in 'flight'. The second entailed the development of pre-cinematic devices that animate still images. Muybridge developed the Zoöpraxiscope, a sequential movement projection machine first used in 1879, and applied for a patent of this 'picture feeding device' in 1881. Anne Friedberg identifies the hybrid photographic-cinematic form of Muybridge's Zoöpraxiscope in its potential to project single images in a single frame, animated by sequential dissolve (2006: 196). For Friedberg, the Zoöpraxiscope is part of a pre-cinematic tradition of optical devices that provide illusions of movement from a single-point, fixed perspective that is enveloped and constrained within a fixed frame (2006: 196). This remains mechanically and literally true in the *Muybridgizer* as the illusion of movement itself works against the fixed boundaries of touchable screens.

In his photographic experiments, Muybridge used a range of technical, chemical, natural and artistic elements to capture intricate details of animals and humans in motion. He was also photographing at a time of rapid technological progress. He notes that the wet plate process provided obstacles to the speed of registration and definition of the photographs that he had been taking. Muybridge writes that,

[a]t this time the rapid dry plate had not yet been evolved from the laboratory of the chemist, and the problem before him was to develop a sufficiently intense and contrasted image upon a wet collodion plate, after an exposure of so brief a duration that a horse's foot moving with a velocity of more than a hundred lineal feet in a second of time, should be photographed practically 'sharp'.

(1893: 4)

He acknowledges the timeliness of this invention when he indicates that his motion studies were only possible because the 'then newly discovered dry plate process, would result in throwing much additional light on the hitherto little known but important problem of animal movements' (Muybridge 1907: 7). The dry plate, or gelatin process, increased sensitivity of the chemicals so that the plate could register the image quickly and maintain it until it reached the darkroom. Muybridge offers an impression of the significance of timing in his own contribution to photography when he describes the ways in which he

conceptualized the mathematically precise set-up for the motion picture study of the racing horse. Muybridge writes,

> [b]y means of three batteries of cameras electrically operated by a motor-clock, twenty-four successive photographic exposures could be made in a quarter of a second of time; and twelve successive exposures, simultaneously made from each of three different points of view could be completed in the one-fifth of a second. The time-intervals between each consecutive exposure of a series were recorded by a chronograph, in one-thousandths of a second, and are, with a few exceptions, reprinted under each series of illustrations.
>
> (1907: 8)

Muybridge's famous experiments at Palo Alto aimed to use the photographic equipment and processes to register an instant of time that was imperceptible to ordinary vision. The aim was to capture an image of the horse in 'flight', with all four feet in the air. The movement of the horse, Occident, triggered spring electrical contacts that activated the motor clocks and shutters of the consecutively arranged cameras. Time, movement and speed were at the core of this experiment. The motion of Occident's legs caused the bursting threads, followed by the tension and release of strings and the opening and closing of aperture shutters. Muybridge describes his process in this way, '[s]everal phases of as many different movements have been photographed, which the Author endeavoured with little success to arrange in consecutive order for the construction of a complete stride' (1893: 5) Muybridge hints at his intervention in arranging shots to form a sequence, artificially creating an illusion of coherent movement. Muybridge's experiments had two objectives. The first was to capture the intricacy of the fraction of a second of time as disrupted motion when the horse 'flies', and second to show the sequence of movements, the force of Occidental's locomotion. One is vertical, the other, horizontal.

The newspapers reported on these images as 'instantaneous photographs', inscribed onto a negative that had been exposed to less than one thousandth of a second of light (Braun 2013: 42). Muybridge called these images 'Automatic Electro-Photographs', a title that seems to undermine the systematic arrangement, delicate processes and deliberate mathematical calculations of his work and, instead, highlight the motor clock and the magical spontaneity of all of the individual elements operating in unison. Muybridge's motion studies arise from a combination of animal movement and products, technical, chemical, environmental and human forces. Marta Braun describes Muybridge's development process as reliant on the dry plate, gelatin, silver, paper, egg white and sunshine. She writes that, '[t]he photographic image was suspended on the surface in the albumen (egg white) coating rather than embedded in the paper fibres. That meant that the image was glossy, not matte and a final toning gave the picture a Sepia colour' (Braun 2013: 32). The image is inscribed into the egg white and sits just above the surface of the paper. In some versions the paper was subsequently toned in

Figure 15: Eadweard Muybridge, 'The Horse In Motion', 1878.

shades of brown using dual chemical baths, others maintained the range of colours across the black-and-white spectrum.

The *Muybridgizer* introduces a broader history that dispels the illusion of Muybridge as singular, masculine force in the history of photography and film by including techniques that were introduced and practised by other photographers. The cyanotype option references the influence of blue photography in botanical science and later in architectural design. Muybridge used the cyanotype process that was initially developed by John Herschel in 1842 and subsequently practised by Anna Atkins. Atkins's experiments with the cyanotype and heliographic, sun-printing processes allowed her to develop blue prints representing the natural sciences. Her images of leaves, plants and even algae brought early photographic processes into an exchange with botany. Atkins's process of reproduction uses ammonium ferric citrate and potassium ferricyanide in combination with plant specimens and sunlight to create white impressions of plant shapes that are set against the deep blue that emerges from these camera-less photographs. Atkins was not the first to use the cyanotype process, but her work was the first to be published and distributed. Her cyanotypes of botanic specimens were published in her book from 1843 entitled *Photographs of British Algae: Cyanotype Impressions*. This book is identified as the first photography book, or more accurately, the first book to use light-sensitive materials to produce photographic prints along with text written by hand.

As an inventor, Muybridge's history is marked by successive attempts to prove ownership and authenticity. He applied for a patent on the camera shutters in 1883, and in 1878 received copyright control over a series of cabinet cards depicting the horse in motion (Braun 2013: 44). However, the inventions, ownership and veracity of individual images and sequences continue to be questioned and contested. Braun provides evidence of Muybridge's practice of manipulating the photographic image after printing (2013: 41–51). She mentions how Muybridge's practice included photographing paintings that were glued onto canvases before being rephotographed, 'adding details that the camera could not capture' (2013: 43). Muybridge also painted some photographs to enhance the contrast and clarity of their outline. Braun suggests that, 'Muybridge certainly retouched the final prints when he needed to, outlining the legs, mouth, or mane of the horse, highlighting the mid tones and de-emphasizing the background' (2013: 44). In these instances painting is used to enhance the clarity of the photograph. The hand that designed the system of trip wires, camera positions and dry plate developing processes also used the paintbrush to clarify, define and improve the contrast of the image.

Not only was the individual photograph retouched, the temporal arrangement of many of the motion studies was manipulated and re-sequenced. Braun reveals that a 1999 discovery of Muybridge's cyanotypes and contact proofs made from the negatives show differences with the published collotypes (2013: 47). The images printed on glass slides were cropped, reframed and repositioned out of sequence. The stills may even represent individual shots taken from multiple rehearsals of movement. What are now termed 'bullet time' sequences are actually montages of still photographs that are falsely positioned to offer an impression of continuous time. However, Braun understands this process of photo collage as entirely acceptable for its time and that to make a claim against its veracity is quite a modern response to questions of photographic authenticity (2013: 42). The seemingly random numbering on the *Muybridgizer's* sequence hints at Muybridge's tendency to manipulate the ordering of his photographs to provide an illusion of sequential motion. Suspicion of the digital image's potential to manipulate indexical reality has a firm base in Muybridge's intervention in the post-production of the motion studies that he created as early as 1867.

The *Muybridgizer* not only captures disruptions of time, but a swipe of the user's finger extends it both forwards and backwards at various speeds. In the animated view, those numerical inscriptions that distinguish frames appear to count and regulate time. Movement is instigated by touch, with force dictating velocity in a similar way to the spinning Zoöpraxiscope. However, the signification of both time and movement is illusory. Not only are the numbers misleading in the *Muybridgizer*, but the sequential arrangement of still images of locomotion is built from a range of gestures repeated and photographed. In the motion studies false ordering gives rise to an illusion of movement as images of the body in motion display an impression of stilted, disconnected time. This is continued in the app where a disjointed temporal flow is created as a retrospective illusion of disjointed temporal flows, an overall signifier of the precariousness of motion in pre-cinematic images. Disjointed time as well as the appearance of blurred focus at the edges and a lack of

definition in the image is an effect created with digital technologies that have the capacity for high-definition imagery. False movement and experiments with continuity are not limited to photography and early cinema. Deleuze identifies false movement as emerging from 'false continuity' in modern cinema (2014: xi). Here, Deleuze is referring to images that are linked by irrational cuts. He also identifies the potential for the revelation of time in the movement of the body. Deleuze writes that, '[e]ven the body is no longer exactly what moves; subject of movement or the instrument of action, it becomes the developer [révélateur] of time' (2014: xi).

The *Muybridgizer* is deliberately nostalgic for the imperfections and eccentricities of pre-cinema. It offers a nostalgic illusion of early photography and motion studies. There is no desire here to conceal the flicker, or to disguise the disruption that arises from a sequence that does not quite reach the flicker fusion threshold. The *Muybridgizer* uses key moments, inventions and aesthetics from the history of photography to produce post-photographic, digital films. Analogue, photographic inscriptions of movement are presented as artificially stilted, digital impulses, taking the form of fake nostalgia. In this instance, we can recall Benjamin's suggestion of the importance of the present in determining lost or forgotten moments as the *Muybridgizer* reveals the concealed details of the historiography in the transition of photography to film.

The historicization of Muybridge's motion studies does not end with the development of the *Muybridgizer*. This is a history that reconnects with the sciences and extends towards the future. Most recently, scientists from Harvard University digitized a sequence of five of Muybridge's images of the horse 'in flight' and recast them into the very essence of the body, the DNA. Muybridge's motion studies of bodies that were earlier captured on photographic plates have now been transcribed into the cell structure of DNA. This is an experiment in the capacity of cells to store and collect data. Movement remains the area of focus, but in this instance it is the miniscule movement of biological cells in response to Muybridge's images that is under investigation. In this experiment the roles are reversed. Bodies and cells become screens, exhibiting rather than being exhibited by the moving image. Digital versions of early cinema revise experiments with time, photography and the body that recalls pre-cinema.

Touching the Moving, Moving Image

What might at first appear to be a key difference between Muybridge's production mode and that of Watson and Gobeille concerns the portability of the technologies for production. The cumbersome equipment that Muybridge transported by horse and cart is vastly scaled down. The *Muybridgizer* presents film history as mobile and in miniature. But it is in the app's invitation to create that we can note some similarities with the inclusive culture of pre-cinema. Pre-cinema was both accessible and surprisingly, similarly tactile. Erkki Hutamo identifies pre-cinema as involved in a 'conversational relationship with media, and as a

consequence with others' (2013: 368). This resulted from the miniaturization of panoramas where anyone could turn the crank to make the panoramas move, or even add their own prosceniums, picture roles and performances (2013: 368). Hutamo writes about the early nineteenth-century toy movie theatres that,

> bought media to the fingertips. Ephemeral as they might seem, they provided seeds for the growth of personal interactive media – laptop computers, game consoles, iPhones, and all the other gadgets we cannot stop fingering these days. As the device became smaller, the human grew – or at least seemed to grow – bigger.
>
> (2013: 368)

Hutamo's work invites us to consider the role of interactivity in pre-cinema, dispelling the assumption that this level of engagement is what makes the contemporary film experience distinctive. Spectres of earlier forms of cinema and photography are recreated in apps like the *Muybridgizer*, which spring to life with the touch of mobile digital screens.

Thomas Elsaesser references effects such as the impression of hyperreality, agency, tactility, interactivity, along with the suggestion that, rather than being separated by the cinematic frame, contemporary audiences share the space (2013: 39). Significantly, the result of this shift is that it requires a reconsideration of the definition of the illusion. In Elsaesser's words, 'on both sides of the divide, these effects are "illusory," but this implies also a new meaning for the term "illusion"' (2013: 33). Digital film replicates and re-makes the illusion, presenting it within an alternative realm. Contemporary cinema is indebted to early film experiments, re-making the illusion and in some instances, taking it into a new spatial and experiential realm. It is an illusion that is deeply connected to its own visual history. The illusion produced by digital technologies carries the spectre of celluloid on its surface, in the depths of its imagery and in the myriad networks of its history.

In considering how the *Muybridgizer* positions the user as both creator and spectator, we can draw from Vivian Sobchack's understanding of the discursive relationship between film and spectator. For Sobchack, '[b]oth the spectator and the films visible bodies are lived also as visual bodies. They both are capable of commuting perception to expression and expression to perception' (1996: 290). This extends the discursive range and envisages a paradigm that includes film, the spectator, the past as well as present of film history. We can see this clearly in the traces of Muybridge's experiments, in those hints revealing false continuity, in the spectrum of colours reminiscent of the work of Atkins and Herschel, as well as in the unsettling questions of authenticity that arise from the nostalgic illusion created as the digital revises analogue. What remains to consider is the relationship between new and old cinema and the contingency of their relationship. If they are inextricably connected, how might we conceptualize the shape and form of this reliance? If a digital app can carry traces of a hidden, critical history of chronophotography, how might we characterize this within the overall history of cinema? Is the digital Muybridgizer cinematic?

New Film Histories

A renewed conceptualization of the history of the moving image perceives it as a matrix of connected and disconnected moments. Rather than segmentation or division, this disconnection invites innovative approaches to exploring the interrelationship of the digital and the celluloid. A media archaeology that is associative, diachronic and innovative conceptualizes the past in the present and the presence of the past. It is an approach that is ambitious in its encapsulation of diverse media, including the still and the moving, the photographic and the animated sequence. Elsaesser and Hagener propose a new scenario for understanding the connections between film and digital, suggesting that

> 'digital cinema' gives notice of a new hierarchy and power-relation, whereby the adjective trumps the noun, and the tail wags the dog: cinema is henceforth an adjective or attribute of the digital, rather than the other way round: this tacit reversal then, would be the common denominator, to which the embedded contradiction can only point.
>
> (2009: 173)

This re-ordering of digital and cinema undervalues the reliance of the digital on its celluloid past. The digital image is drawn from the language, style, form, history and context of the cinema. It is little more than a pixel without it. They also argue that in the era of digital cinema, the senses are

> even more central for a theoretical understanding of the film experience, whether it is the feeling of bodily presence created through digital sound, the sensory overload and profusion of detail achieved by high-definition digital images when projected in an IMAX theatre, or the 'freedom' to have 'movies on the go' on portable devices and control their sequence and flow with our hands.
>
> (Elsaesser and Hagener 2009: 171)

The sensory experience of the *Muybridgizer* delimits sound and connects touch with vision, adding slightly different touches and lateral gestures to the tactility necessary to produce the photographs. However, the touch of materials differs from fine paper, wet liquids and warm sunlight to the hard, cool glass of the portable screen. The relationship between celluloid and digital, specifically apps that reimagine visual history, is not one of replacement or redundancy, but could be more accurately characterized as reinvention and rediscovery. It is through an examination of the similarities and the differences between older film and new media that a more inclusive, multimedia history can be proposed.

Mulvey's research proposes an understanding of new and old cinema based on an interweaving and intermingling of past and present (2011: 71–81). She posits that new technologies open up new forms of temporality. Mulvey argues that the transfer of celluloid into a digital format allows for complex temporalities receiving greater visibility

(2011: 76–77). We saw how damage to celluloid can survive and exceed the digital in *A Trip to the Moon*. Here, we can see the revelation of chronophotographic disruption of Muybridge's motion studies in the sequences created via the *Muybridgizer*. Mulvey writes, 'the "then-ness" that appears within the old celluloid image brings the history that belongs to it palpably into the present, translated onto an easily accessible form' (2011: 76). The dynamic interrelationship between past and present is rarely depicted more clearly in early cinema that has been restored, or reimagined, and transferred to the digital format. This is noticeable in traces of history that are carried in digital forms. It becomes evident in the momentary pause that exposes the traces of orthochromatic film, the use of colour as spectacle in the serpentine dance films and the references to achronological display in the *Muybridgizer*. We might add the metonymic patterns of editing designed to virtually assault the spectator in films from *The Great Train Robbery* to *Crossfire*. The dynamic square that Eisenstein found so compelling (and concerning) is cast into light in *Film* and reconnected to its photographic indice in *Chance*. German Expressionist narrative and aesthetics are remembered in the 'strange eroticism' and neon lighting of contemporary noir films. The spectator in The Grand Café who is imagined as pulverized into dust by a speeding locomotion might feel the impact of *Piece Mandala (End War)*'s strobing montage dilating her pupils and escape to the neon pink cinematic wonderland of *Valstar Barbie*. Lana Del Ray's morphing, deconstructing digital dress reimagines Loïe Fuller's experiments with radium and coloured light. In scaling it up to extreme proportions and in the intricacy of its deconstruction, contemporary digital effects re-make experiments in early film and its exhibition. In Mulvey's words: 'different kinds of temporality and relations between times become more clearly apparent as the indexicality of celluloid is translated onto and manipulated through new media' (2011: 77). Mulvey's assertion is that, '[a]s the flow of cinema is displaced by the process of delay, spectatorship is affected, re-configured and transformed so that old films can be seen with new eyes and digital technology, rather than killing the cinema, brings it new life and new dimensions' (2011: 80).

The shift to digital film does not signal the end of cinema. Key questions remain, however, about how more than a century of cinema will be archived and how it will be exhibited. Where are we able to see early film and how might that experience of spectatorship change in the digital world? Elsaesser questions the impact of digital film culture on film history, asking:

> Does this mean that we should endorse, after all, the 'death of cinema' or rather accept its historical function as an intermediary – some have even called it an 'intermezzo' and a 'detour' – between the visualization of natural phenomena previously imperceptible to the human eye (chronophotography as understood by Eadweard Muybridge and Etienne-Jules Marey) and the coding, compression, and transmission of information graspable by the human mind (of which narrative cinema has until now been the *historically contingent* 'database' and 'memory' because it inscribes the perceiving observer into the impersonal data flow)?
>
> (2013: 38)

One of the suggestions offered by Elsaesser specifies that, *'digital cinema "emulates" photographic cinema as one of its possibilities (and this is still the majority of its applications), but it obeys different logics'* (2013: 37, original emphasis). These arguments surrounding the index, cinematic specificity and materiality support an understanding of film history as a series of interrelated moments in optical experiments including digital media. Elsaesser asks,

> did it bring about a rupture in the history of cinema that some critics have experienced as traumatic and terminal, or have we simply misunderstood the meaning of 'index'? For those in the former camp, digitization quite literally means the end of the cinema, so that there cannot possibly be convergence. Instead, in this light, an era of post-cinema has begun, with its own characteristics and certainly based on a different-ontology.
>
> (2013: 22)

The argument about a loss of indexicality in digital film imagines a coherent, formal, evolutionary history, a dominant narrative that has framed cinema for more than one hundred years. Such historical mapping according to a traditional understanding of indexicality and cinematic specificity reduces the definition of film to its potential to capture the 'real'. It prioritizes the documentary image and with that, verisimilitude. It is illuminating to consider the concept of indexicality beyond the confines that limit the debate to photographic inscriptions of the real onto film and to broaden the focus to incorporate cinematic images of spectacular imagination. These are images that are not invested in replicating or reproducing verisimilitude; rather, they exploit the potential for cinema to extend beyond the reality principle. As Elsaesser suggests, this would necessitate a consideration of post-cinema alongside a revised ontology of the moving image. Such a consideration must surely be framed within a reconceptualization of cinema as multimodal, intermedial and trans-historical.

I built this argument on a foundation provided by the approach to pre and cinematic optical histories written by Jonathan Crary. He writes that, 'it should not be necessary to point out there are no such things as continuities and discontinuities in history, only in historical explanation' (Crary 1992: 7). New film histories should be open enough to consider intersecting moments across a protracted timeline. It should also offer an explanation of discontinuities and continuities, presenting dynamic, emergent histories via a consideration of these intersections. It identifies histories as constructions, and mine is one of many, each with their own political motivations. Crary writes, 'how one periodizes and where one locates ruptures or denies them are all political choices that determine the construction of the present' (1992: 7). Additionally, these explanations, constructions and political choices are most certainly about understanding the present, but not in a strictly chronological, cause and effect, pattern. They enable an imagination of time and histories as cyclic, or rhizomatic, rather than limited to an exclusively progressive momentum. Whilst Crary's focus is on the historical construction of vision, looking specifically at the change in

the culturally established notions of observer and representation, I have attempted to flesh out the experience of vision to be inclusive of the broader range of senses.

Moving beyond the historical chronicle allows for an understanding of cinema as intermedial. It always was and will be deeply aligned with the broader visual and media arts. It is deeply connected to photography in its early development, and it remains so in the transition to digital practice. Cinema is, obviously, inextricably connected with its own history and the broader histories of visual culture, but this history is one of dialogic connection as the older informs the newer, as the newer is indebted to the older. The assertion of a specific cinematic materiality should not distinguish or limit the intersections between analogue and digital film; rather, this could be understood productively and respectfully with a recognition of the materiality of digital film. Cinema is multimodal and multimedia[1]. It exists in the form of prints, copies, re-makes, revisions and simulations. It is rarely original or singular. But this has always been the case. From the ways that Muybridge painted his motion studies and constructed artificial illusions of movement, from the ways that Méliès's films were copied and re-made, from how black-and-white films were coloured by girls and women working in colour factories, producing spectacular variants, from Loïe Fuller's theatrical performance of the serpentine dance, re-made in multiple versions in silent film, revised by Lana Del Ray who disarticulated the dance using the digital effects. We notice it in the continuing significance of Eisenstein's vertical montage in digital installations and it is clear in the ways that noir films and the histories that surround it rely on memory. A more accurate understanding of film and history, material and concept would see celluloid and digital as contingent, dynamic and fluid. Film history is actively engaged on contemporary screens. Early cinema and new media share a desire to explore the limits of their forms and to exploit the possibilities of vision and illusion, provoking astonishment through interactivity. This perspective rejects a history of film that perceives only ends, proposing a new understanding of cinema in the digital age that is defined by interlaced beginnings, interactive engagement and recognition of the inextricable link that connects the present image with its past and future.

Bibliography

Adams, H. C. (2004), *Eadweard Muybridge: The Human and Animal Locomotion Photographs*, Cologne: Taschen.

Albera, F., Le Forestier, L. and Turquety, B. (2013), 'De la Terre a la Lune (Dossier about film preservation and *A Trip to the Moon* by George Méliès)', *1895: Mille huit cent quatre-vingt-quinze*, 69, https://journals.openedition.org/1895/4613#tocto1n1. Accessed 5 September 2018.

Albright, A. C. (2007), *Traces of Light: Absence and Presence in the Work of Loïe Fuller*, Middletown: Wesleyan University Press.

Allen, C. (2014), 'Christian Boltanski takes a big chance with installation at carriageworks', *The Australian*, 22 February.

Arnheim, R. (1957), *Film as Art*, Berkeley: University of California Press.

Atkins, A. (1843), *Photographs of British Algae: Cyanotype Impressions*.

Aumont, J. (1996), 'What's the difference', in D. Hertogs and N. de Klerk (eds), *Disorderly Order: Colours in Silent Film*, Amsterdam: Stichting Film Museum, pp. 50–61.

Balsom, E. (2013), *Exhibiting Cinema in Contemporary Art*, Amsterdam: Amsterdam University Press.

Barker, J. (2009), *The Tactile Eye: Touch and the Cinematic Experience*, Berkeley: University of California Press.

Barthes, R. (1973), *The Pleasure of the Text*, Paris: Editions du Seuil.

—— (1981), *Camera Lucida: Reflections on Photography*, New York: Hill and Wang.

Baudrillard, J. (1994), *Simulacra and Simulation*, Ann Arbor: University of Michigan Press.

Bazin, A. (1960), 'The ontology of the photographic image', *Film Quarterly*, 13: 4, pp. 4–9.

Beckett, S. J. (1900), *Loie Fuller Dancing*, London (gelatin silver print).

Bellour, R. (1991), 'The film stilled', *Camera Obscura*, 24, pp. 98–124.

Benjamin, W. (1940), 'On the concept of history' (trans. Dennis Redmond), https://www.marxists.org/reference/archive/benjamin/1940/history.htm. Accessed 26 November 2016.

—— (1968), *Illuminations* (ed. H. Arendt, trans. H. Zohn), New York: Schocken Books.

—— (1999), *The Arcades Project* (trans. H. Eiland and K. McLaughlin), Cambridge, MA: Harvard University Press.

Birchard, R. S. (2011), 'Restoring Méliès' marvel', *American Cinematographer*, October, pp. 68–72.

Boltanski, C. (2011), *Chance*, Venice Biennale.

Bolter, J. D. and Grusin, R. (2000), *Remediation: Understanding New Media*, Cambridge, MA: MIT Press.

Borde, R. and Chaumeton, E. (1996), 'Towards a definition of *Film Noir*' (originally published in *Panorama du Film Noir Américain* 1955), in Alain Silver and James Ursini (eds), *Film Noir Reader*, New York: Limelight, pp. 17–35.

Bordwell, D. (2011), 'Time piece', Observations on Film Art, 21 February, http://www.davidbordwell.net/blog/2011/02/21/time-piece/. Accessed 20 June 2015.

Braun, M. (2013), 'Muybridge, authorship, originality', *Early Popular Visual Culture*, 11:1, pp. 41–51.

Bruno, G. (2002), *Atlas of Emotion: Journeys in Art, Architecture and Film*, New York: Verso.

Buñuel, Luis and Dali, Salvador (1929), *Un Chien Andalou*, Paris: Les Grandes Films Classiques.

Campbell, J. (2000), *Illuminated Average #1 – Hitchcock's Psycho*, San Francisco, CA: Hosfelt Gallery.

Chaplin, C. (1936), *Modern Times*, Los Angeles, CA: Charles Chaplin Productions.

Cook, P. (2005), *Screening the Past: Memory and Nostalgia in Cinema*, London: Routledge.

Coole, D. and Frost, S. (2010), *New Materialisms: Ontology, Agency, and Politics*, Durham, NC: Duke University Press.

Cornell, J. (1936), *Rose Hobart*, New York: Joseph Cornell.

Cosandey, R. and Malthête, J. (2012), '*Le Voyage dans la Lune* (Lobster Films/Georges Méliès, 2011): Ce que restaurer veut dire', *Journal of Film Preservation*, 87, pp. 7–10.

——— (2013), '*Le Voyage dans la Lune* (Lobster Films/Georges Méliès, 2011): Ce que restaurer veut dire', *1895: Mille huit cent quatre-vingt-quinze*, 69, https://journals.openedition.org/1895/4613#tocto1n1. Accessed 3 September 2018.

Cowie, E. (1993), 'Film Noir and women', in Joan Copjec (ed.), *Shades of Noir: A Reader*, London: Verso, pp. 121–66.

Crary, J. (1992), *Techniques of the Observer: On Vision and Modernity in the Nineteenth Century*, Cambridge, MA: MIT Press.

Crooks, D. (2016a), *Phantom Ride*, Melbourne and Singapore: Anna Schwartz Gallery and Future Perfect.

——— (2016b), *Phantom Ride: Interview*, The Australian Centre for the Moving Image, https://www.youtube.com/watch?v=4FrOoxz71Zg. Accessed 1 March 2017.

Cubitt, S. and Thomas, P. (2013), *Relive: Media Art Histories*, Cambridge, MA: MIT Press.

Daumal, R. (2010), *Mount Analogue: A Novel of Symbolically Authentic Non-Euclidean Adventures in Mountain Climbing*, New York: The Overlook Press.

De Almeida, P. (2014), 'In veneration of lost souls: Christian Boltanski's *Chance*', *Art Monthly Australasia*, April, 268, pp. 18–21.

de Chomón, S. (1908), *An Excursion to the Moon*, Paris: Pathé Frères.

——— (1908), *The Gold Spider*, Paris: Pathé Frères.

Dean, T. (2011a), *Film*, [35mm film], London: Tate Modern.

——— (2011b), *Film*, London: Tate Publishing.

——— (2013), 'On *Film*: Interview at the Australian Centre for Contemporary Art', https://www.youtube.com/watch?v=8dOEXl_3lzI. Accessed 3 July 2014.

Deleuze, G. (2014), *Cinema II: The Time Image* (trans. Hugh Tomlinson and Robert Galeta), London: Bloomsbury.

Dick, P. K. (1968), *Do Androids Dream of Electric Sheep?*, New York: Doubleday.

Dimendberg, E. (2004), *Film Noir and the Spaces of Modernity*, London: Cambridge University Press.

Doane, M. A. (2002), *The Emergence of Cinematic Time: Modernity, Contingency, the Archive*, Cambridge, MA: Harvard University Press.

——— (2007a), 'The indexical and the concept of medium specificity', *Differences: A Journal of Feminist Cultural Studies*, 18:1, pp. 128–52.

——— (2007b), 'Indexicality: Trace and sign', *Differences: A Journal of Feminist Cultural Studies*, 18:1, pp. 1–6.

Duchamp, M. (1926), *Anemic Cinema*, Paris: Marcel Duchamp.

Durgnat, R. (1996), 'Paint it black: The family tree of film noir', *Film Noir Reader*, New York: Limelight, pp. 36–51.

Edison, T. A. (1894–97), *Annabelle Dances and Dances*, New Jersey: Black Maria Studio.

Eisenstein, S. (1957), *The Film Sense* (ed. and trans. Jay Leyda), New York: Meridian Books.

——— (1970), 'The dynamic square', in Jay Leyda (ed. and trans.), *Film Essays and a Lecture*, Princeton, NJ: Princeton University Press, pp. 48–66.

Elsaesser, T. (2004), 'The new film history as media archaeology', *CiNeMAS*, 14, pp. 75–117.

——— (2013), 'Digital cinema: Convergence or contradiction', 'Cinema in the realm of the digital: Foundational approaches', in A. Herzog, J. Richardson and C. Vernallis (eds), *The Oxford Handbook of Sound and Image in Digital Media*, Oxford: Oxford University Press, pp. 13–44.

Elsaesser, T and Hagener, M. (2009), *Film Theory: An Introduction through the Senses*, New York: Routledge.

Ezra, E. (2000), *Georges Méliès: The Birth of the Auteur*, Manchester: Manchester University Press.

Faiman, P. (1986), *Crocodile Dundee,* Byron Bay, NSW: Rimfire Films.

Flitterman-Lewis, S. (1996), *To Desire Differently: Feminism and the French Cinema,* New York: Columbia University Press.

Fossati, G. (2012), 'Multiple originals: The (digital) restoration and exhibition of early films', in A. Gaudreault, N. Dulac and S. Hidalgo (eds), *A Companion to Early Cinema*, West Sussex, UK: Wiley-Blackwell, pp. 550–67.

Foster, H. (2004), 'An archival impulse', *October*, 11, pp. 3–22.

Foucault, M. (1969), *L'Archéologie du savoir* (*Archaeology of Knowledge*), Paris: Editions Gallimard.

——— (1984), 'Of other spaces: Utopias and heterotopias', *Architecture/Mouvement/Continuite*, October, pp. 1–9

——— (2012), *The Birth of the Clinic*, 3rd ed., New York: Taylor and Francis.

Franju, Georges (1959), *Les Yeux sans Visage* (*Eyes Without a Face*), Paris: Champs-Elysées Films/Lux Films.

Friedberg, A. (2006), *The Virtual Window: From Alberti to Microsoft*, Cambridge, MA: MIT Press.

——— (2009), 'The end of cinema: Multi-media and technological change', *Film Theory and Criticism: Introductory Readings*, New York: Oxford University Press.

Fuller, L. (1907–11), *Notebooks and Letters*, New York: New York Public Library.

—— (1913), *Fifteen Years of a Dancer's Life: With Some Account of Her Distinguished Friends*, Boston, MA: Small Maynard.

Galt, R. (2009), 'Pretty: Theory, aesthetics, and the history of the troublesome image', *Camera Obscura*, 24:2, pp. 1–41.

Gaudreault, A. (2001), 'Theatricality, narrativity, and trickality: Reevaluating the cinema of Georges Melies', in M. Solomon (ed.), *Fantastic Voyages of the Cinematic Imagination*, Albany, NY: State University of New York Press.

Gaudreault, A. and Marion, P. (2005), 'The neo-institutionalisation of cinema as a new medium', in V. Toulmin and S. Popple (eds), *Visual Delights Two: Exhibition and Reception*, Eastleigh: John Libbey Publishing, pp. 87–95.

—— (2015), *The End of Cinema?: A Medium in Crisis in the Digital Age*, New York: Columbia University Press.

Gomez, A. H. (2014), *Body Stages: The Metamorphosis of Loïe Fuller*, Milan: Skiro.

Gorky, M. (1996), 'On a visit to the Kingdom of the Shadows', in C. Harding and S. Popple (eds), *In the Kingdom of the Shadows: A Companion to Early Cinema*, London: Cygnus Arts, pp. 1–2.

Gordon, D. (1993), *24-Hour Psycho*, United Kingdom.

Graham, D. (1982), *Cinema 81*, New York: Dan Graham.

Greer, G. (2006), 'Focus', in J. C. Royoux, M. Warner and G. Greer, *Tacita Dean*, London: Phaidon Press.

Groupama Gan (2011), *La Couleur Retrouvee du Voyage Dans La Lune (A Trip to the Moon: Back in Color)*, Technicolor Foundation for Cinema Heritage.

Gunning, T. (1990), 'The cinema of attractions: Early cinema, its spectator and the avant garde', in T. Elsaesser and A. Barker (eds), *Early Cinema: Space, Frame, Narrative*, London: BFI.

—— (1994), 'Colorful metaphors: The attraction of color in early silent cinema', *Fotogenia*, 1, pp. 249–55.

—— (1995), 'An aesthetic of astonishment: Early film and the (in)credulous spectator', in Linda Williams (ed.), *Viewing Positions: Ways of Seeing Film*, New Jersey: Rutgers University Press, pp. 114–33.

—— (1996), 'A slippery topic: Colour at metaphor, intention or attraction?', in D. Hertogs and N. de Klerk (eds), *Disorderly Order: Colours in Silent Film,* Amsterdam: Stichting Film Museum, pp. 37–49.

—— (2007), 'In and out of the frame: Paintings in Hitchcock', in W. Schmenner and C. Corine Granof (eds), *Casting a Shadow: Creating the Alfred Hitchcock Film*, Chicago, IL: Northwestern University Press, pp. 29–47.

Hansen, M. B. (1993), 'Early cinema, late cinema: Permutations of the public sphere', *Screen*, 34:3, Autumn, pp. 197–211.

—— (2012), *Cinema and Experience: Siegfried Kracauer, Walter Benjamin, and Theodor W. Adorno*, Berkeley, CA: University of California Press.

Hanson, M. (2004), *The End of Celluloid: Film Futures in the Digital Age*, Rotovision, UK: Studio Tonne.

Hawkins, J. (2000), 'The scalpel's edge: Georges Franju's *Les Yeux Sans Visage*', in Joan Hawkins, *Cutting Edge: Art-Horror and the Horrific Avant-garde*, Minneapolis, MN: University of Minnesota Press, pp. 65–85.

Hertogs, D. and de Klerk, N. (1996), *Disorderly Order: Colours in Silent Film*, Amsterdam: Stichting Film Museum.

Hitchcock, A. (1927), *The Lodger*, London: Gainsborough Pictures.

——— (1941), *Suspicion*, Los Angeles, CA: RKO Radio Pictures.

——— (1945), *Spellbound*, Los Angeles, CA: Selznick International Pictures.

——— (1958), *Vertigo*, Los Angeles, CA: Alfred J. Hitchcock Productions.

——— (1960), *Psycho*, Los Angeles, CA: Shamley Productions.

Holl, U. (2014), 'Nostalgia, tinted memories and cinematic historiography: On Otto Preminger's *Bonjour Tristesse* (1958)', in Katharina Niemeyer (ed.), *Media and Nostalgia: Yearning for the Past, Present and Future*, London: Palgrave Macmillan, pp. 160–75.

Huston, J. (1942), *The Maltese Falcon*, Los Angeles, CA: Warner Bros..

Hutamo, E. (2013), *Illusions in Motion: Media Archaeology of the Moving Panorama and Related Spectacles*, New York: MIT Press.

Jameson, F. (1983), 'Postmodernism and consumer society', in Hal Foster (ed.), *Postmodern Culture*, London: Pluto Press, pp. 111–25.

——— (1984), 'Postmodernism, or the cultural logic of late capitalism', *New Left Review*, 146, July–August, pp. 53–92.

Jones, S. (2013), *Literature, Modernism and Dance*, Oxford: Oxford University Press.

Juchau, M. (2014), 'Christian Boltanski's chance at life: The French artist in Sydney', *The Monthly*, March, https://www.themonthly.com.au/issue/2014/march/1393592400/mireille-juchau/christian-boltanski%E2%80%99s-chance-life. Accessed 2 September 2018.

Kar-wai, W. (2000), *In The Mood For Love*, Hong Kong: Block 2 Pictures.

Kittler, F. (1999), *Gramophone, Film, Typewriter*, Stanford, CA: Stanford University Press.

Krauss, R. (2016), 'On Tacita Dean's *Film*', Tate Talks, https://www.youtube.com/watch?v=vCU9C V7BAAk. Accessed 5 December 2016.

Krutnik, F. (1994), 'Something more than night', in D. B. Clarke (ed.), *The Cinematic City*, New York: Routledge, pp. 83–106.

Kubelka, P. (1958–60), *Arnulf Rainer*, Vienna: Peter Kubelka.

Landsberg, A. (2004), *Prosthetic Memory: The Transformation of American Remembrance in the Age of Mass Culture*, New York: Columbia University Press.

Lang, F. (1931), *M/Eine Stadt sucht einen Mörder*, Nero Film, A.G.

Latour, B. and Lowe, A. (2011), 'The migration of the aura, or how to explore the original through its facsimiles', *Switching Codes: Thinking through Digital Technology in the Humanities and the Arts*, Chicago, IL: University of Chicago Press, pp. 275–97.

Lévêque, C. (2003), *Valstar Barbie*, Paris: ADAGP.

Lewinsky, M. (1996), 'A slippery topic: Colour at metaphor, intention or attraction?', in D. Hertogs and N. de Klerk (eds), *Disorderly Order: Colours in Silent Film*, Amsterdam: Stichting Film Museum, pp. 37–49.

Lista, G. (1994), *Loïe Fuller: Danseuse de la Belle Époch*, Paris: Éditions Hermann.

Loiperdinger, M. (2004), 'Lumière's arrival of the train: Cinema's founding myth', *The Moving Image*, 4:1, Spring, pp. 89–118.

Lowder R. (1994–95), *Bouquets 1 à 10*, Paris: Rose Lowder.

Lowenstein, A. (1998), 'Films without a face: Shock horror in the cinema of Georges Franju', *Cinema Journal*, 37:4, Summer, pp. 37–58.

Lumiére, A. and Lumiére, L. (1895a), *L'arrivée d'un train en Gare de La Ciotat* (*Arrival of a Train at a Station*), Lyon: Lumiere Films.

——— (1895b), *Repas de bebe* (*Feeding the Baby*), Lyon: Lumiere Films.

——— (1897), *Loïe Fuller – Danse Serpentine*, Lyon, Lumiere Films.

Malpas, J. (2008), 'Cultural heritage in the age of new media', in Y. Kalay, T. Kvan and J. Affleck (eds), *New Heritage: New Media and Cultural Heritage*, London: Routledge, pp. 13–26.

Mann, M. (1981), *Thief*, Los Angeles, CA: Mann/Caan Productions.

Manovich, L. (2007), 'Database as symbolic form', in Victoria Vesna (ed.), *Database Aesthetics: Art in the Age of Information Overflow*, Minneapolis, MN: Minnesota University Press.

Marclay, C. (1995), *Telephones*, New York: Christian Marclay.

——— (2010), *The Clock*, Christian Marclay: United Kingdom.

——— (2017), *Crossfire,* New York: Christian Marclay.

Marks, L. U. (2002), *Touch: Sensuous Theory and Multisensory Media*, Minneapolis, MN: University of Minnesota Press.

Martin, A. (2014), *Mise En Scène and Film Style: From Classical Hollywood to New Media Art*, New York: Palgrave Macmillan.

Mavor, C. (2013), *Blue Mythologies: Reflections on a Colour*, London: Reaktion Books.

Mazzanti, N. (2009), 'Colours, audiences, and (dis)continuity in the "Cinema of the Second Period"', *Film History*, 21, pp. 67–93.

Melford, G. (1931), *East of Borneo*, Los Angeles, CA: Universal Studios.

Méliès, G. (n.d.), '"Star" Films', *The Complete Catalogue*, Paris and New York.

——— ([1902] 2011), *Le Voyage dans la Lune* (*A Trip to the Moon*), Paris: Star Films, Lobster Films.

Michaud, P. A. (2006), *The Movement of Images* (ed. Bruno Racine), Paris: Editions du Centre Pompidou.

Mulvey, L. (2006), *Death 24x a Second: Stillness and the Moving Image*, London: Reaktion Books.

——— (2011), 'Passing time: Reflections on the old and the new', in C. Myer (ed.), *Critical Cinema: Beyond the Theory of Practice*, London: Wallflower, pp. 71–81.

Muybridge, E. (1893), *Descriptive Zoopraxography: Or, The Science of Animal Locomotion Made Popular*, Philadelphia, PA: University of Pennsylvania Press.

——— (1907), *The Human Figure in Motion: An Electro Photographic Investigation of Consecutive Phases of Muscular Actions*, London: Chapman & Hill.

Nava, J. (2014), *Shades of Cool*, Los Angeles, CA: Interscope Records.

Nead, L. (2007), *The Haunted Gallery: Painting, Photography, Film c.1900*, New Haven, CT: Yale University Press.

Neale, S. (1985), *Cinema and Technology: Image, Sound, Colour*, Bloomington, IN: Indiana University Press.

Newmayer, F. C. and Taylor, S. (1923), *Safety Last!*, Culver City, CA: Hal Roach Studios.

Nolan, C. (2000), *Memento*, Santa Monica, CA: Summit Entertainment, Team Todd.

Nora, P. (1998), 'Between memory and history (*Les Lieux de Mémoire*)', *Representations*, 26, Spring, pp. 7–24.

Orr, J. (2006), *Hitchcock and Twentieth Century Cinema*, London: Wallflower Press.

Oswald, G. (1957), *Crime of Passion*, Los Angeles, CA: Robert Goldstein Productions.

Palmer, R. B. (1994), *Hollywood's Dark Cinema: The American Film Noir*, New York: Twayne.

Peirce, C. S. (1931), *Collected Papers of Charles Sanders Peirce* (ed. Charles Hartshorne and Paul Weiss), Cambridge, MA: Harvard University Press.

—— (1955), *The Philosophy of Peirce: Selected Writings* (ed. Justus Buchler), New York: Dover.

Polan, D. (1986), *Power and Paranoia: History, Narrative and The American Cinema 1940–1950*, New York: Columbia University Press.

Polanski, R. (1974), *Chinatown*, Los Angeles, CA: Paramount Pictures.

Porter, E. (1903), *The Great Train Robbery*, New York: Edison Manufacturing Company.

Rees, L. (2014), 'Interview: Christian Boltanski', *Lucy Rees Art*, http://www.lucyreesart.com/blog/2014/5/13/cemeteries-waiting-for-lovers-an-interview-with-christian-boltanski. Accessed 2 January 2015.

Refn, N. W. (2011), *Drive*, Los Angeles, CA: Bold Films, Odd Lot Entertainment, Marc Platt Productions and Motel Movies.

Rodowick, D. N. (2007), *The Virtual Life of Film*, Cambridge, MA: Harvard University Press.

Rohmer, É. (1986), *Le Rayon Vert (The Green Ray)*, France: Ministère de la Culture et de la Communication.

Royoux, J. C. (2006), 'Survey', in J. C. Royoux, M. Warner and G. Greer, *Tacita Dean*, London: Phaidon Press.

Schlüpmann, H. (1996), 'Anarchy: But not without order', in D. Hertogs and N. de Klerk (eds), *Disorderly Order: Colours in Silent Film: The 1995 Amsterdam Workshop*, Amsterdam: Stichting Film Museum, pp. 62–70.

Schrader, P. (1972), 'Notes on Film Noir', *Film Comment*, Spring, 8:1, pp. 8–13.

Sconce, J. (2000), *Haunted Media: Electronic Presence from Telegraphy to Television*, Durham, NC: Duke University Press.

Scorsese, M. (2011), *Hugo*, Los Angeles, CA: Paramount Pictures.

Scott, R. (1982), *Blade Runner*, Los Angeles, CA: The Ladd Company, Shaw Brothers and Blade Runner Partnership.

Serra, R. (1968), *Hand Catching Lead*, New York: Artist's Rights Society (ARS).

Sharits, P. (1966), *Piece Mandala (End War)*, New York: Anthology Film Archives.

Sietsema, P. (2002), *Empire*, Los Angeles, CA: Regen Projects.

Sinsky, C. (2010), *Loïe Fuller*, New Haven, CT: Yale University, The Modernism Lab, http://modernistcommons.ca/islandora/object/yale%3A77. Accessed 2 September 2018.

Sobchack, V. (1996), *The Address of the Eye: A Phenomenology of Film Experience*, Princeton, NJ: Princeton University Press.

—— (2014), '*Detour*: Driving in a back projection, or forestalled by Film Noir', in Robert Miklitsch (ed.), *Kiss the Blood Off My Hands: On Classic Film Noir*, Chicago, IL: University of Illinois Press, pp. 113–29.

Solomon, M. (2011), 'Introduction', in Matthew Solomon (ed.), *Fantastic Voyages of the Cinematic Imagination*, Albany, NY: State University of New York Press.

Sommer, S. R. (1975), 'Loïe Fuller', *TDR/The Drama Review*, 19:1, pp. 53–67.

—— (1981), 'Loïe Fuller's art of music and light', *Dance Chronicle*, 4:4, pp. 389–401.

Stern, E. (1999), 'Hitchcock's *Marnie*: Dreams, surrealism and the sublime', *Hitchcock Annual*, Fall, pp. 30–50.

Teshigahara, H. (1966), *Tanin no Kao (The Face of Another)*, Japan: Teshigahara Productions.

Thompson, K. (1988), *Breaking the Glass Armour: Neoformalist Film Analysis*, Princeton, NJ: Princeton University Press.

Ulmer, E. G. (1945), *Detour*, Los Angeles, CA: Producers Releasing Corporation.

Usai, P. C. (2000), *Silent Cinema: An Introduction*, London: Palgrave.

—— (2001), *The Death of Cinema: History, Cultural Memory, and the Digital Dark Age*, London: British Film Institute.

—— (2010), 'The conservation of moving images', *Studies in Conservation*, 55, pp. 250–57.

Verne, J. (1865), *De la Terre à la Lune (From the Earth to the Moon)*, Paris: Pierre-Jules Hetzel.

Vertov, D. (1929), *Man with a Movie Camera*, Ukraine: VUFKU.

Villeneuve, D. (2017), *Blade Runner 2049*, Los Angeles, CA: 16:14 Entertainment.

Walsh, P. (2007), 'Rise and fall of the post-photographic museum: Technology and the transformation of art', in F. Cameron and S. Kenderdine (eds), *Theorizing Digital Culture: A Critical Discourse*, Cambridge, MA: MIT Press.

Warner, M. (2006), 'Interview', in J. C. Royoux, M. Warner and G. Greer, *Tacita Dean*, London: Phaidon Press.

Watson, T. and Gobeille, E. (2010), *Muybridgizer*, London: Nexus Studio/The Tate Gallery.

Wells, H. G. (1901), *The First Men in the Moon*, London: George Newnes.

Welles, O. (1958), *Touch of Evil*, Los Angeles, CA: Universal International Pictures.

Whitcomb, A. (2007), 'Materiality of virtual technologies: A new approach to thinking about the impact of multimedia in museums', in F. Cameron and S. Kenderdine (eds), *Theorizing Digital Culture: A Critical Discourse*, Cambridge, MA: MIT Press.

White, H. (1975), *Metahistory: The Historical Imagination in Nineteenth-Century Europe*, Baltimore, MD: Johns Hopkins University Press.

Yang, F. (2010), *The Fifth Night*, 7 channel video installation, Toronto: TD Bank Group.

Yeoh, P. (2013), 'Tacita Dean and the "Genius of nothing"', *The Glass Magazine*, 14, http://www.theglassmagazine.com/tacita-dean-and-the-genius-of-nothing. Accessed 4 January 2014.

Yumibe, J. (2009), 'Harmonious sensations of sounds by means of color: Vernacular Colour Abstractions in Silent Cinema', *Film History: An International Journal*, 21: 2, pp. 164–76.

—— (2012), *Moving Color: Early Film, Mass Culture, Modernism*, New Jersey: Rutgers University Press.

Zielinski, S. (2006), *Deep Time of the Media: Toward an Archaeology of Hearing and Seeing by Technical Means*, Cambridge, MA: MIT Press.

Index